PhotoOp

Photo Op. *In the language of most humans it means "photo opportunity." But not to photographers. They have been known to take a perfectly good phrase and twist it to conform to their own eccentric and sometimes mischievous ideas, particularly any phrase implying that someone was doing them a favor by allowing them to do their job. In this case, the expression "photo opportunity" was coined by a staffer in the Nixon press office. It was demeaning and insulting to the talented professionals who had devoted their lives to capturing the images of history.*

The first time anyone heard the term was when it was used in an announcement made over the public address system in the press room: "There will be a photo opportunity in the Oval Office at 3 :00 P.M. with the President."

There was immediate grumbling among the assembled photogs. "Who do they think we are, for Christ's sake!" said Frank Cancellare, the dean of the White House shooters. "Why don't they just say there'll be a photo with the president?"

"The next thing you know they'll be calling us photojournalists," complained another grizzled old lensman as he crushed his cigar into an ashtray. These were the same photographers who used to sit around drinking whiskey and playing poker with Harry Truman, and the idea of some twenty-five-year-old pinstripe-suited Yalie handing them an opportunity wasn't sitting well.

The second time a "photo opportunity" was announced, Frank Johnston, the Washington Post *lensman and resident dry wit, said, "What the hell, guys, it's only a photo op." Now that was a good expression. Not only was the spanking new term coined by the White House shot down, but it was being mocked at the same time. Better yet, the White House hated our abbreviated usage. Needless to say, we have used it proudly ever since. Photographers like that sort of thing.*

Photographers spend their lives trying to make great pictures, and they do so by employing a combination of perseverance, experience, talent, instinct, guts, competitiveness, and plain old luck. Great photos can be made at a press conference, during a wedding, in a first-grade classroom, or in combat, but I've never heard of one being handed to anybody on a silver platter. Photo ops. The world is full of them.

PhotoOp

David Hume Kennerly

A Pulitzer Prize–Winning Photographer Covers Events That Shaped Our Times

Published in Cooperation with
The University of Texas Center for American History

 UNIVERSITY OF TEXAS PRESS AUSTIN

Requests for permission to reproduce material
from this work should be sent to
Permissions, University of Texas Press,
Box 7819, Austin, TX 78713-7819.

∞ The paper used in this publication meets the
minimum requirements of American National Standard
for Information Sciences—Permanence of Paper
for Printed Library Materials, ANSI Z39.48-1984.

Library of Congress Catalog Card Number 95-60228

Design and typography by George Lenox

*We are grateful for permission
to reproduce David Hume Kennerly's photographs from:*

UPI/BETTMANN

Photographs on pages 8, Governor and Mrs. Reagan,
Hugh Hefner, Elizabeth Taylor and Richard Burton;
9, Denny McLain, Bob Gibson; 10–13, all photographs;
16–18, all photographs; 19, Horst Buchholtz, Don Clendenon;
20, Tom Seaver and Gary Gentry, Brooks Robinson;
21–23, all photographs; 26, machine-gunner;
27–36, all photographs; 37, bomb-laden fighter,
Steve Richie, *Constellation* deck; 38, disabled vet;
39–42, all photographs; 45, little girl, toast.

THE GERALD R. FORD PRESIDENTIAL LIBRARY

Photographs on pages 63–103.

TIME INC.

Time magazine covers on pages 150–151.

*We are also grateful for permission
to reproduce photographs of David Hume Kennerly by:*

RON BENNETT

Photograph on page 14.

DAVID BURNETT/CONTACT PRESS IMAGES

Photographs on pages 102 and 112.

MATT FRANJOLA

Photograph on page 26.

TERRY O'DONNELL

Photograph on page 72.

The David Hume Kennerly photographic archive
is located at the Center for American History,
University of Texas at Austin.

Dedicated to my wonderful son, Byron (class of '02)

The superb black and white prints for this book were made by Chris Crichton and Debra Wainwright at The Film Lab in Portland, Oregon. They are great professionals.

My UPI pictures now reside at the Bettmann Archive in New York City. I'm grateful to David Greenstein, Ann Rudin, Darby Harper, and Al Tillman at Bettmann for helping me find them and for making them available.

Thanks also to Frank Mackaman, Ken Hafeli, and Dick Holzhousen at the Ford Library for all their help with my research.

And a deep debt of gratitude to Dr. Don Carleton and his staff at the Center for American History at the University of Texas at Austin. Without Don's perseverance this project would not have happened.

INTRODUCTION

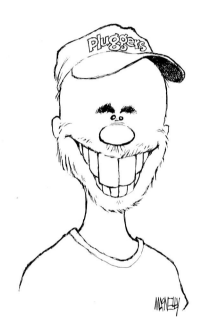

Kennerly by MacNelly, 1995.

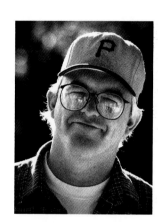

MacNelly by Kennerly, 1993.

Writing introductions is no easy matter, and doing one for this book would be particularly difficult. I needed someone who could put an entire generation into perspective, someone good enough to define what we are all about. It was a tall order. I narrowed the necessary qualifications to just a few criteria. I wanted someone who was born in 1947, graduated high school in 1965, flunked out of college, had a sense of humor, and was able to sum up our generation in a couple of pages so as not to take valuable space from my pictures. That pretty much left Jeff MacNelly.

MacNelly came to my attention the year he won a Pulitzer for his editorial cartooning. I read all about him in the New York Times. *At twenty-four he was the youngest person to ever win that high journalistic honor. I know this because the story about him was right next to the one about me winning mine—and he was only a few weeks younger than I. I suddenly didn't like MacNelly, even though I hadn't met him. I wanted to be the youngest. Since then Jeff has won two more Pulitzers and I haven't. It's another reason not to like him, but I've gotten over it—after all, between the two of us we now have four . . .*

When he isn't winning prizes for his editorial work, sketching cartoons for his friends' books, or driving his wife, Susie, around her Virginia farm on a tractor, Jeff draws Shoe *and* Pluggers, *two excellent features that appear in newspapers all over the world.*

D.H.K.

The Adventures of
Baby Boomer

A self-centered
generation comes of age,
and usually has a
name for it...

— by Jeff MacNelly

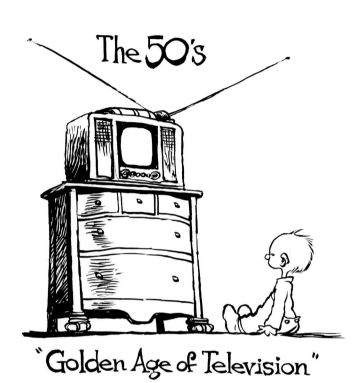

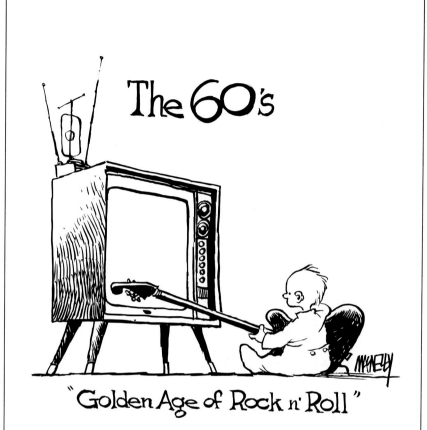

The 90's

"Golden Age of Healthcare"

The 2000's

"Golden Age of Arthritis"

FOREWORD
Dirck Halstead

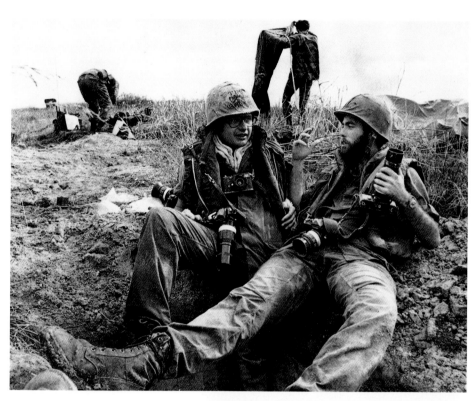

Dirck Halstead (left) and I
at Chon Thanh, Vietnam, 1972.

My father, O.A. "Tunney" Kennerly, and I,
San Francisco, 1966.

Dirck Halstead is a shooter's shooter. He is Time *magazine's senior White House photographer and has been around the world more times than most astronauts. Halstead has shot forty-four covers for* Time *and has won practically every major photo award, including the Robert Capa medal for bravery. His most important credit, however, is that he is godfather to my son, Byron.*

D.H.K.

On a brisk spring afternoon in 1976, President Gerald R. Ford emerged from a side entrance of the St. Francis Hotel in downtown San Francisco. As he waved to the crowd across the street, a shot rang out, barely missing him and passing within inches of the left ear of his personal photographer, David Hume Kennerly.

A Secret Service agent pushed the president headfirst into his armor-plated limousine, and the car squealed away from the curb, heading for the airport.

Waiting there aboard Air Force One, First Lady Betty Ford was told of the assassination attempt. By the time the motorcade arrived at the plane's side, both the president and the first lady were visibly shaken. In the airplane's cabin the tension was so high that nobody could think of anything to say—until Kennerly stepped in and asked, "Other than that, how did you like San Francisco, Mr. President?"

The first couple dissolved into each other's arms in laughter.

To understand David Kennerly you have to know that his father, O. A. "Tunney" Kennerly, was one of the last great pitchmen.

As David was growing up in Roseburg, Oregon, he traveled with his father to trade shows, watching his dad as he stood for hours on end mesmerizing audiences and extolling the wonders of such products as "Everclear, the little stick that will keep your eyeglasses from ever fogging up." His dad was so good that at the end of his colorful pitch, people would practically throw money at him to purchase his product.

Tunney always told his son that you have to get people's attention and then give them a good time if you're going to make the sale. And you may have to stand in one place for hours to do it.

Photographer David Burnett once described the key to success in his profession as "being able to see the king."

Kennerly has an uncanny ability to gain access to the people in the news, whether it be a monarch, a president, a movie star, or a soldier under fire. And more importantly, his pictures reveal the hearts of his subjects. For the past three decades David Kennerly has pulled that rabbit out of the hat more than any other photographer in the world. Perhaps more astonishing is that his subjects have always welcomed him back.

I have worked with Kennerly since 1968. Our first meeting was in San Diego, where as a young UPI photographer he was assigned to develop the film I was taking of Richard Nixon, who was running for president. Despite the fact that he wanted to be out there taking pictures himself, he handled my film as if it were his own and bubbled over every time I got a good shot. It wasn't long before others were developing his.

If there is one element that defines Kennerly's style, it is that for him photography is "no big deal." In a way he reminds me of the Peter Falk character Columbo. He snares his subjects with a relaxed and open approach.

He has even carried the same basic equipment for years. A couple of Nikons with 20, 35, 85, 180, and 300 mm lenses in his bag—that's it. Nothing exotic that would require fiddling or preoccupation as he establishes a bond with his quarry.

His targets, whether Henry Kissinger on his honeymoon or Anwar Sadat in a crisis in the Middle East, find themselves snared and charmed—and David always gets the picture.

While many of his fellows stand in awe of David's abilities to talk his way into exclusive situations, his greatest talent is as a competitive photographer and newsman. He's the ultimate professional. In fact, in Kennerly's mind the ultimate compliment is to be called a "good shooter," especially by those he respects the most, his colleagues.

In 1972 I showed up in Vietnam on an assignment for *Time* magazine, and I dropped in on Kennerly, who was UPI's photo bureau chief in Saigon, the same post I had held some seven years earlier. When I got to the bureau a celebration was in progress. Kennerly had just won the Pulitzer Prize for photography. The next day Kennerly and I were out taking pictures on Highway 13 and ended up in the middle of the worst firefight I'd ever been in. The unit we were with took dozens of casualties, and at one point we were surrounded by North Vietnamese regulars. It's about as close as I've ever come to buying the farm. Luckily we got out, and on the way back to Saigon I asked Kennerly why he would place himself in danger just a day after winning the Pulitzer. He laughed and said, "It's what I do."

Fourteen years later and ninety degrees colder in Reykjavík, Iceland, David was trying desperately to keep his fingers from freezing after spending hours on a camera platform waiting for President Reagan and Premier Gorbachev to appear at the end of their second summit. The meeting, which was supposed to have been a pro forma affair, was scheduled to end in midafternoon on Sunday. As the sun slipped below the horizon Kennerly began to suspect that something had changed. The hours dragged on, and many of the photographers sharing the platform wandered off to warm up, but David held his position.

After several hours the doors suddenly opened, and Reagan and Gorbachev briskly walked down the stairs. The president's normally smiling face was set in grim determination, mirroring the tight-lipped demeanor of the Soviet premier. In an instant Kennerly whipped up his old 300 mm lens and squeezed off four frames. Only one other photographer of the multitudes present got that moment, and he had been shooting a much faster black and white film. Kennerly's problems were tougher. His color transparency film was much slower, necessitating a shutter speed of one-fifteenth of a second, almost impossible to hand-hold, especially if you're shaking from the cold.

I was editing his film that night, as our New York office waited anxiously for an unprecedented late Sunday close to get a cover picture on the stands the following morning. As I looked at the still-wet film I held my breath. The first frame was out of focus, the second had movement, but the third was sharp as a tack. Kennerly had precisely captured the decisive moment as the two faced off after their meeting ended in discord.

To this day Kennerly takes great glee in *Time*'s exclusive cover, which appeared worldwide less than ten hours later.

That competitive instinct still drives Kennerly, but conversely, he is one of the most generous photographers I have ever met. While serving as President Ford's personal shooter Kennerly went to great lengths to offer presidential access to his colleagues, even those who had been his direct competitors. More than sixty photographers were able to document the Ford presidency from the inside because of his efforts. Thanks to Kennerly, Wally McNamee of *Newsweek*, who had been his main competition, was able to shoot inside the family quarters the night Ford lost the election. Another, Dick Swanson, went so far as to don scuba gear to picture the president as he swam above him in the White House pool.

His father's lessons were never lost. That ability to get the subject's attention opened doors all over the world. This brought to a whole generation intimate pictures of the events that helped shape their lives, courtesy of one of their own, the kid from West Linn High, Class of '65. It's what he does.

PhotoOp

David Hume Kennerly

I was the high school photographer in the small town of West Linn, Oregon, Class of '65. Unlike most others who took pictures in high school, I didn't put my camera down after graduation. Instead, I kept on shooting, and as a result, my camera took me on a trip that has covered millions of miles through some 125 countries over more than a quarter of a century and let me witness the events that have shaped my generation. My camera has been my magic carpet.

I wanted to be a photographer ever since I was a kid. I looked at the camera as "my ticket out," meaning not just a way to escape small-town life but also, and more importantly, a way to see what was happening in this wide world and show it to those who couldn't go there.

My journey out of Oregon and around the world followed many of the stories that most affected us—"us" being those people born between 1946 and 1964. We have been called by a lot of names: Baby Boomers, the Vietnam Generation, the Me Generation, the Post-War Generation, the TV Generation, etc. As "class photographer" of my generation, it has been my privilege to witness and photograph many of the defining events of our collective journey, events that have touched each and every one of us in some way. I see this collection of my pictures as a scrapbook for the thirty-year reunion of the Class of '65.

In 47 B.C. Julius Caesar, after winning a major battle, declared, "Veni, vidi, vici (I came, I saw, I conquered)." In A.D. 1947, almost two thousand years later, and the year in which I was born, Reddi-Wip was introduced. Some of the other "boomers" who came along in 1947: Nolan Ryan, Johnny Bench, Kareem Abdul-Jabbar, David Bowie, Albert Brooks, Billy Crystal, Ted Danson, Steven Spielberg, Carlos Santana, Danny Glover, Kevin Kline, Elton John, Tyne Daly, Glenn Close, David Mamet, Emmylou Harris, Danielle Steel, Richard Dreyfuss, Jeff MacNelly, Mick Fleetwood, Jane Curtin, David Letterman, P. J. O'Rourke, Farrah Fawcett, Jaclyn Smith, Kenny Loggins, Dan Quayle, Harvey Keitel, Stephen King, Arlo Guthrie, Cheryl Tiegs,

A mirror image of myself with some high school friends, Portland, 1965.

Famous Amos, Dick Fosbury, Roger Helliwell, Greg Allman, Dennis Keller, Ann Beattie, Rob Reiner, James Woods, Peter Serkin, Minnie Riperton, Jessica Savitch, Thurman Munson, Pete Maravich, Mark Watson, Bernard Goetz, Laurie Anderson, Larry Nelson, Henry Cisneros, Doug Henning, David Hare, Tom Clancy, Cher, Meridith Baxter, Jim Ryun, Jim Plunkett, Donna DeVerona, Suzanne Somers, Holly Woodlawn, Linda Lovelace, Carole Bayer Sager, Marsha Norman, Anne Archer, Clarence Page, Taylor Branch, Ry Cooder, O. J. Simpson, and approximately 3,817,000 others in the United States.

In 1947 Harry Truman was president; Chuck Yeager broke the sound barrier; the CIA was founded; UFOs were spotted; Jackie Robinson signed with the Brooklyn Dodgers; Steve Canyon debuted; SONY was founded; James Michener's *Tales of the South Pacific* was published; Howard Hughes flew the "Spruce Goose"; India gained independence and Pakistan became an independent Muslim state; the Taft-Hartley Act was passed; the film industry

blacklisted the "Hollywood Ten" for refusing to tell the House Un-American Activities Committee (HUAC) whether they had been Communists; sexual reproduction was found to occur in bacteria; the first Dead Sea scrolls were found; Marlon Brando played Stanley Kowalski in the Broadway production of Tennessee William's *Streetcar Named Desire; Miracle on 34th Street* premiered; Polaroid introduced a camera that developed film within its body in sixty seconds; Picasso painted *Ulysses with His Sirens;* Christian Dior convinced the women of the world to lower their hemlines to twelve inches from the floor, calling it the "New Look"; the Everglades National Park was established; Thor Heyerdahl sailed across 4,300 miles of ocean on a raft called *Kon-Tiki;* Henry Ford died; Ajax cleanser, Almond Joy bars, MSG, and the microwave were introduced; Seagram's 7 Crown became the world's largest-selling brand of whiskey; and the "Woody Woodpecker" song hit the airwaves.

Because I was brought up in a small town (Roseburg, Oregon, population 8,390), it would be many years before my focus would shift to earthshaking events. Word from the outside was slow to reach "The Timber Capital of the Nation," and when it did, the news wasn't usually all that bad. The most violence I was aware of as a young boy centered on Gillette's *Friday Night Fights* in black and white—if you could see it at all through the snow on the TV screen.

When I was seven "Shake, Rattle, and Roll" was a hit song. Nineteen fifty-four was also the year that color TV came out, but more important for me, it was the year that Kodak released their high-speed film, Tri-X. I saw Jules Verne's *20,000 Leagues under the Sea,* the first film I remember seeing in a theater. I vividly recall Captain Nemo and his fantastic submarine exploring the unknown and having one great adventure after another. I wanted desperately to be like him.

The tide of international events finally reached Roseburg in the late fifties. In 1956, at a reception in Moscow, Soviet premier Nikita Khrushchev had announced to a group of Western ambassadors that "History is on our side. We will bury you!" His proclamation sent a shiver up every capitalist spine in the free world, a feeling exacerbated the following year when Khrushchev and his fellow Soviets proceeded to launch Sputnik I, the earth's first artificial satellite.

All across America people started building bomb shelters, and the folks in my hometown were no exception. It seemed as if every kid I knew had a father who was digging a hole underneath their house and building blast walls to save them from the coming nuclear holocaust. But not mine. My dad thought that the nuclear threat was a conspiracy promulgated by the same people who gave us aluminum siding. His skepticism gave me little comfort, though, and I felt sure that I would be incinerated when the Big One dropped.

In 1959, as I rode on a covered wagon in a parade celebrating Oregon's Centennial, Fidel Castro took power in Cuba. This ultimately precipitated the Cuban Missile Crisis in 1962 and made me regret the fact that we didn't have that shelter under the living room. It also made me wonder about those people who wanted to kill us. I was destined to find out who they were firsthand. That same year I became interested in photography, and coincidentally, it was the year that Nikon unveiled their single-lens reflex camera, whose various incarnations I have used to this day.

A striking moment in my young life came after I was prevented from crossing police lines to see a fire. I tried to convince a cop to let me in because I needed to see what was happening. He told me to leave, saying that I was just a kid and didn't need to see anything. Then I saw a photographer from the *Roseburg News Review* show his press pass to that same officer; the photographer was immediately allowed inside.

That was the day I pretty much decided what I wanted to be when I grew up—or sooner, if possible. To try to speed up that process I bought an old twin-lens reflex and started taking pictures of anything that moved. I envisioned myself as a globe-trotting photog, a Captain Nemo with a camera, sneaking pictures inside the Kremlin one day and covering a war in the Congo the next. As it happened, my dreams weren't that far from future reality.

By the time I reached my senior year in high school, the world had pretty much been turned upside down. President Kennedy had been shot and the man who replaced him had been reelected and was bombing North Vietnam. Fortunately for us, the Vietnamese didn't have nukes.

In 1965, the year I graduated from high school, I was well down the path to becoming a professional photographer, shooting for the high school paper and annual and helping to teach a class in photography. I didn't want to read about history any more; I wanted to see it being made. I wanted to be there—with my camera. That desire became my passion and my career.

As it happened, 1965 was a big year for news. The bombing of North Vietnam was being protested, Malcolm X was shot, Martin Luther King was arrested in Selma, there was a riot in Watts, the Rolling Stones sang "Satisfaction," Diet Pepsi was introduced, and the U.S. Marines landed in Da Nang, spearheading what would be a buildup of 125,000 American troops in Vietnam by July of that year. My graduating class of '65 was staring down the barrel of that Vietnam gun. The Baby Boomers were coming of age.

Pendleton Roundup,
Oregon, 1966.

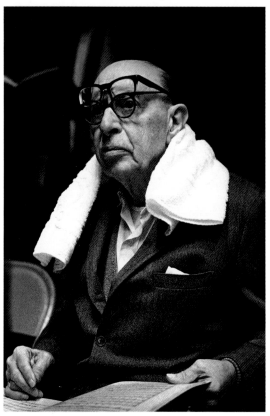

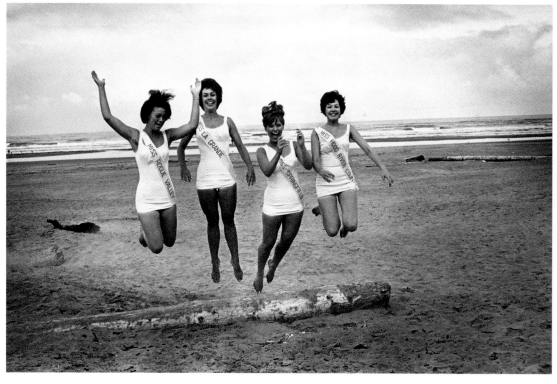

Left: Igor Stravinsky, Portland, 1966.
Above: Miss Oregon beauty contestants, Seaside, Oregon, 1966.

The following year I was hired by the *Oregon Journal* as a photographer. The editors had been impressed with my enthusiasm and potential—the latter term being emphasized, for they felt that my photo-taking technique left substantial room for improvement. I was happy to get the job, however, and I don't think it occurred to me how difficult it was to land a staff job on a large metropolitan daily, particularly at the age of eighteen. Of course, at that age nothing seems impossible. The *Journal* gave me my first real taste of big-time journalism.

Even though Portland was fairly small by big-city standards, it still produced some good stories. Between taking pictures of check presentations and beauty queens, I was able to cover everything from forest fires and antiwar demonstrations to important figures like Robert Kennedy, Hubert Humphrey, Igor Stravinsky, Miles Davis, Stokely Carmichael, the Rolling Stones, and the Supremes, all of whom passed through town. I remember wistfully watching the national press accompanying Kennedy as they boarded his plane heading for the next stop. I wanted to be with them. I suppose I should have been satisfied with my role as one of the youngest newspaper photographers in the country, but I needed more.

It was my forest-fire coverage that paid off. The pictures were noticed by a United Press International executive who offered me a job in their Los Angeles bureau. I jumped at the chance and headed south, U-Haul trailer in tow.

Fire fighter in eastern Oregon, 1966.

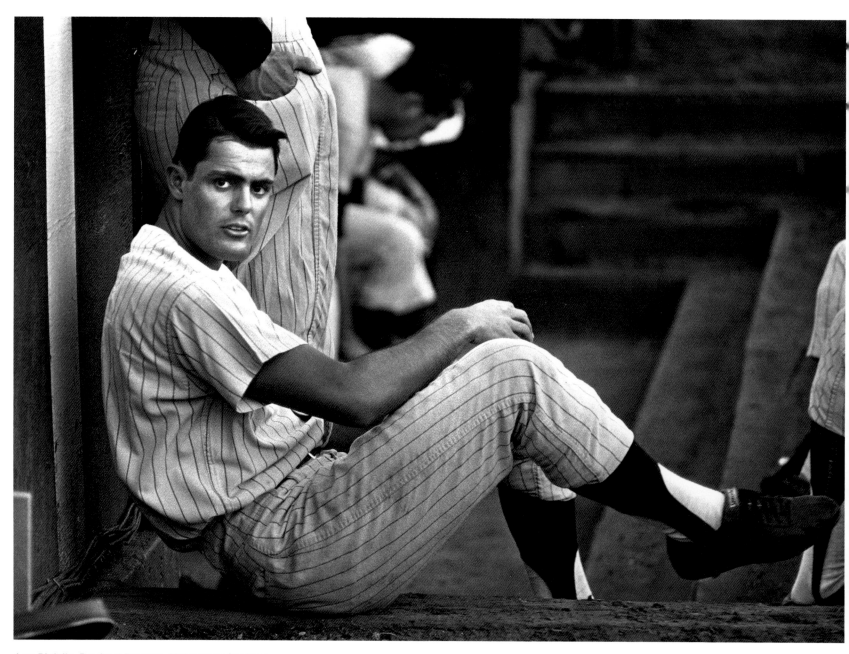

Lou Piniella, Portland Beavers, Multnomah Stadium,
Portland, 1966.

Right: Diana Ross and the Supremes, Portland Memorial Coliseum, 1966.

Miles Davis, Portland, 1966.

Black Power leader Stokely Carmichael, Portland, 1967.

Anti-war demonstrators protest Vice President Hubert Humphrey's visit, Portland, 1967.

L.A. was more of what I had in mind, and working for UPI was the perfect situation. For one thing, wire-service photogs cover everything. Their motto is "a deadline every minute," which was perfect for a twenty-year-old shooter with energy to burn. On some days I would cover eight or nine assignments and ask for more. The older photogs thought I was a bit squirrelly, but they were happy to have me cover the lousier assignments, which usually involved working on holidays or in any situation where people were being beaten or shot.

One holiday that I worked was Christmas 1967. My assignment was to take a picture of Gov. Ronald Reagan and his family at their home in L.A.'s Pacific Palisades. I arrived to find the governor and Mrs. Reagan with their children, Ron, Jr., and Patti, all dressed up and ready to be photographed. They were pleasant and offered me coffee and some Christmas cookies. The picture isn't the most spontaneous I've ever taken, and I probably wouldn't have used it here if the Reagans hadn't celebrated Christmas in the White House fifteen years later.

I shot professional and college sports as well as news for UPI. The best I had managed in Portland was the occasional assignment to photograph the Portland Beavers baseball team, a farm club for the Cleveland Indians. Even so, Portland provided a few worthwhile photos. A shot of Beavers' minor leaguer Lou Piniella sitting on the edge of the dugout remains one of my favorite sports pictures. Piniella would go on to the bigs and have a successful major league career as both a player and a manager.

Fellow Baby Boomers O. J. Simpson and Lew Alcindor (Kareem Abdul-Jabbar) played their college ball in Los Angeles, giving me a chance to catch them early in their careers. I also photographed two great pitchers, the St. Louis Cardinals' Bob Gibson and the Detroit Tigers' Denny McLain, in 1968.

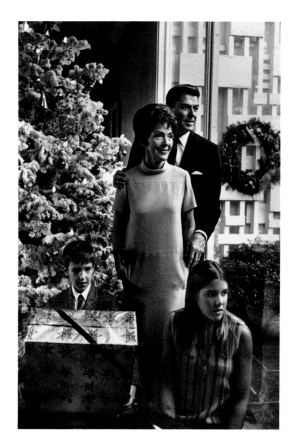

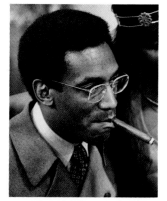

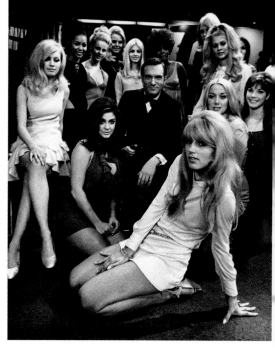

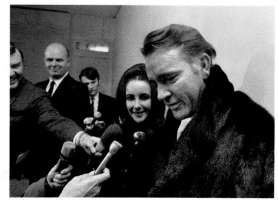

Clockwise from top left:
Governor and Mrs. Ronald Reagan with Patti and Ron, Jr., Pacific Palisades, 1967; Entertainer Bill Cosby, 1968; Hugh Hefner and his Playmates, Los Angeles, 1968; Natalie Wood on the set of *Bob & Carol & Ted & Alice*, Los Angeles, 1968; Elizabeth Taylor and Richard Burton, Los Angeles Airport, 1968.

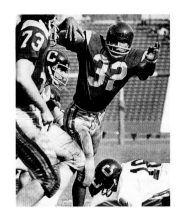

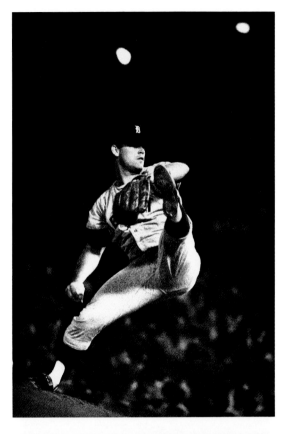

I covered McLain at Anaheim Stadium pitching against the Angels when he was going for his twenty-eighth win on his way to thirty-one victories. McLain was—and still is—the only pitcher to win more than thirty games since Dizzy Dean did in 1934, and he was that year's American League MVP and Cy Young winner. Gibson also had his greatest year, with a 22–9 record and a 1.12 ERA, the lowest since 1920. His 13 shutouts and 268 strikeouts earned him the National League's MVP and Cy Young awards. The two faced each other in the World Series that year, with Gibson and St. Louis coming out on top. Gibson went on to the Baseball Hall of Fame. McLain went on to serve time in a federal penitentiary for dealing drugs, his Hall of Fame entry forever blocked by those steel bars.

One can't be a photog in L.A. without doing Hollywood stories. Some of the people I photographed were Natalie Wood, who was making *Bob & Carol & Ted & Alice*, Elizabeth Taylor and Richard Burton, *Playboy* publisher Hugh Hefner surrounded by Playmates, Bill Cosby, and Ann-Margret.

Clockwise from above:
Ann-Margret, Los Angeles, 1968; USC running back
O.J. Simpson sprints for a touchdown at the
Los Angeles Memorial Coliseum, 1968; Detroit Tigers
pitcher Denny McLain pitches his 28th win on the way
to a season record 31, Anaheim, 1968; St. Louis
Cardinal pitcher and MVP Bob Gibson in Dodger
Stadium, Los Angeles, 1968.

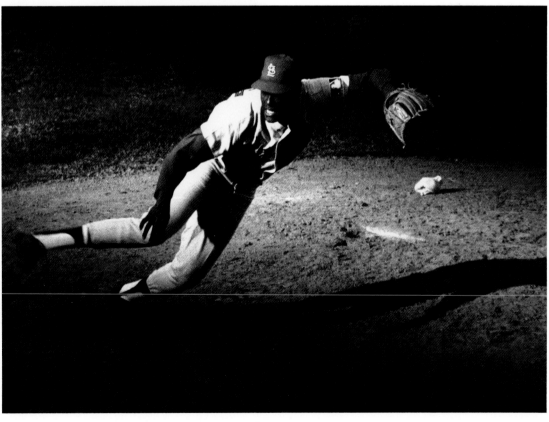

Something a little less safe than photographing celebrities happened at a small motel in Manhattan Beach, an ocean-side community twenty-five miles from downtown Los Angeles. When I arrived on the scene, the police had blocked traffic around the single-story structure. Inside was a murderer named Arthur Glenn Jones, who had recently escaped from San Quentin. The police had him surrounded, but he wasn't about to give up. I stood in the parking lot of the horseshoe-shaped motel as a police officer tried to talk Jones out, but he stayed inside. The detective walked away, and a minute or so later one of the officers fired a tear-gas shell through a back window. Nothing happened. As I looked around I could see armed officers crouched behind cars and doorways. A CBS cameraman and I were the only two people visible to Jones. It didn't seem like a problem to us until a huge explosion ripped through the motel. Jones had some explosives with him and they blew up. We figured that he went up along with them. We were wrong. About thirty seconds later a face appeared in the window, followed by a body diving through the opening. At that moment the police opened fire and hit him. Jones fell over an ivy-covered wall and started crawling. I don't remember taking pictures, but I did. He couldn't have been more than twenty feet away when he looked up and stared into my lens. I must have been the last living thing he saw. I watched as his head drooped to the ground. I couldn't help thinking that I just saw a man die and that it made one hell of a good snap.

The shoot-out happened on the same day that Lyndon Johnson announced that he would not seek reelection. The photos of Jones being gunned down ran alongside a picture of the president on scores of front pages around the country.

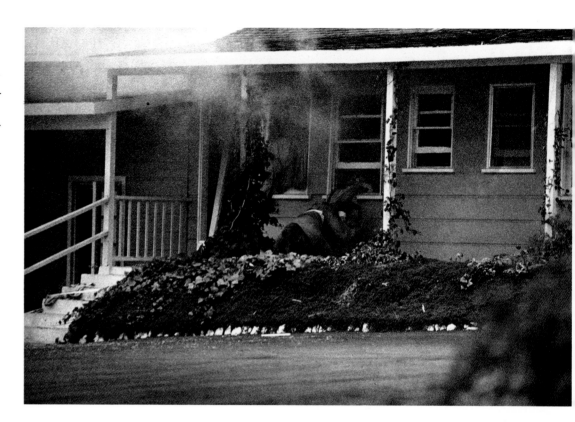

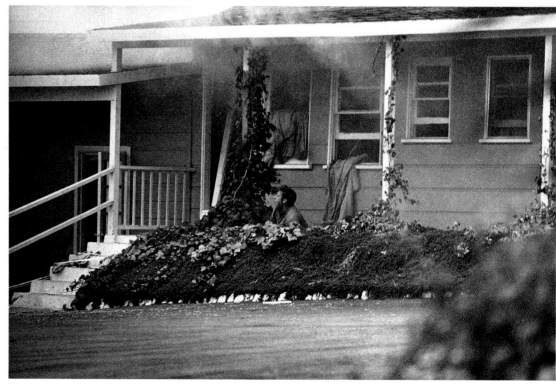

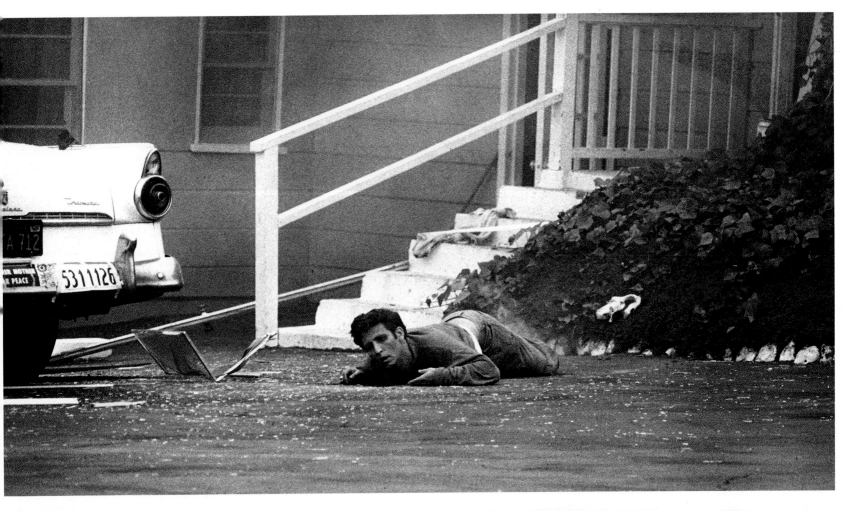

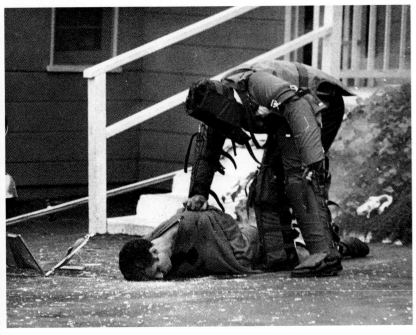

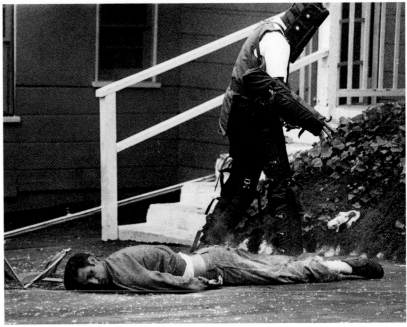

Picture sequence: Escaped murderer Glenn Arthur Jones as he crawls from his dynamited motel room and is mortally wounded by police bullets. A police officer checks Jones for explosives before walking away from the dead criminal, Manhattan Beach, California, 1967.

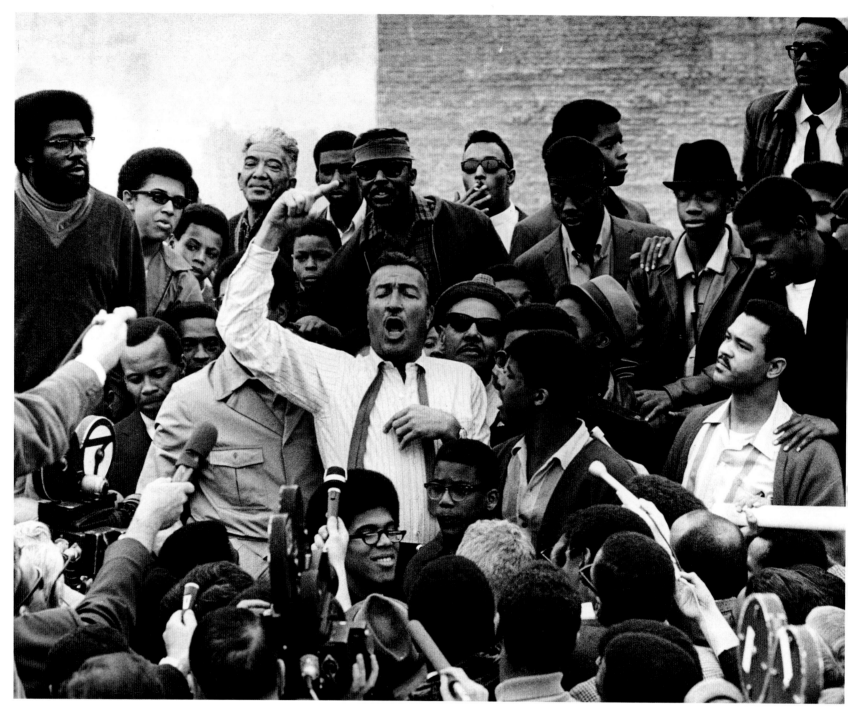

Congressman Adam Clayton Powell speaks at UCLA, 1968.

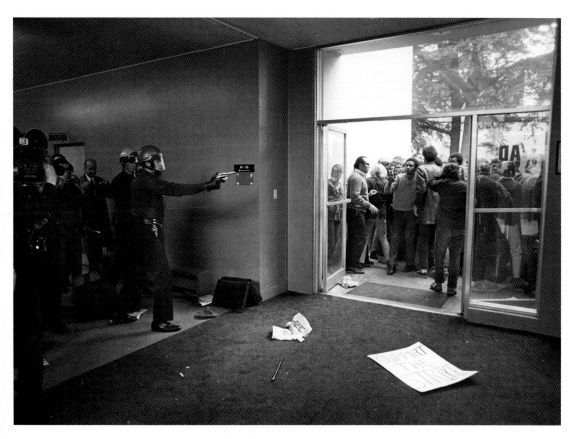

When Adam Clayton Powell came to town, a little bit of the civil rights movement came along with him. The fiery congressman from Harlem drew a big crowd at UCLA that day, preaching against the war and speaking about injustice toward blacks. Powell was one of those rare people who made both news and great pictures.

In keeping with the "send Kennerly" philosophy the older photogs had when it came to civil unrest, I landed an assignment to cover the upheaval at San Francisco State College. S. I. Hayakawa, a semantics expert, had been brought in to run the college and put an end to the student demonstrations. An unlikely looking peacemaker, he wore a tam-o'-shanter and occasionally a lei around his neck as he tried to calm a volatile situation, one way or another.

The only time I ever saw police draw guns against demonstrators happened as an angry mob charged the administration building in an effort to get Hayakawa. The police and students went at each other outside, and one of the rioters hit a police officer with an iron rod, breaking his collarbone. Another officer saw what happened and hit the assailant so hard that he bounced off the ground. The two injured parties went to the hospital in the same ambulance, and it was my understanding that the police officer received better attention.

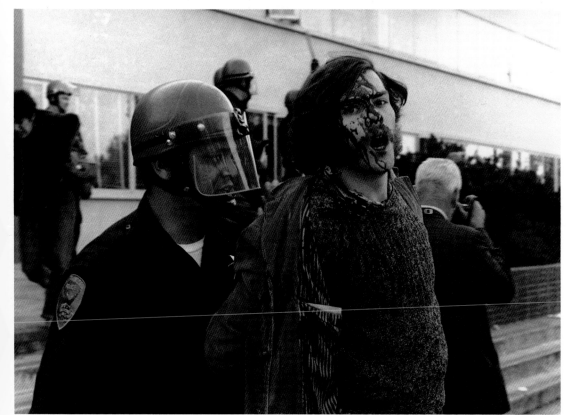

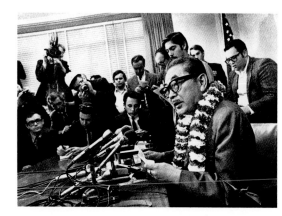

S.I. Hayakawa, president of San Francisco State College, 1968.

Above: Police with guns drawn keep demonstrators at bay, San Francisco State, 1968. *Below:* Police officer with wounded demonstrator.

I finally got my chance to cover Robert Kennedy and ride on his plane, just like one of the big guys—or so I thought. I had some difficulty convincing the senator's staff that I was indeed a UPI photographer sent from Los Angeles to photograph his campaign. I guess the fact that I was a rather young-looking twenty-one didn't help. They finally relented and let me on board with them in Albuquerque, but the staff and the traveling press gave me the cold shoulder. A couple of stops later Kennedy walked by and saw me sitting by myself next to a window. He said, "Hi, I don't remember you." I introduced myself, and he sat down for a moment. He asked the rather innocuous question, "So, how's it been going?" I jumped at the chance to tell him that I was having a hard time doing my job due to the interference of his people and that I felt like covering him was as difficult as winning the lottery. He told me not to worry, that it wouldn't happen again. And it didn't. Everybody's attitude took a remarkably positive turn in my direction after that—almost as if I had become one of the boys.

Kennedy related well to people, particularly the young ones. When we passed through the Indian reservation in Window Rock, Arizona, the senator attracted a young girl who couldn't have been more than six years old. He smiled and took her hand, and she walked around with him the rest of the time we were there. It wasn't done for the media, and it wasn't done to impress anyone; it was simply a natural act, the kind we rarely see from politicians anymore.

Another stop on the trip was in Phoenix, where Kennedy addressed a fund-raising dinner. As he sat by himself waiting to be introduced, I noticed a melancholy look on his face and took a picture. He normally seemed upbeat, so his expression surprised me a bit. Every now and then, especially after his assassination, I have looked at that picture and wondered what he was thinking.

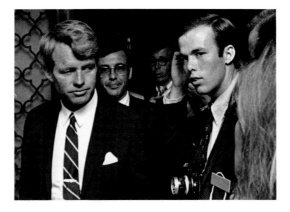

Ron Bennett photographs me with Senator Robert Kennedy at the Ambassador Hotel the night Kennedy was shot.

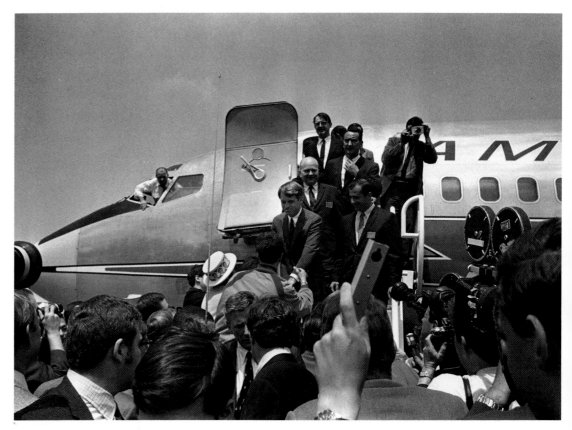

Kennedy arrives in Los Angeles during his presidential campaign, June 1968.

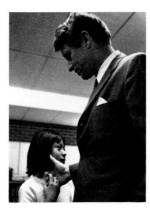

Kennedy with young Native American, Window Rock, Arizona, 1968.

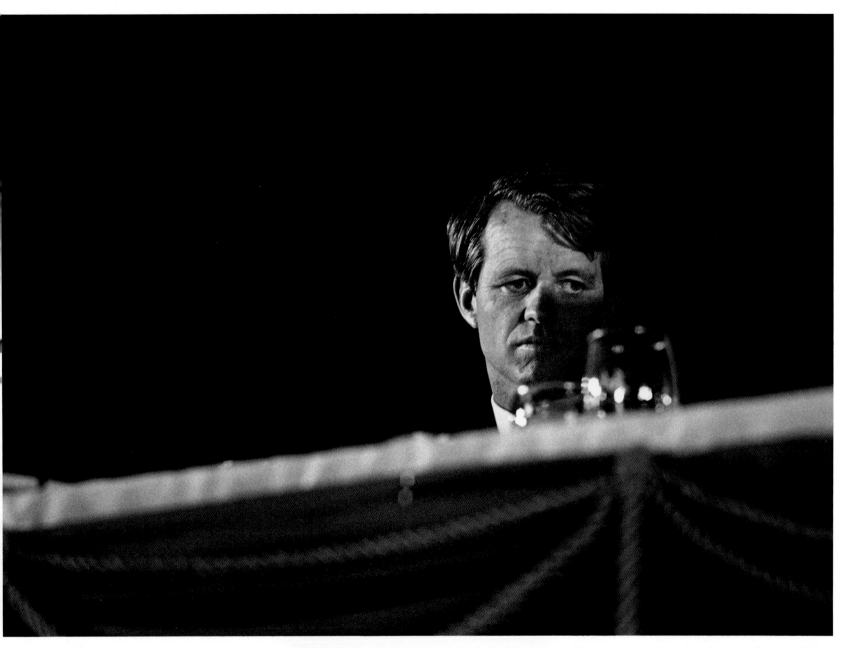

Kennedy at a fund-raising dinner in Phoenix, 1968.

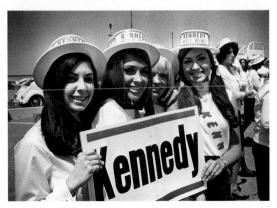

Kennedy supporters, Los Angeles, 1968.

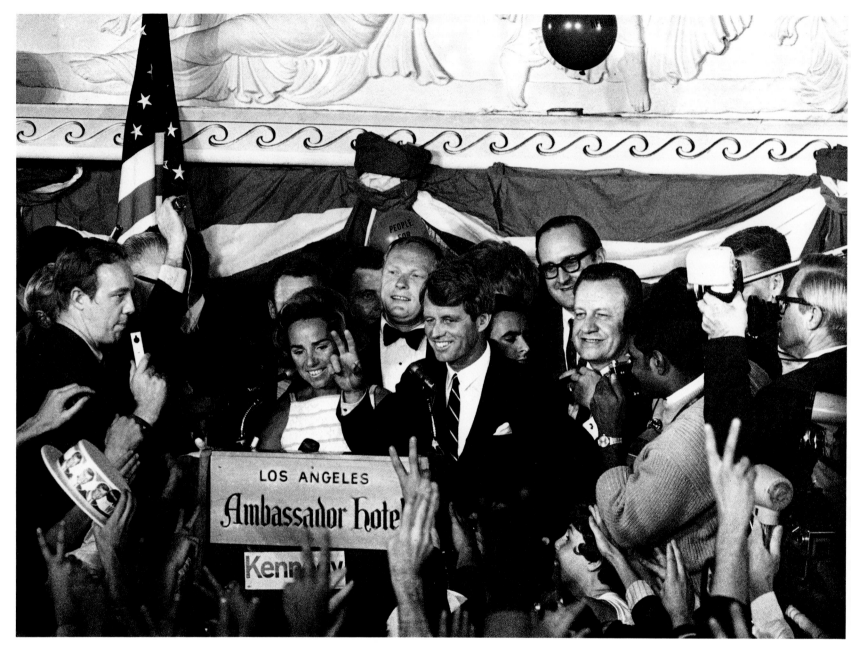

Kennedy at a victory celebration just prior to being shot, June 5, 1968.

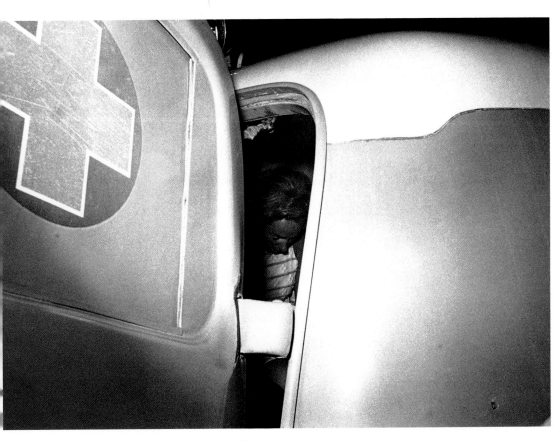

Ethel Kennedy in the back of the ambulance waiting for her husband to be taken to the hospital.

A few weeks later, on June 5, Kennedy was at the Ambassador Hotel preparing to celebrate winning the California primary. I was upstairs with his group and ran into *Life* photog Bill Eppridge, whom I had met in Oregon. He and I were the only people taking pictures of the senator as Kennedy gave an exclusive interview to ABC's Sandy Vanocur before heading downstairs to the celebration. Fellow UPI shooter Ron Bennett joined me in the hallway outside Kennedy's room, and we flipped a coin to see who would be up on the podium with RFK and who would be in the back on the photo stand. I lost and headed down to the risers in the rear of the room.

Robert and Ethel Kennedy emerged to face the wildly cheering crowd, and the pictures I got were terrific. The senator gave the V-for-victory sign, and everybody went nuts. I went downstairs to another room that held an overflow crowd of supporters who couldn't get into the main ballroom. After several minutes Kennedy still hadn't appeared. For some reason I started to get edgy and headed back upstairs. By then the rumor of a shooting had run through the crowd and the place was a bedlam. I couldn't get into the kitchen, so I headed outside. I thought that anyone who had been hurt would be taken out the back. What I saw was shocking. They were loading Robert Kennedy into an ambulance. There was no way to get a picture, so I jumped into my car and followed them out the gate, which was sealed by the police as soon as I sped through.

The senator was already in the emergency room when I arrived at the nearby Central Receiving Hospital, and there was pandemonium outside. Bill Barry, his personal bodyguard and a former FBI agent, walked along a corridor with his head bowed. He was devastated. A short time later they relocated Senator Kennedy to the better-equipped Good Samaritan Hospital, and I took a picture of a distraught Ethel Kennedy through the rear door of the ambulance as they prepared to transfer him. This whole episode had been a nightmare.

Robert F. Kennedy died two days later.

Bill Barry, Kennedy's bodyguard, outside the hospital emergency room.

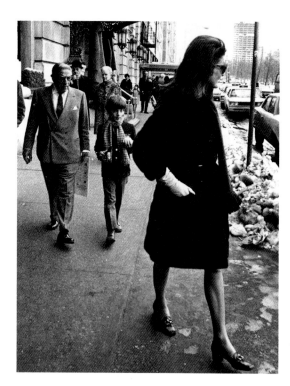

Jacqueline Onassis followed by Aristotle Onassis and John Kennedy, Jr., New York City, 1969.

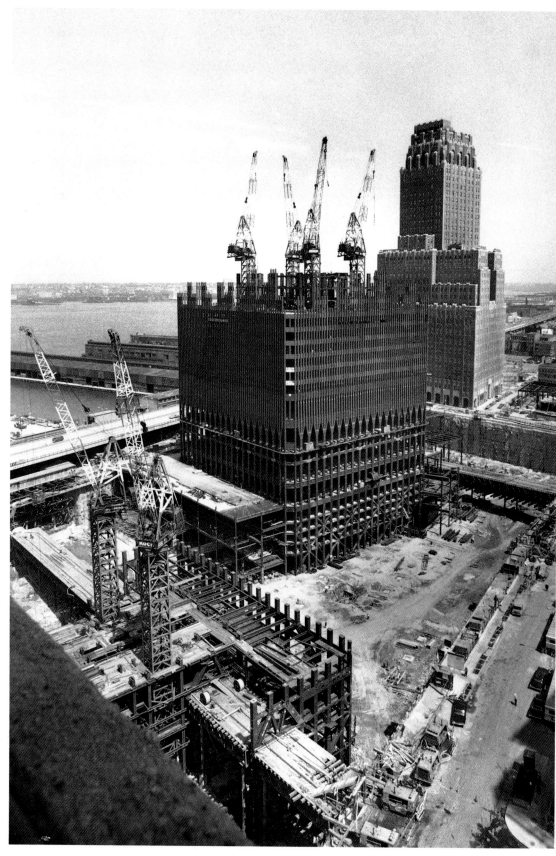

The World Trade Center under construction, New York City, 1969.

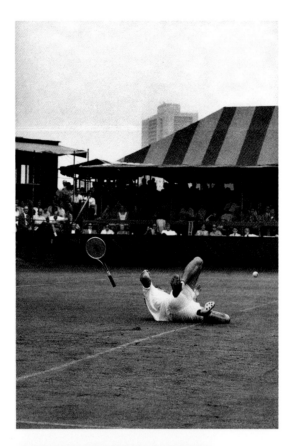

Above: Mia Farrow during the filming of *John and Mary*, New York City, 1969. *Right:* Horst Buchholtz, Forest Hills, 1969.

UPI transferred me to New York later that year, and I was back on the general assignment beat (actually, being a wire photographer means you're always on general assignment). There were some similarities to working in L.A.; for one thing, the editors still wanted me to snap some celebrities now and then. On one occasion I was assigned to catch Jacqueline Onassis, which wasn't exactly my cup of tea because she didn't want her picture taken. Unless there was a legitimate news reason to photograph someone who didn't want to be photographed, I always rebelled against doing it.

One "celebrity" story that I enjoyed shooting was Mia Farrow filming *John and Mary* with Dustin Hoffman in a snow-covered Central Park. Ms. Farrow and I hit it off right from the start after I pulled a burning stick away from her feet when she got too close to a fire built to keep her warm. There wasn't any actual danger, but she thought I was funny, which made her more comfortable with me. As we sat in her trailer she told me a little bit about herself. She recalled how when she was little and wanted to get out of going to school, she would hang her head over the side of the bed until her face turned bright red and then yell for her mother to come and see how sick she was. Mia asked me if I'd ever done that, and I told her that I wasn't a good enough actor.

In 1969 the New York Mets were the story of the year in the Big Apple. They had never been above ninth place since entering the league in 1962, and their opening-day loss to the expansion Montreal Expos didn't bode well for the rest of the season. After they started winning, though, I was assigned to cover their games, and when the Mets actually got into the National League playoffs I was given the coveted first-base dugout position, which was on the field and had the best view of the action. Following the playoff-winning game I went into the locker room and caught a shot of first baseman Don Clendenon being hit in the face with champagne.

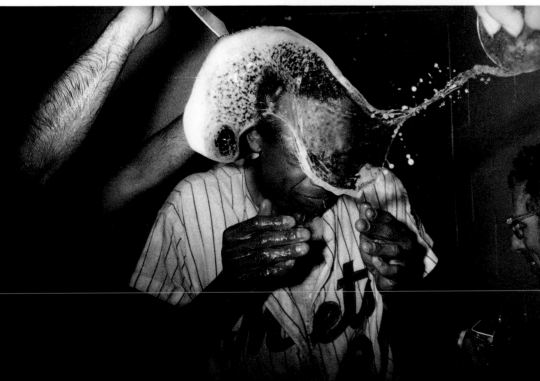

Mets first baseman Don Clendenon is doused with champagne after his team won the National League championship, New York City, 1969.

The Miracle Mets went on to win the World Series, after which their fans went berserk, tearing up huge chunks of the field. Tom Seaver, a twenty-five-game winner during the regular season and the pitcher who won the fourth game, ventured out onto the field after everyone had left. He and teammate Gary Gentry silently checked out the devastation that was left in the wake of victory. Seaver went on to be elected to the Hall of Fame after the end of his exceptional career. For some reason, that quiet moment was worth more to me than all the screaming and jumping up and down that happened after the game.

Being a news photog sometimes means the opportunity to photograph someone you have only read about and who has been your hero since you were a kid. Such was the case when I covered the legendary quarterback Johnny Unitas, who in the late 1960s was toward the end of his career with the Baltimore Colts. Unitas played for the Colts from 1956 to 1973, and his record of throwing a touchdown pass in forty-seven consecutive games still stands. The year I took his picture Unitas's Colts won the league championship and went on to win the Super Bowl.

I felt the same way about Baltimore Orioles third baseman Brooks Robinson, whom I covered in the 1969 and 1970 World Series. In the 1970 series Robinson batted .429 and hit two home runs to help his team beat the Cincinnati Reds. He was definitely one of the good guys.

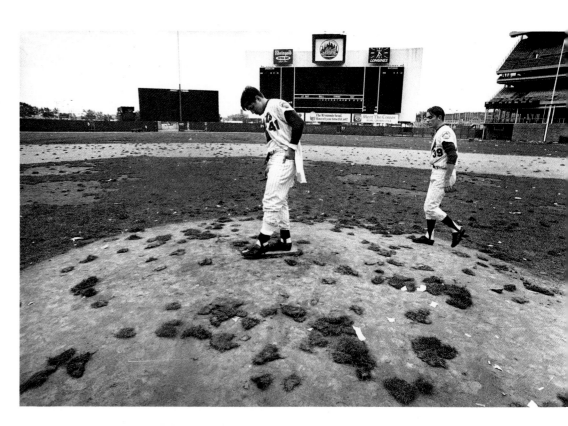

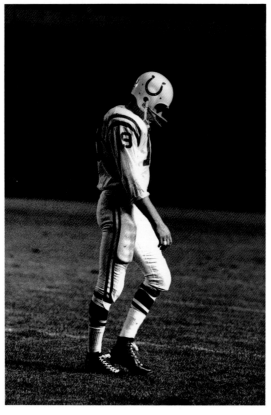

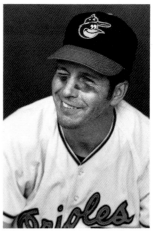

Top: Mets pitcher Tom Seaver and teammate Gary Gentry survey the damage done to the field after their team won the World Series, New York City, 1969. *Above:* Baltimore third baseman and MVP Brooks Robinson gives a wink after his team won another game on their way to the World Series, Baltimore, 1970. *Left:* Baltimore Colts legendary quarterback Johnny Unitas, RFK Stadium, 1970.

You can't beat a heavyweight championship fight for excitement, particularly when two undefeated champs square off for all the marbles. Such was the case when Muhammad Ali and Joe Frazier went at it in Madison Square Garden in March of 1971. I was ringside at the event, which was billed as "the fight of the century," and from my point of view it was at least that. Ali had never been knocked down before, but "Smokin' Joe" sent him flying to the canvas, and I nailed the whole sequence as he fell earthward. There were dozens of other photogs there, but I had the right angle coupled with the perfect lens and apparently the fastest finger. The picture of Ali in midair before he touched down is one of my best, and it ended up on the front page of the *New York Times* the next morning, which also happened to be my twenty-fourth birthday. It was a great present.

Muhammad Ali is knocked down by Joe Frazier in Madison Square Garden, 1971. Frazier won the heavyweight crown that night.

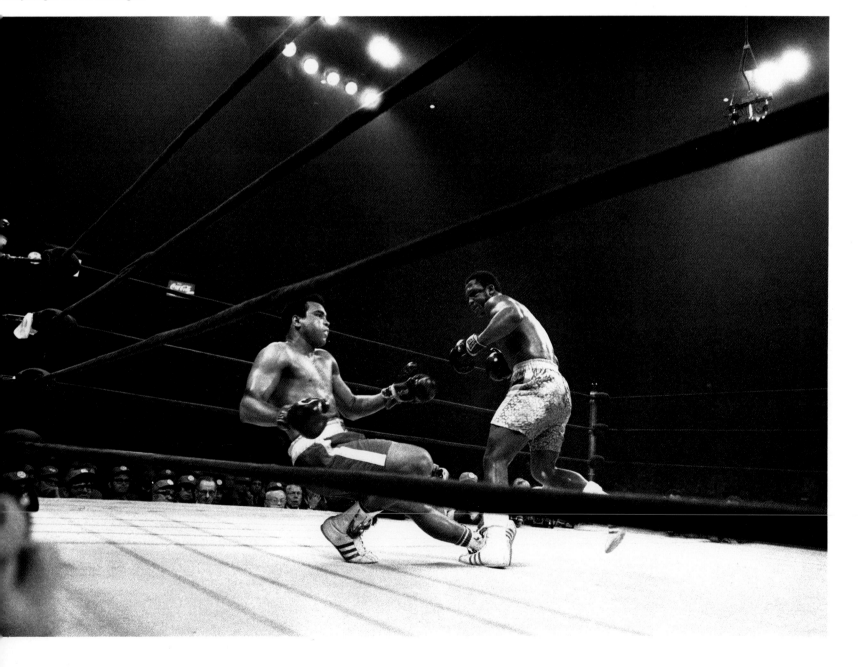

Most of my career has revolved around news and not sports, so when UPI dispatched me to be based in their Washington, D.C., bureau in early 1970, I was excited on one hand but apprehensive on the other. I had always had the impression that the nation's capital was very clubby, especially in the press corps. My problem was that I've never been a clubby kind of guy. I also have never liked working behind the ropes. In Washington, much of what you do is in a controlled area. I chafed at that then, and I chafe at that now. So there I was, a twenty-three-year-old photog with more attitude than experience, preparing to enter the big leagues armed with nothing more than a few old

Nikons and the knowledge that if I could succeed in D.C., I could make it anywhere.

Working in Washington is unlike working anywhere else. It's a company town, and the business of that company is government—lots of government. During my first few months in D.C. I did general assignment duties, which meant shooting demonstrations, hearings, and anything else that came up. Those who didn't have a regular beat, such as covering the White House, Senate, or House, became utility players, available for anything.

Since I consider my coverage of the office of the presidency to be one of the highlights of my career, it now seems strange

that the first president I covered wasn't alive. He was Dwight D. Eisenhower, and the event was his funeral. It was an impressive affair. I photographed his flag-draped casket being saluted by soldiers and marines as it was pulled by horses up Pennsylvania Avenue. The death of "Ike" was in many ways the end of an era. He had helped lead our country to victory in World War II and had kept a steady hand on the helm for eight years as our chief executive. But now he was gone, and the man who had once been his vice president was now sitting in the Oval Office.

President Eisenhower's funeral cortege makes its way to the Capitol Building, Washington, D.C., 1969.

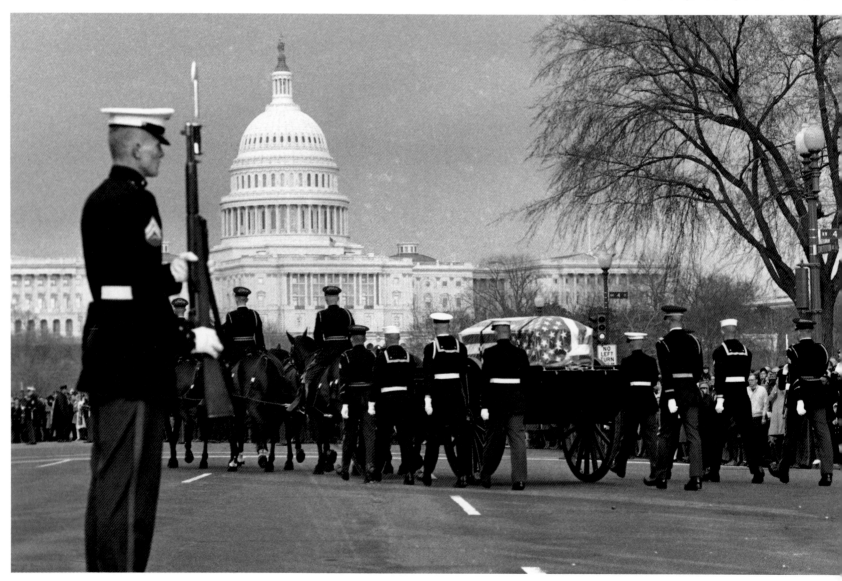

Soviet Foreign Minister Gromyko and President Nixon at the White House, 1970.

My first live president was Richard Nixon, and as a wire service photographer I went everywhere he went, even on his plane. I was an admittedly enthusiastic soul, so you can imagine my thrill at riding on Air Force One for the first time. A White House press pool travels everywhere with the president, even with Nixon, who hated the media. The two wire services each sent a reporter and a photographer; they were joined by a newspaper writer, a radio reporter, a network television correspondent, and a cameraman. We sat all the way in the back of the presidential aircraft, collectively pocketing matches and napkins bearing the first plane's logo.

The UPI photographers covering the White House rotated monthly. Because there were six photographers in the rotation, I worked the White House beat only twice a year. During my first month Nixon announced that U.S. troops were going into Cambodia, triggering one of the biggest antiwar demonstrations of all time. Things were so bad that the police surrounded the White House for blocks with city buses to prevent the demonstrators from getting near it. It was during that period that Mar-

tha Mitchell, the attorney general's feisty wife, on seeing thousands of marchers in the street below her husband's office, commented that "it looked like the Russian Revolution down there." Martha was one of the most quotable and colorful people in town.

Covering the Nixon administration meant standing behind a lot of ropes and getting no access to "The Man." I should know; I tried—repeatedly. Actually, I became a pain in the ass with my daily requests to the press office as I attempted to get an exclusive picture of the president for UPI. "Not today"; "Maybe some other time"; "Later"; "If you get one, then everybody will want one"; "No"; "Not in my lifetime"—those were some of the responses I got from various officials of the administration. But I never gave up, and I almost got one. Publicly, however, Nixon was still a great subject for photographers. On one occasion, as he was walking back to the Oval Office from his private suite in the old Executive Office Building (EOB) with Soviet Foreign Minister Andrei Gromyko, I took a picture of the two together that made them look like twins.

Attorney General John Mitchell and his wife Martha at the Justice Department, Washington, D.C., 1970.

An important bit of press jargon when covering the White House is the term *lid.* A lid is what the press office issues when there won't be any more news to cover that day. Essentially, they are guaranteeing that the president will not appear in any way, shape, or form to "commit news." Two blinking stars above the press office door symbolized the anticipated moment, their illumination usually preceded by the disembodied voice of a press office flunky declaring that there was a lid for the day. Their mouths watering, those newsies remaining would hit the outside door running, heading back to their offices or favorite watering holes.

One night, for some unknown reason, we didn't get a lid. It was Christmas Eve 1970, and the only people left in the press room were the two wire reporters and two wire photogs. Everyone else had left. Because all the networks, newspapers, and other media depend on the wires, we get there first and stay until the bitter end. So we stayed and tried to find out whether something was going to happen, but we got no answer. In fact, no news was produced, but in a way something better happened. Ron Zeigler, Nixon's press secretary, dropped by and told us to follow him. He told the AP photog and myself to leave our cameras behind. This was highly unusual, but we had no choice. He walked us over to the EOB, up the stairs, and through an unmarked door. It was President Nixon's private hideaway office. The man himself greeted us with a cheerful "Merry Christmas" as we walked in. I had seen Nixon only at the other end of my lens and had never talked to him. I guess I felt exactly like what I was: a goofy kid from Roseburg who just happened to be dropping in on the president of the United States because he sent for me.

As I stood there in awe, he asked me what I wanted to drink. "A martini?" I said, naming my father's favorite drink, though I don't think I'd ever had one.

"Good choice, but there's only one way to make those," he said, walking over to a small kitchen. He rummaged around in a cabinet until he found what he was looking for. He pulled a bottle off the shelf and held it up. "Beefeaters," he said. "You can't make a proper martini without it." He then proceeded to mix it for me, popped an olive into the glass, and watched apprehensively as I took a sip. "Am I right?" he asked.

"This is great!" I replied.

Nixon said with a wink, "It's the one thing I do well."

Manolo Sanchez, Nixon's valet, made drinks for everyone else, and we walked into the main part of his office for a chat. I stood next to him as he talked about sports and other nonpolitical subjects. I noticed that he was about the same height as I am (six feet) and comfortable in his own surroundings. At that moment I was suddenly gripped with the sinking feeling that I had finally gotten that exclusive I'd been fighting for—and I didn't have a camera. Merry Christmas. Oh well, I still like martinis with Beefeaters and olives.

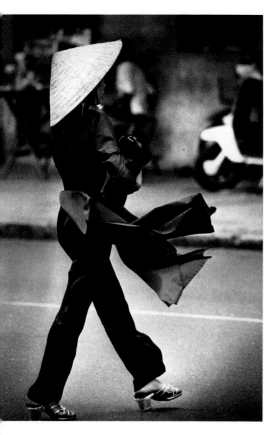

A woman, her *ao dai* blowing in the wind, crosses a street in Saigon, 1971.

In 1971 I had a problem (one that Dan Quayle and Bill Clinton might later wish they could have had). I wanted to go to Vietnam, but I had to get out of the army to do it. Most men at the time were trying to get into the National Guard or the reserves to avoid going to Southeast Asia. I wanted to go as a civilian photographer, but the catch was that I had to fulfill my one-weekend-a-month, two-weeks-a-summer obligation to my country as a Spec. 4 in the U.S. Army Reserves, and I had to do it all right here in the good ol' US of A. I started looking for alternative measures, even exploring the possibility that I could serve out my time doing weekends with real soldiers in the real war over there.

There was, however, no contingency that allowed anyone to transfer from the reserves to a combat unit in a war zone, not that anybody had ever inquired. The commanding officer of my unit, Major General Lowell Bradford, volunteered to take my problem directly to the Pentagon, despite the fact that he thought I was slightly nuts. The brass there had never heard of a case where someone actually wanted out of the military in order that they might go to war. The Pentagon approved my request.

You may wonder why a twenty-four-year-old photographer would trade in Air Force One and cocktails with the president for combat and bad beer. I myself have wondered that at times. But I believed then as I do now that if you were in my business and didn't go to Vietnam, you missed one of the biggest stories of our generation. I just didn't want to be sitting around years later rationalizing why I didn't go. That's where the pictures were, and that's where I wanted to be.

A couple of weeks before I left the States four news photographers were killed when their chopper was shot down over Laos. Among them were the man I would replace in UPI's Saigon bureau, Kent Potter, AP's Henri Huet, *Newsweek*'s Keisaburo Shimamoto, and a man whom I had never met but who was an inspiration to me, Larry Burrows of *Life* magazine. All told, more than thirty-four photographers and cameramen were killed in Vietnam. I guess the Captain Nemo inside must have pushed me on board that plane to Saigon, because the kid from Oregon wanted to run away screaming.

After I landed in Saigon, most of my anxiety and fear was replaced by my natural curiosity and eagerness for a new challenge. I'd never been to Asia, and everything from the cyclo drivers to the women in their colorful *ao dais* caught my eye. Most photographers, myself included, find that their first few months in a place produce the best pictures. The eye is fresh. That was certainly true in Vietnam, although in two and a half years I never seemed to run short of things to shoot.

Journalists in Vietnam were accredited through the Military Assistance Command Vietnam (MACV) and issued cards that granted them PX privileges and an equivalent rank of major.

No one ever had to wait in line to go into combat. Soldiers didn't have any choice, but very few others wanted to go along for the ride. I would find out where the big battles were being fought and then try to get there any way I could. It usually involved a hellacious ride on a "slick," as they called the Huey helicopters. Going on a combat assault, or CA, was the Army's way of saying you were going to have a bad day. I would perch just inside the chopper, my boots on the skids, waiting for the aircraft to get close enough to the ground for me to jump off—this amid helicopter blades chopping the air, enemy fire hitting the landing zone, men screaming, and the sound of my pounding heart blanking out all of the above. Even thinking about a combat assault is a near-death experience.

Most photographers hope to get "The Picture" when they cover a war. I know I did, even though I never admitted it. The best example of The Picture was taken by Robert Capa during the Spanish Civil War. It was the moment of death: that instant when a bullet strikes a soldier and he falls to the ground mortally wounded. Even though that particular image is surrounded by controversy (some say it was set up), it is still the icon of war photography, the holy grail to battalions of stills shooters. Had going after a shot similar to Capa's been my sole objective, I would have been blanked. (It occurred to me years later that if the man I had photographed being gunned down by the cops in Manhattan Beach had instead been wearing a helmet and crawling through a rice paddy in Vietnam, his "moment of death" would have won me a Pulitzer and placed me in the Photo Heroes Hall of Fame next to the legendary Robert Capa. But he wasn't, and I never saw a scene there that even came close.)

Even though I had plenty of experience under fire, what I primarily went after in Vietnam were pictures of the events before and after combat. I wanted to show the periphery of war and to depict the people who lived there. They were soldiers and civilians, adults and children, Americans, Vietnamese, and other nationalities. They were the ones who lived sundown to sundown in a country in turmoil, whether in a foxhole holding a gun or in a VC village waiting for bombs to fall. They all lived in a place where peace was only a distant rumor.

One of the hardest things to make people understand is that Vietnam wasn't like the movies. There wasn't a firefight every few minutes, and rockets weren't raining down twenty-four hours a day. Most of the time things were pretty quiet. What made it intense was knowing that something bad—really bad—could happen at any moment. This created great anxiety, particularly if you were in the field waiting for the next attack.

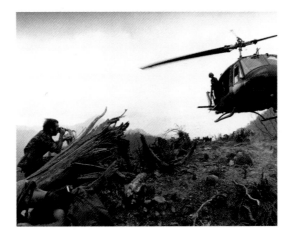

Matt Franjola photographed me on a hot landing zone near Khe Sanh, Vietnam, 1971.

Combat sometimes made for good pictures. During a firefight, however, we would be as low as we could go. That did not make for good pictures. As a result, some of my best photographs were of people in circumstances that might be considered routine. One good example is the time I came across some GIs who were conducting an operation near Khe Sanh on Easter Sunday. They had been through a battle the night before and were weary and frightened. I noticed one of them sitting in front of a machine gun atop an armored personnel carrier, his head in his hands and a cross dangling from his neck. The photo of that young soldier is one of my favorites, and I made it at the edge of combat, not in it.

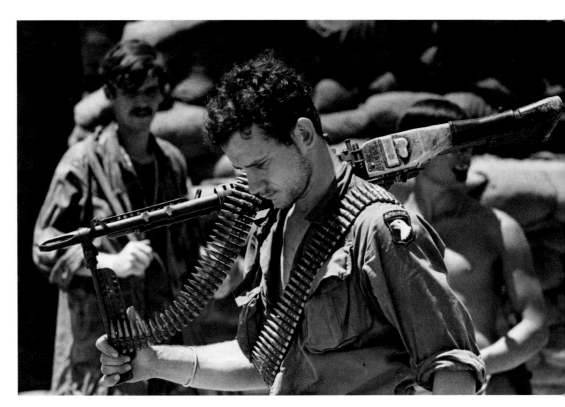

An M-60 machine-gunner at Firebase Rakkasan, Vietnam, 1971.

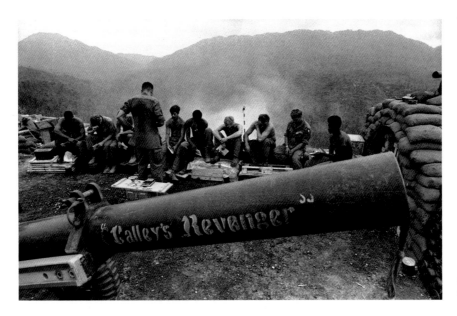

Below: Easter, near Khe Sanh, Vietnam, 1971.

Church service at a firebase near the A Shau Valley, 1971.

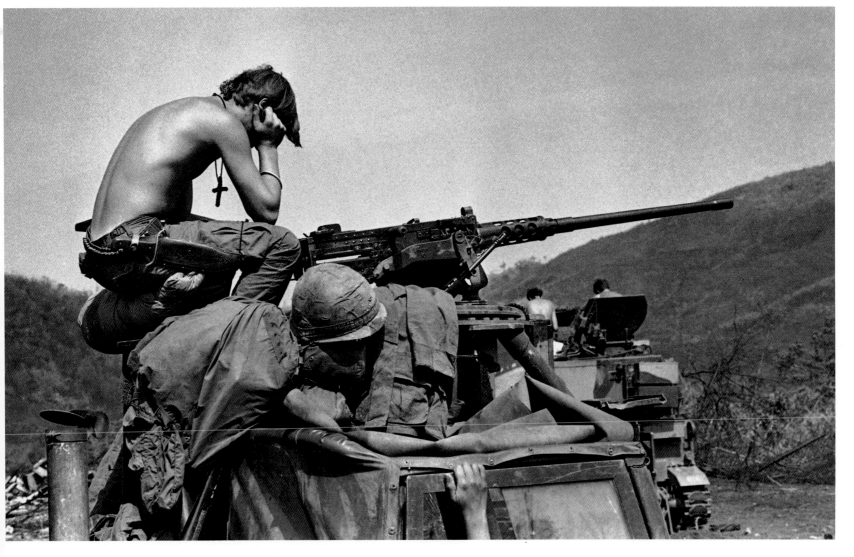

Another quiet situation that produced a dramatic photo was the day I was above the A Shau valley with a company of U.S. soldiers. Nothing much was happening, but there had been fierce fighting in the area, and the place was a jumble of blown-up trees set against a denuded landscape. I watched a single GI make his way across the top of a scarred hill, his weapon at the ready. He looked hunched over, and though weary he was also wary. I framed him between a couple of bare trees in the foreground. At the time it was just another good snap, but to the Pulitzer committee it "captured the loneliness and desolation of war." That picture, along with several others, composed a portfolio of a year's shooting in Vietnam that won me the profession's top prize in 1972.

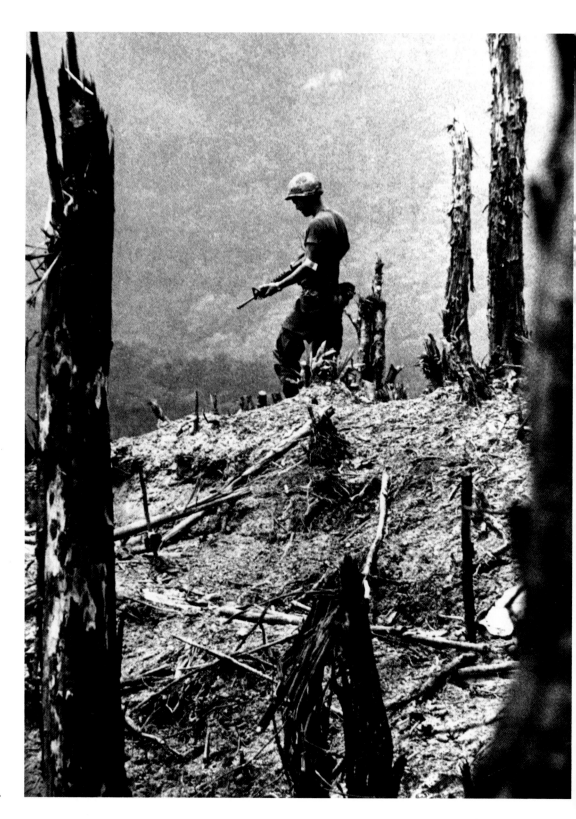

A GI walks across the devastated landscape, 1971.

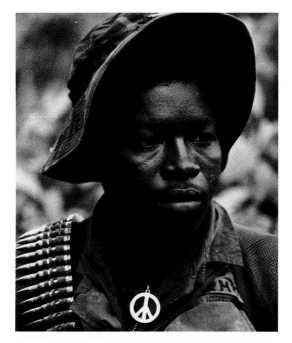

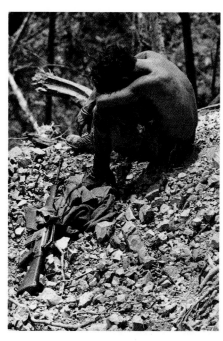

Right: An American GI wearing a peace symbol, 1972.
Far right: Weary soldier at Landing Zone Hotlips, 1971.
Below: Weathering the monsoon, 1971.

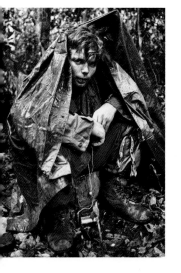

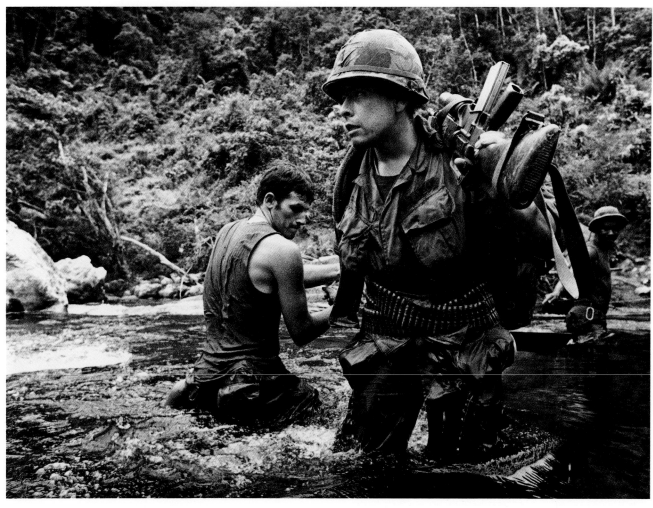

Americans ford a stream
south of Da Nang, 1971.

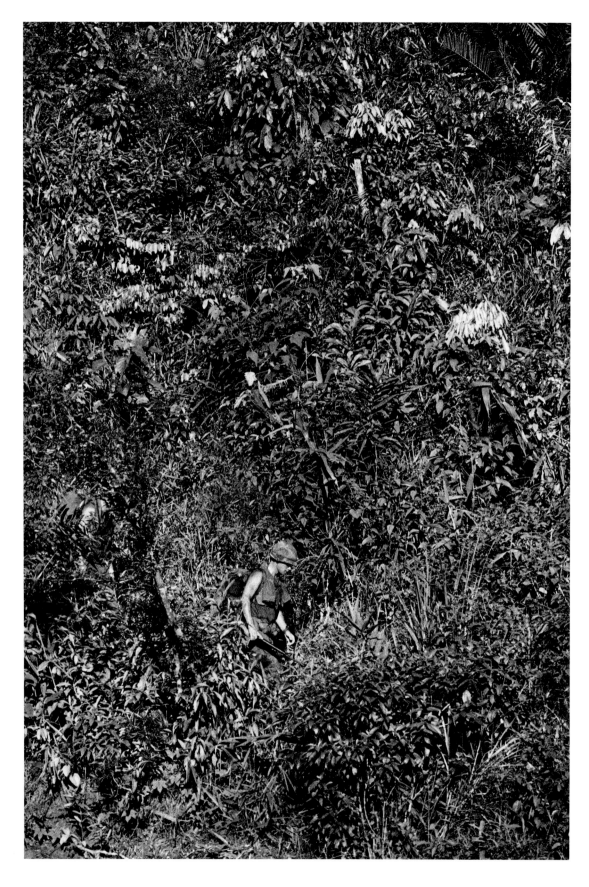

An American soldier patrols the jungle south of Da Nang, 1971.

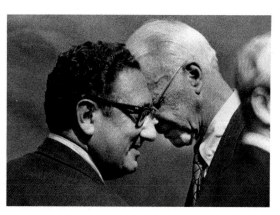

Secretary of State Henry Kissinger with
U.S. Ambassador to Vietnam Ellsworth Bunker,
Tan Son Nhut Air Base, 1971.

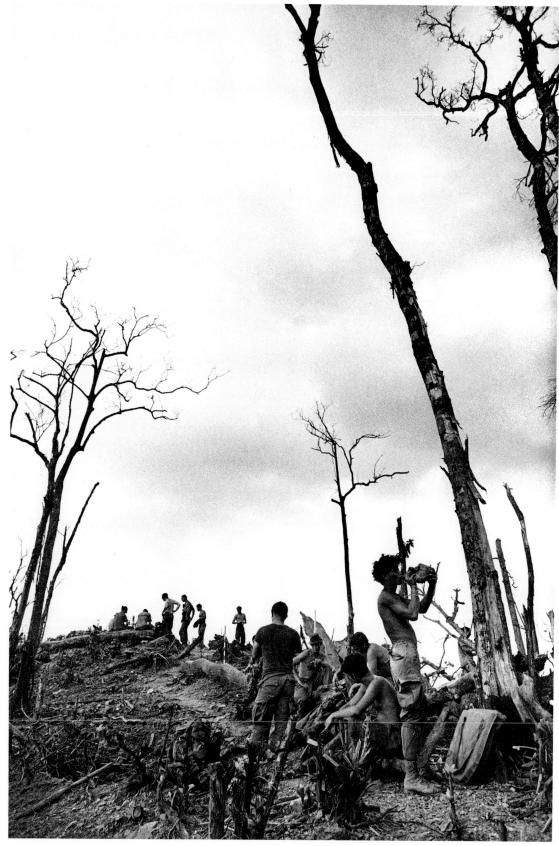

U.S. troops take a break on a blown-away hillside
above the A Shau Valley, 1971.

And then there was the time that Richard Avedon waltzed into Vietnam wanting to do his war thing. Avedon, who was selected as the most important person in photography by *Photo* magazine in 1993, is noted mainly for his set-up pictures of models and other celebrities. He even brought a mini-studio with him, plain white background included, and assistants to carry his gear. His plan was to get soldiers directly from the field, sit them on a bench in his Fifth-Avenue-come-to-combat rig (which was located several safe miles from any fighting), and capture the grittiness of war. I wish I'd thought of it. I'm sure Avedon envisioned the men who would pass before his lens as being dirty, unshaven, sunken-eyed GIs with that thousand-yard stare just in from fire-fighting with the VC. But alas, although the men selected to pose were whisked in from the field, their first stop wasn't to see Richard Avedon. They were initially taken for a shower, shave, haircut, and a new set of fatigues. By the time they got to the famed photog, they looked as if they'd just gotten back from R & R in Hawaii. Sensing Avedon's concern, I suggested that he might find the right "look" out where the men were warring but he never made it to the action.

My big advantage has always been that, because of the way I see things, I'm usually able to come up with good photos in situations that might be considered dull. I was not the best shooter in Vietnam, and certainly not the bravest. Still, although plenty of them got better shots, fewer were more consistent. I think curiosity, consistency, and a good eye are the three traits that have helped me the most.

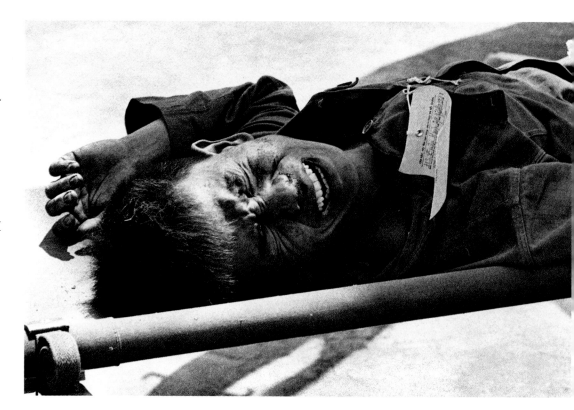

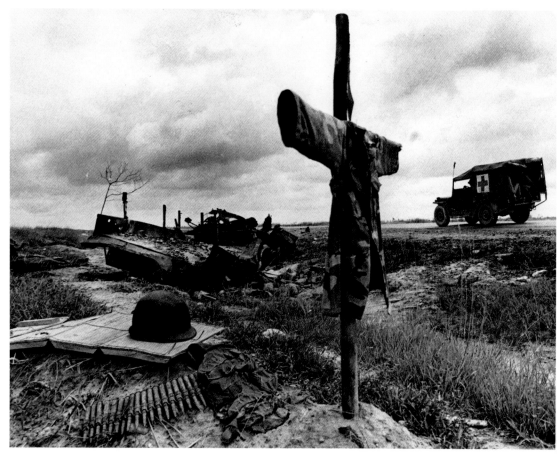

Above: A wounded South Vietnamese soldier is taken from a helicopter that lifted him out of Firebase 6, which had been under heavy fire for 15 days, Tan Canh, 1971. *Right:* Grave of a South Vietnamese soldier near Chon Thanh, 1972.

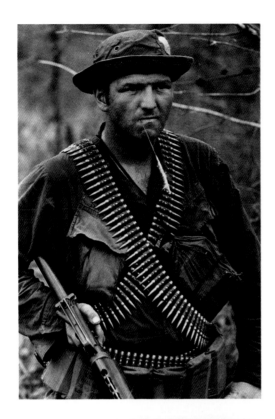

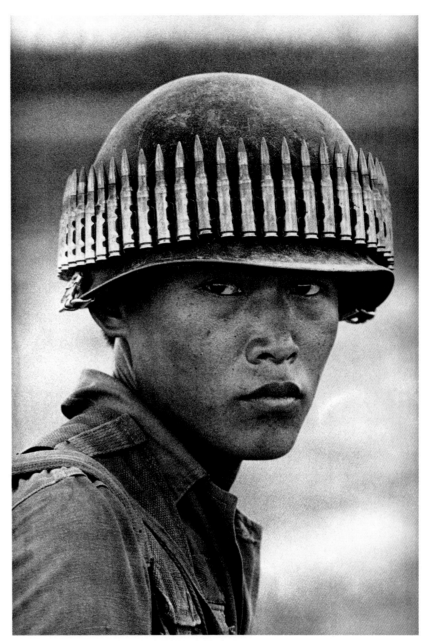

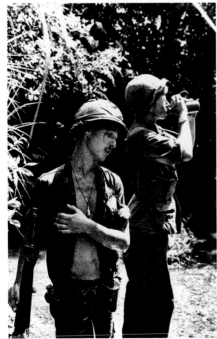

American and South Vietnamese soldiers, 1971–72.

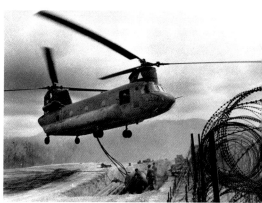

Chinook chopper resupplies a firebase, 1971.

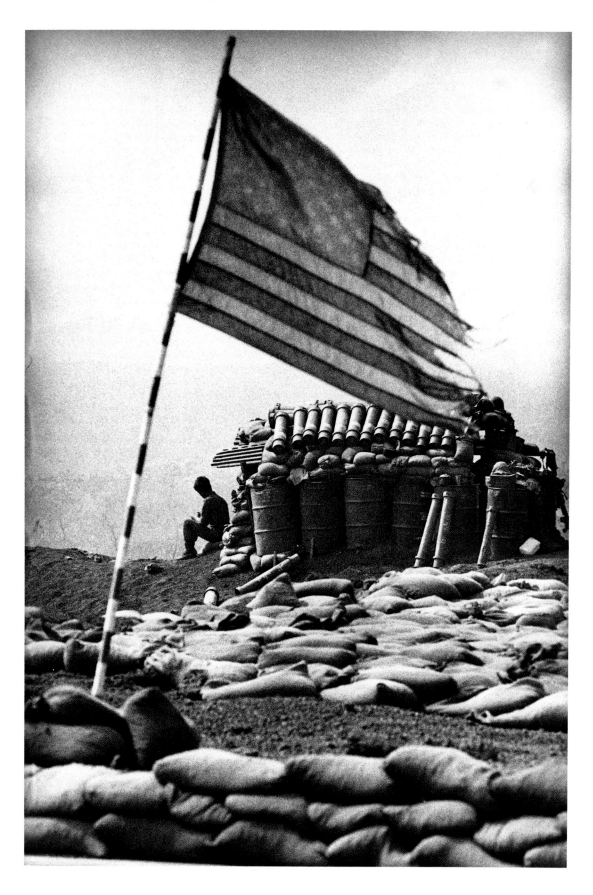

Landing Zone Lonely, 1971.

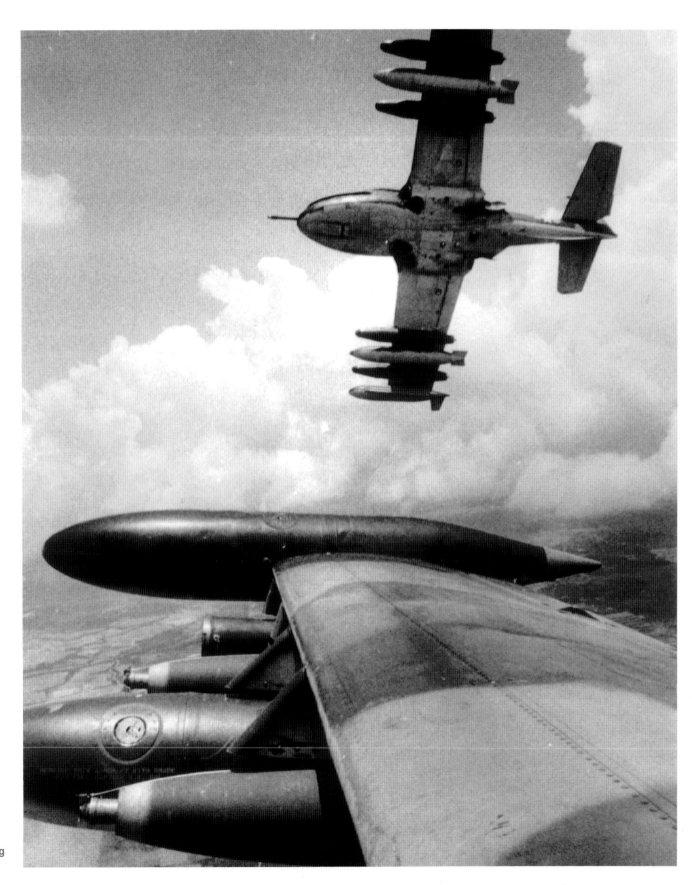

U.S. Marine A-37s on a bombing run in the Mekong Delta, 1972.

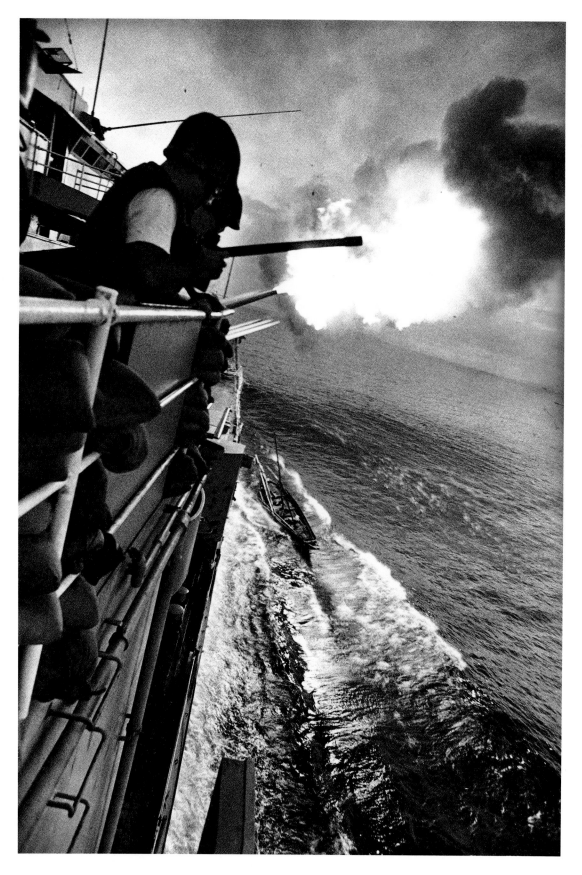

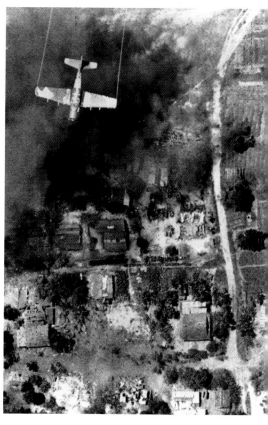

A Vietnamese Skyraider attacks an enemy position near An Loc, 1972.

Big eight-inch guns from the heavy cruiser U.S.S. *Newport News* shell targets inside North Vietnam, 1972.

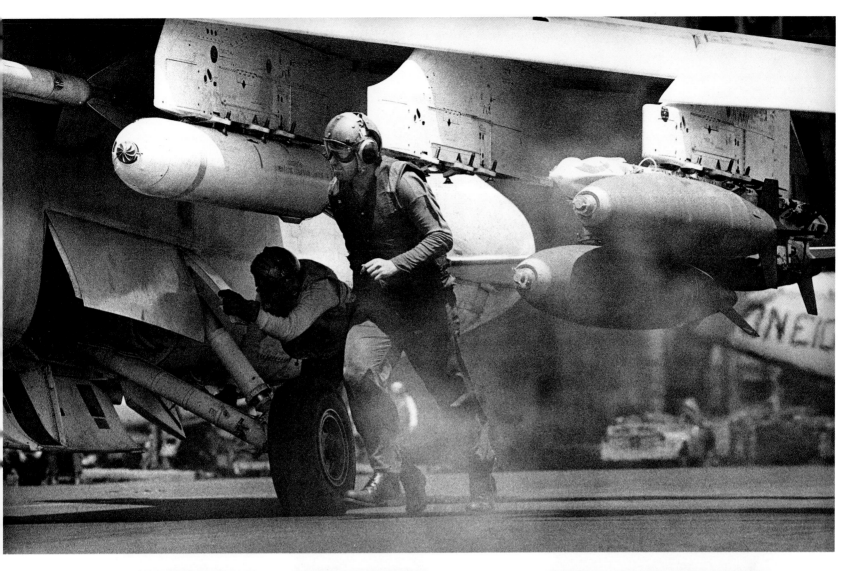

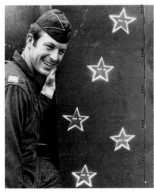

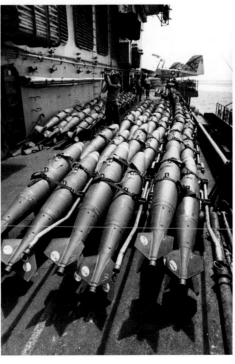

Top: A bomb-laden fighter prepares to take off from the aircraft carrier U.S.S. *Constellation* in the Tonkin Gulf, 1972. *Above:* The only U.S. fighter ace in the Vietnam War, Steve Richie displays the five stars on his F-4 Phantom jet, Da Nang, 1971. *Right:* Bombs on the deck of the *Constellation* await loading onto fighters, 1972. *Far right:* Craters from B-52 strikes dot the landscape near Loc Ninh, 1973.

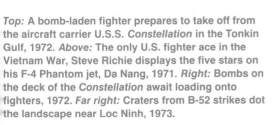

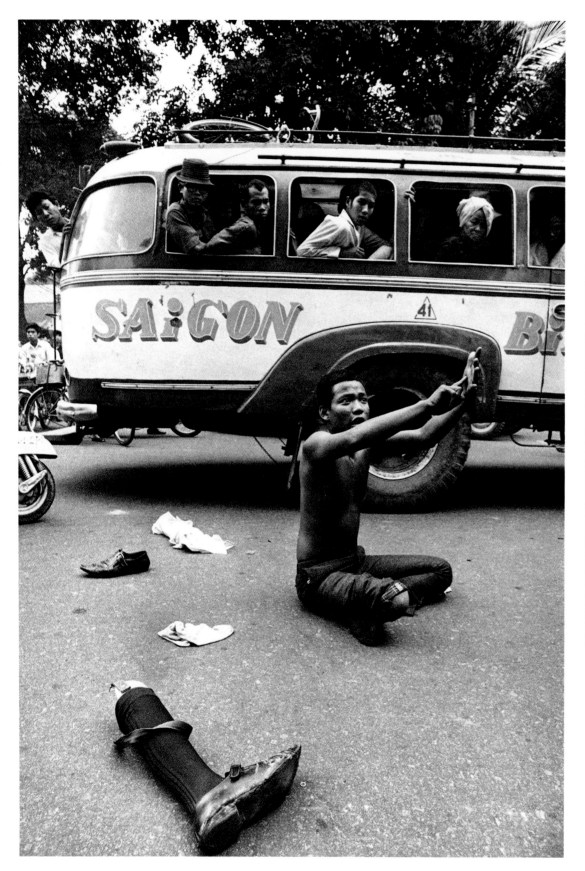

A nun at a funeral in Saigon, 1973.

A disabled Vietnamese vet protests his lack of benefits from the government, Saigon, 1971.

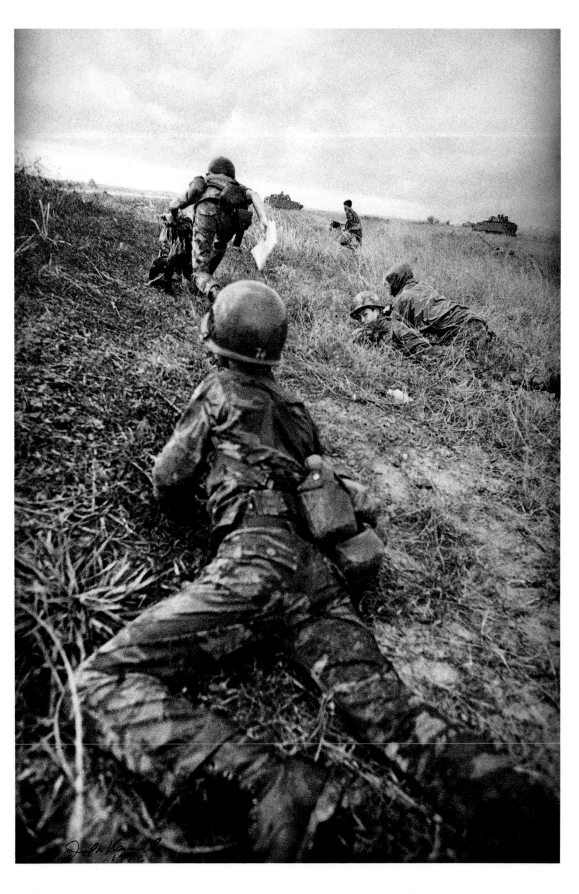

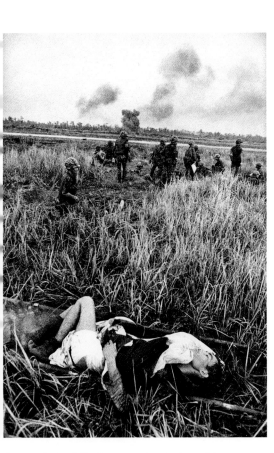

A wounded soldier lies near death alongside Highway 13, Lai Khe, 1972.

A Vietnamese soldier ducks as he runs under heavy fire near Chon Thanh, 1972.

Vietnam wasn't the only conflict in Asia at that time. There was, among others, the ongoing problem in Cambodia. I loved going there, at least for the scenery. Phnom Penh, the small nation's capital, was a lovely city built by the French. It seemed incongruous that a place so beautiful should be in the middle of a war, but that was the fact, and Cambodia had the dubious distinction of being one of the most dangerous places for journalists to cover. Several had been captured by the Khmer Rouge, never to be seen again. I loved sitting by the pool at the Hotel Royale but hated going out on the road to try to find the action. In Cambodia you rode to battle in an air-conditioned Mercedes rented from the hotel. For some reason, driving to my possible death in relative comfort never seemed to make it easier. After a while I quit going to Cambodia, preferring instead the more conventional method of visiting combat zones used in Vietnam, namely, dropping into battle from a whirlybird.

Another contest brewing in Asia at the time was between India and Pakistan. Tens of thousands of refugees were fleeing East Pakistan into India every day, driven from their homes by fighting between the Pakistani army and Bengali separatists. When I arrived in Calcutta I was overwhelmed by the number of people crowding into an already overcrowded country. I photographed one tent city that alone held more than twenty-five thousand people. An estimated five to seven million people arrived in India to escape the persecution, which put an incredible strain on a country that had monumental economic problems of its own. There had always been animosity between India and Pakistan, and this was the final straw. In December 1971 they went to war, and I was there at ringside.

I covered the fighting with the Indian army as they advanced deeper and deeper into East Pakistan. It was as close as I would ever come to seeing how the battles of World War II must have been fought. Both sides had British-trained officers, and many of them had gone to school together. English, in fact, was the common language used by officers of both sides. The fighting was traditional squad-to-squad, hand-to-hand combat. Tanks, backed by soldiers moving behind them, maneuvered against one another. I took pictures of dead Indian soldiers as they were carried away lashed to a pole, much the way hunters carried their kill from the bush.

One of my Indian officer friends observed an English tradition that I would have preferred to have missed: tea under fire. The captain insisted that I join him for a cup in the middle of a huge battle. Bullets were slamming into the hut where we sat, and the shock of artillery shells exploding nearby caused plaster to fall from the ceiling, but he insisted on serving me a steaming cup, which I figured would probably be my last. After he finished he simply said, "Now I must go see to that enemy machine gun that has been shooting at us." Which he did. I, on the other hand, having already made a number of good pictures, quickly headed away from the front lines. India ultimately won the brief but vicious war, and East Pakistan became Bangladesh. After the hostilities ceased I headed back to the relative safety of Vietnam.

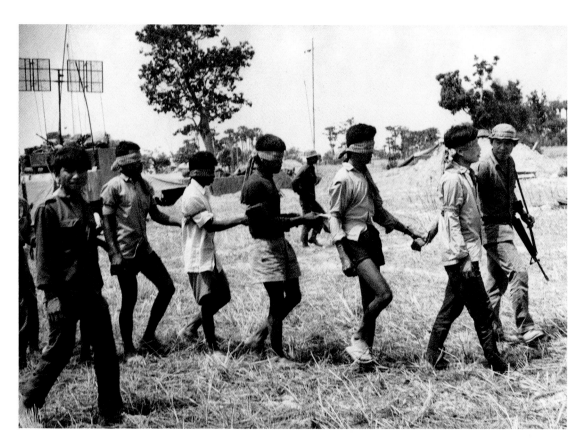

Khmer Rouge prisoners, Cambodia, 1972.

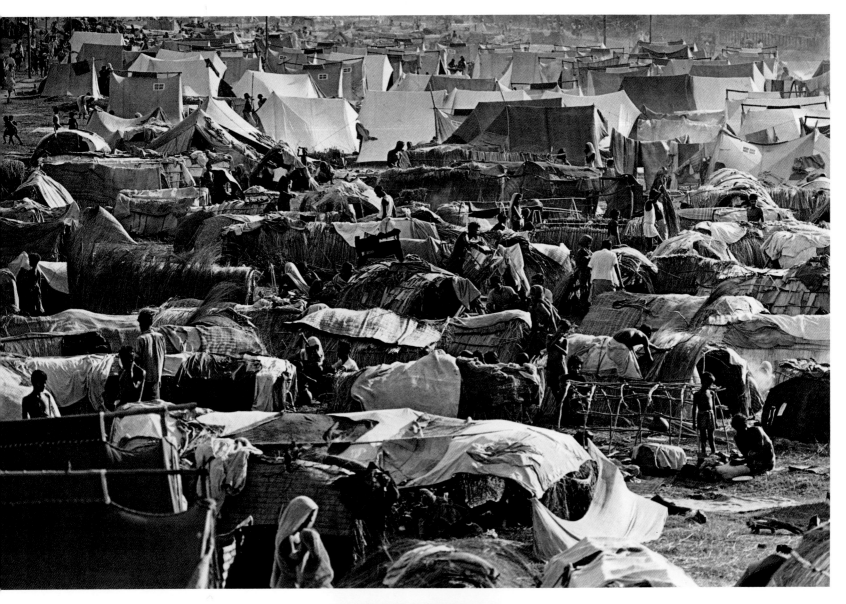

Refugee camp filled with East Pakistani refugees on the outskirts of Calcutta, 1971.

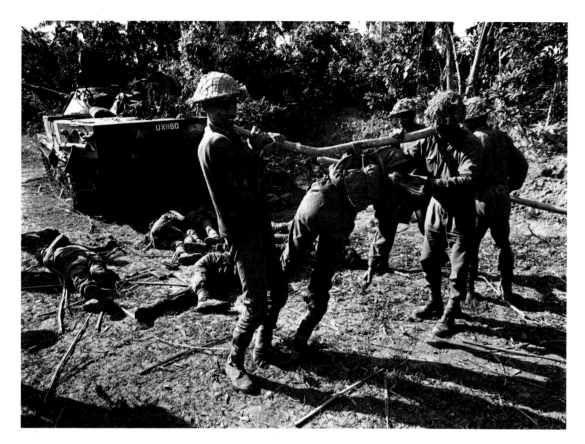

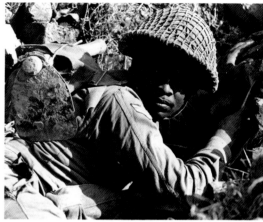

Indian soldier under fire during the war with Pakistan, Jessore, East Pakistan, 1971.

A dead Indian soldier is removed from the battlefield near Khulna, East Pakistan, 1971.

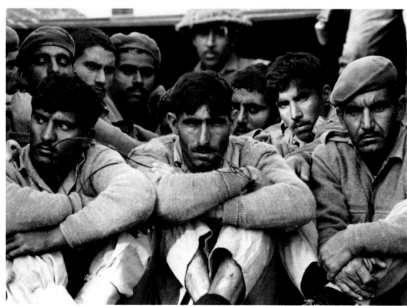

Pakistani POWs, Khulna, East Pakistan, 1971.

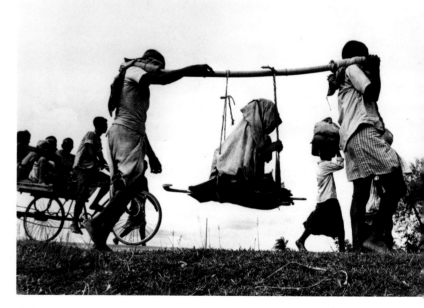

Refugees on the road into Calcutta from East Pakistan, 1971.

I returned to the United States for a little R & R in mid-1972 after being out of the country for almost a year and a half. I was looking forward to seeing family and friends and catching up on what was happening in the "real world." I experienced my first moment of apprehension as soon as I landed in San Francisco. I was in a taxi heading downtown when we got trapped in a big traffic jam. The driver asked me where I was coming from, and because I didn't want to talk about Vietnam, I told him, "Los Angeles." "L.A. sucks—too many cars," he said as he honked his horn at the other vehicles, which were also moving at five mph. I felt hemmed in and wanted to jump out.

Things didn't get much better. I couldn't concentrate on anything, and every loud noise made me jumpy. I listened to people talking, but I never really heard anything they said. I found myself in a grocery store buying tons of things I could never find and then realized I wasn't in Saigon. I think I was more afraid of being back in "civilization" than of living in Vietnam.

My old friend Bill Snead, who had been the UPI bureau chief in Vietnam in 1968, summed up my problem quite neatly when he said, "What you have is a case of culture shock coupled with the sense that nothing seems significant unless it has to do with the war in Vietnam." That made sense. There was only one remedy for my ailment. I cut my trip short and headed back to Indochina.

The staff in the UPI office, Saigon, Vietnam, 1971. *Left to right:* Willie Vicoy, Nguyen Ngoc Anh, me, Jeff Taylor, Nguyen Thanh Ngoc.

I had spent my first year in Vietnam mainly as a combat photographer, out in the field hopping from one story to the next. UPI appointed me photo bureau chief after that, and although I still got out to shoot, I mostly stayed in Saigon and assigned others the dirty work. I actually had more difficulty asking others to put their lives on the line for a picture than I had doing it myself. The fact that we were all there because we wanted to be didn't make it easier for me when someone I assigned to a job came back all shot up—or didn't come back at all. One day, for instance, Gerard Hubert, a French Canadian, staggered through the bureau doors wrapped in bloody bandages. "What the hell happened?" I asked.

"The VC shot me when I was in An Loc," he said, "but here's the film. I now go to the hospital." An Loc had been surrounded by North Vietnamese regulars, and nobody had been able to get there to take pictures. But Hubert got in, took the pictures, and got out alive—barely. A few weeks later he wasn't so lucky. He was with a Vietnamese Airborne unit near the DMZ when he was killed by an artillery round. We buried him with the French Airborne at their cemetery in Saigon.

Another photojournalist who courted close calls was Willie Vicoy. He was a particularly fearless photog and would go into any situation under any circumstances. Willy was riding on the turret of a tank that was attacking an enemy position. As they closed in on the bunker, a rush of wind snatched Willie's hat from his head. When he retrieved it he discovered that the "wind" had been a VC bullet. He showed me the hat when he got back to Saigon, a smile on his face and his finger wiggling through the hole. Willie was killed several years later back in his native Philippines while covering rebel activity.

Taizo Ichinose, a young Japanese photographer whose English consisted of the phrase "have good picture," was another gutsy shooter. He used to bring me lots of great action shots and seemed to get in and out of danger regularly. Taizo's luck ran out when he went into Cambodia. He was last seen bicycling to Angkor Wat, where he was captured by the Khmer Rouge and reportedly killed.

More than thirty-four photographers and film cameramen were killed during war. The first was Robert Capa in 1954, and the last was Pulitzer Prize–winning Michel Laurent in 1975. Michel was my friend and competitor. He was a slightly built Frenchman with a sense of derring-do and a heart of gold. In Dacca, on the day that the new leader of Bangladesh showed up to a waiting throng of a million cheering supporters, I was so sick I couldn't even lift my camera. Michel took it from me, told me to go back to the hotel, then shot the event and gave me the film. The pictures he took for me were better than the ones he shot for himself. There aren't many people like Michel Laurent.

All of Asia was my beat. In late September 1972 I was one of three Americans who accompanied the Japanese prime minister into the People's Republic of China. Crossing that bridge just outside of Hong Kong and setting foot on mainland China was akin to Alice ending up in Wonderland. The PRC had been off-limits to most foreigners, particularly from the West, since Mao Zedong took over in 1949. He had effectively sealed off his country. It was as if time had been frozen, and other than a few buildings built in homage to the regime, everything else was as it had been for the previous fifty years. The last time I had been anywhere so unaffected by the outside world was in my hometown of Roseburg.

There was a distinct thrill to being in China at that time. The world was changing so quickly that one of my biggest fears was somehow missing out on seeing at least a sliver of an earlier era. In China I got a chance to see a country that hadn't been turned into every place else. As a young man I used to dream about how it was for the *Life* photographers to cover assignments back in the 1930s. Travel was much more difficult then, and distant lands must have seemed really exotic. That's how I felt when I arrived in China. I remember staying in the National, an old thirties-era hotel with big rooms and huge overstuffed chairs. A walk through those corridors really felt like a stroll through a different time, and it was certainly a different place. (It's worth noting that today when you go to Beijing, you can stay in a Holiday Inn. I don't think that would have fulfilled my romantic notions.)

I also had that feeling of being in another period when I photographed Zhou Enlai. The aging Chinese leader was the human embodiment of another era. He was on the Long March with Mao and was one of the most important figures in modern China. Very few Westerners ever saw Zhou, so getting his picture proved to be difficult. Because I was an American, and not part of the Japanese press corps, some Chinese officials decided to make up a special set of rules for me, essentially keeping me out of camera range of Zhou. I didn't appreciate how big the Great Hall of the People was until I was detained in the back of it and the person I was supposed to photograph was in the front. I had to think fast, or I would miss my picture. I spotted a high-ranking PLA (People's Liberation Army) officer and walked over to him. He didn't speak English, which was essential for my plan to work. I told him that it was great to be there and said, "Isn't the weather terrific?" He smiled and nodded. I waved to my uncooperative escorts, who were noticing my conversation. I then pointed to my cameras and said, "Aren't these Japanese cameras great?" He smiled and nodded. I pointed to Zhou Enlai and said, "Wouldn't it be wonderful if I could go up and take his picture?" The general nodded and smiled. I thanked him, shook his hand, and returned to my humorless bureaucrats. "He said I could go up and take Zhou's picture," I told them. They muttered and complained, but not wanting to offend such a high-ranking comrade, they put me in a better position to snap the Chinese leader.

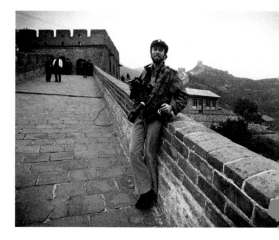

On the Great Wall, China, 1972.

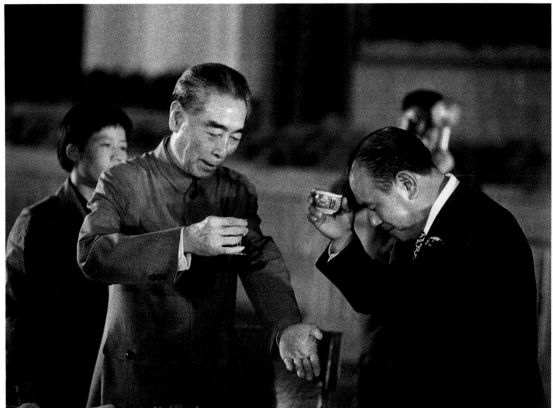

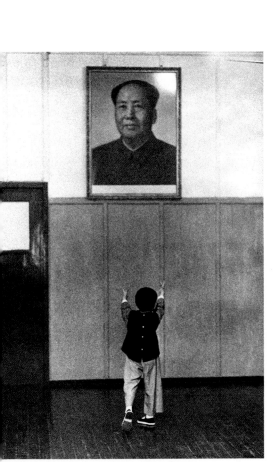

A little girl dances in front of a portrait of Mao Zedong, Shanghai, 1972.

Two young Chinese students, Shanghai, 1972.

Above: Japanese Prime Minister Tanaka toasts Chinese Premier Zhou Enlai, Shanghai, 1972.

My time in Asia was starting to wind down. After returning to Vietnam from China, I resigned from UPI to become a photographer for *Life*. It was ironic that a childhood dream would be fulfilled and then end in the period of just six weeks. As fate would have it, I became the last photographer the great picture weekly hired. I started with them Nov. 1, 1972, and they announced that they were folding the magazine the following month. It was a serious blow, particularly to all the people who had worked at *Life* for a long time. I was lucky, however, and went to work for *Time*.

One of my first assignments for the news magazine was to get behind enemy lines and try to photograph the Viet Cong, which was no small order. After all, they had been winning the war by capturing and killing Americans. I was an American. I was scared.

The opportunity to try it came when the North and the South agreed to a ceasefire. The VC (or National Liberation Front, as they preferred to be called) had put up flags to mark their terrain, which under the agreement was supposed to be safe from attack. Before the flags were raised, the only way you knew that a village was sympathetic to the other side was if you walked into it by accident, which could easily have resulted in capture or death. In theory it was safe now to go into one of these communist strongholds, but in theory the South Vietnamese were supposed to have stopped bombing, which they hadn't. In fact, I was told that the NLF flags made excellent targets for the South Vietnamese pilots.

I always wanted to see the war from "the other side." I don't know of one shooter who didn't. In the case of the Vietnam War, however, it rarely happened. For one thing, the communist government in the North would never allow anyone not sympathetic to their cause to accompany their troops in combat, so the reporting was totally one-sided. There were other cases, particularly in Cambodia, where photographers and writers succeeded in getting to the other side but were never seen again, so I was apprehensive about trying to link up with the enemy, to say the least. I had spent so much time being shot at by the VC that I had started to take it personally. Most of us did. I simply didn't know what to expect, even if I could get behind enemy lines.

For my attempt I chose an area about twenty-five miles south of Saigon. I had covered fighting there previously and had been told that the area was predominantly VC. As I drove along the highway I saw the NLF flags flying a few hundred feet from the main road. It was an exhilarating sight. This was a unique experience in the two years I had been there covering the war. An enemy village was just a stone's throw away, and no one was shooting at us. As my driver and I turned off the road toward the flags, we were stopped by government troops at a roadblock. They warned us that if we continued on, we would most likely be killed. I told them that I wasn't worried. The arrogant young lieutenant who stopped us then said, "Well if they don't kill you, then maybe we will when you come out." That was one situation I hadn't considered, but for some reason I didn't think that the lieutenant was kidding. After all, it wouldn't exactly help the cause of the Saigon government if the VC were depicted as controlling the area. The other thing that crossed my mind was that the "good guys" could kill us and make it look as if the VC had done it. Regardless of who killed us, the government would gain and I would lose. I decided to not push them and withdrew.

Viet Cong soldier with children in the Delta, Vietnam, 1972.

A young North Vietnamese boy looks at the damage caused by American air strikes, Hanoi, 1973.

I didn't give up, however, and the next day I went back to the same area. This time I dodged the soldiers and made it to a place near the village. My Vietnamese interpreter was highly nervous, and so was I. Because the road ended, we had to walk along a small path to get to the village. We didn't see anyone. It was really ominous. Usually when it was this quiet, something bad was about to happen. I looked toward a line of trees, and suddenly I saw several sets of eyes staring at me. My interpreter saw them at the same moment. "VC," he whispered. "Okay, Dave," I thought, "this is it. Too late to get out now." We pressed ahead, and as we walked two unarmed young men materialized to show us the way. They led us to a hut where we were offered tea. This was the second time I had tea under stress. I began to think that I didn't really like tea that much anymore.

Nobody talked to us, and they seemed to be waiting for something. I hoped whoever showed up would be friendlier. My interpreter's eyes lit up as he looked out a window. I got up to see what was happening and saw several armed men emerging from the jungle. Their rifles were not U.S. Army issue; they were AK-47s, the Viet Cong's weapon of choice. "We've had it," I whispered to my companion and then, on further consideration, said, "but it's one helluva scoop while it lasts!"

Leading the group of men was a man wearing a blue tunic and armed with a Chinese-made pistol. Only VC officers carried those. He was the leader, the one to whom everyone deferred—including me. He looked me up and down and then reached out with both his hands to grab one of mine. He smiled. His men smiled. I giggled. We followed the group of communists for a mile through the jungle until we reached their hamlet. It had never occurred to me that the VC lived in regular villages and had wives and children. I saw some younger women carrying weapons; they too were soldiers.

Someone asked me which country I came from, and I felt I had to be up-front. "America?" I answered tentatively. "You are welcome," he said. He wondered why we hadn't come before, and I told him that up until the cease-fire it had been impossible, but I wished I had been able to. After touring that village and several others, it was time to head back. I suddenly feared being bombed by the "friendlies" on my own side, but I managed the return trip without a hitch.

There was only one thing I really wanted to do after my experience with the VC, and that was to get into Hanoi. The seat of North Vietnam's communist government had been off-limits to Americans for the most part, unless you were an unwilling guest as a prisoner of war at the "Hanoi Hilton." My chance to enter Ho Chi Minh's den came after the North announced that they were going to release the last American prisoners of war. The authorities okayed Western press coverage, so I flew to Hanoi with several other newspeople, including the legendary Walter Cronkite.

They let us inside the Hanoi Hilton to see the POWs before the release. I got into a bit of trouble when I gave one of the prisoners an American-made cigarette, but after that I managed to take some good pictures of the men in their cells. I was happy that they were getting out that day, so I didn't feel bad about showing their plight. One of them, tears streaming down his face, said he didn't believe he was going to be released until he saw Walter Cronkite. Only then did he know it was true. Such is the power of television.

At the airport where all the POWs had been brought for transfer to the U.S. authorities, one prisoner suffered a final humiliation. The POWs' names were read through a loudspeaker at intervals of a minute, after which the prisoners who had been named walked to a waiting U.S. transport plane. Toward the end only one name remained to be called. For five minutes nothing happened. The last prisoner stood alone, surrounded by his captors and some curious kids. His hands were clenched at his side, and his eyes were squeezed shut. He was living a nightmare. Finally his name was called, and the last bit of torture for Airman Agnew ended. Only the Vietnamese laughed at their little joke.

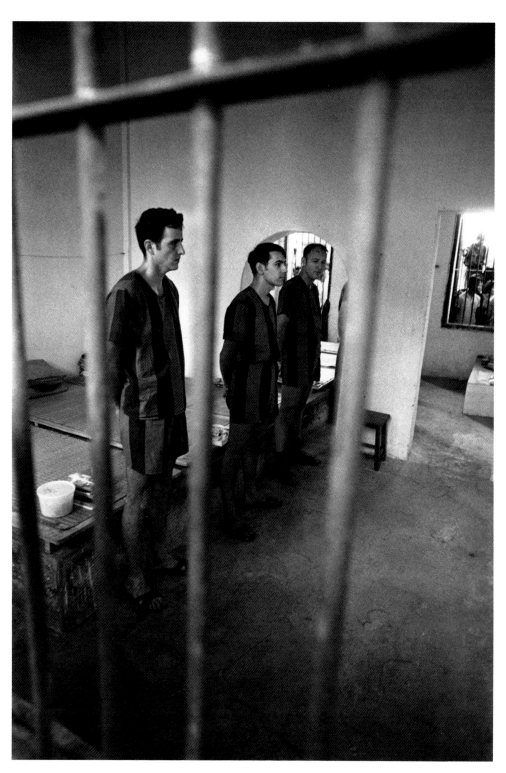

American POWs inside their cell at the Hanoi Hilton, 1973.

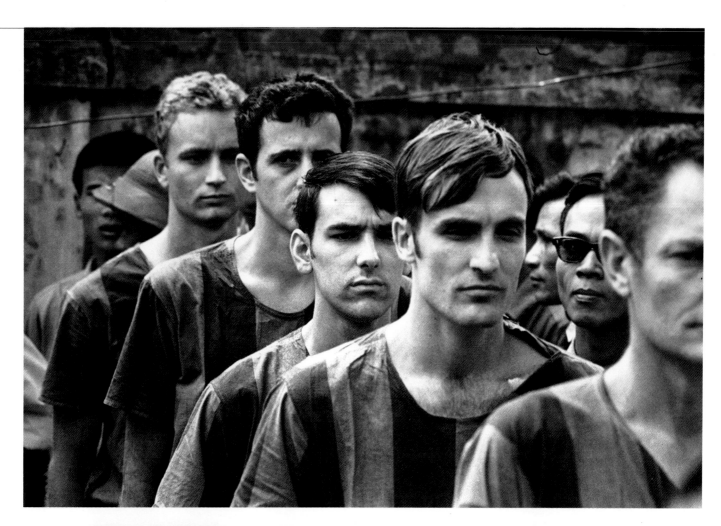

Above: American POWs in the Hanoi Hilton prior to their release. *Right:* An American officer scowls at a North Vietnamese jailer as he waits for prisoners to be released. *Far right:* The last American POW waits for his name to be called by his North Vietnamese captors, who will release him to U.S. authorities, 1973.

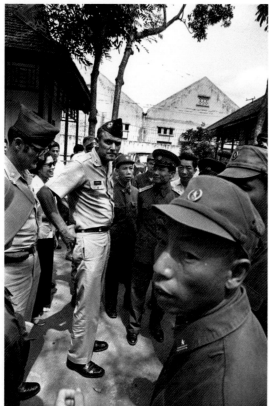

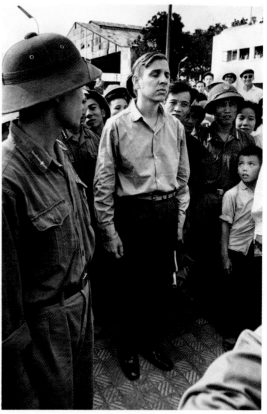

Photographer David Burnett and I with
Vietnamese soldiers at Tay Ninh, 1972.

My Vietnam days were over, too, at
least for the moment. Like Airman Agnew,
I wanted out, and it was time for me to go.
So after a few detours, including one more
look at the action in Cambodia and another
one at the colonial war in Mozambique, I
made my way back to the United States.
(On March 30, 1994, exactly twenty-one
years after the POW release, Rebecca Sola-
day and I chose the former enemy's strong-
hold as the site for our wedding. The cere-
mony took place in the Hanoi Opera House,
the place where Ho Chi Minh had declared
independence from the French in 1946. A
Vietnamese official who spoke at the wed-
ding said, "The war is over; it is time for us
to be friends." We obviously agreed.)

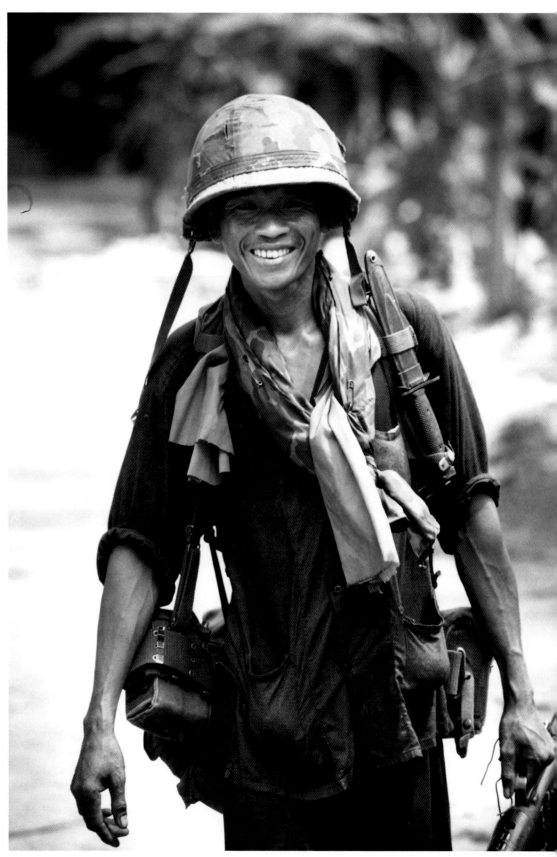

Cambodian soldier near Phnom Penh, 1973.

Mozambiquan army troops in a rail car, Mozambique, 1973.

A protester dressed up in a Nixon mask is hustled away from the federal courthouse by the police after yelling at arriving Watergate conspirators, Washington, D.C., 1973.

President Richard Nixon at the dedication of the
new Grand Ole Opry in Nashville, 1974.

Things had changed. When I left, *Patton* was the big film and Simon and Garfunkel's "Bridge over Troubled Water" was a hit song. When I landed in Washington, D.C., in 1973, *Mean Streets* and *The Exorcist* were the movies to see and Eric Clapton's version of Bob Marley's "I Shot the Sheriff" was what people were listening to. That same year Secretariat won the Triple Crown, electronic package codes were suggested for all supermarket items, and in their landmark *Roe v. Wade* decision, the Supreme Court ruled that a woman's freedom to abort is guaranteed by her right to privacy.

More pertinent to me as *Time* magazine's newest Washington shooter were the events that were unfolding on the political scene. Top Nixon aides H. R. Haldeman and John Erlichman had been forced to resign because of the Watergate cover-up, and the Senate had named a committee to investigate the affair headed by Senators Sam Ervin and Howard Baker. It looked as if the big story had shifted from the battlefields of Southeast Asia to the banks of the Potomac. The good news for me was that I was right in the middle of the action with no danger of being shot.

I never liked standing in front of doorways waiting to take a picture, but that's part of the job when you cover Washington. In this case the doorways were at the U.S. Courthouse, and the people I staked out were the various figures implicated in the Watergate conspiracy. On one day alone I managed to snap Haldeman, Erlichman, White House aide Chuck Colson, former attorney general John Mitchell, and presidential secretary Rosemary Woods as they passed through those portals. There were some entertaining but bizarre moments there as well. A man wearing a huge papier-mâché Nixon mask was hustled away by the police as he yelled at the arriving conspirators. I remember thinking that if you couldn't get an exclusive with the president himself, this was the next best thing.

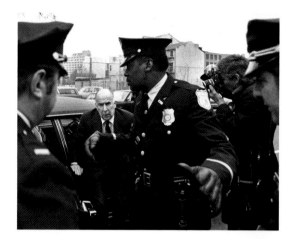

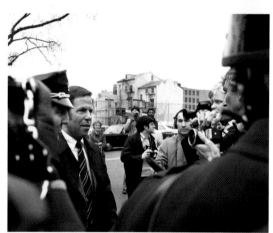

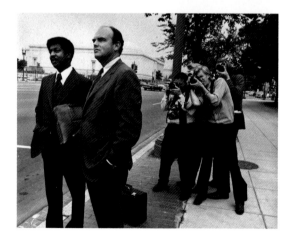

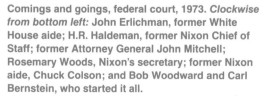

Comings and goings, federal court, 1973. *Clockwise from bottom left:* John Erlichman, former White House aide; H.R. Haldeman, former Nixon Chief of Staff; former Attorney General John Mitchell; Rosemary Woods, Nixon's secretary; former Nixon aide, Chuck Colson; and Bob Woodward and Carl Bernstein, who started it all.

Watergate wasn't the White House's only problem; another storm was building on the horizon. In August Vice President Spiro Agnew was informed that a Baltimore grand jury was inquiring into his finances. In announcing this to the press he maintained his innocence and later demanded that the House initiate a "full inquiry." The magazine assigned me to follow the vice president's every move, and I was the only one doing so on a daily basis. Agnew, who had once referred to the press as "nattering nabobs of negativism," wasn't very happy to see me, but I pursued him anyway, photographing him playing golf at country clubs, giving speeches, and appearing at public functions.

In early October Agnew addressed a group of rabidly loyal Republican women who swooned when he announced that he "would not resign if indicted." They hated the press as much as they loved the VP and even attacked a couple of us with umbrellas. It occurred to me that next the time I covered the nation's number-two executive, I should bring a flak jacket.

On Oct. 10, just a few days after saying he wouldn't quit under any circumstances, Spiro Agnew resigned. I trailed the now former vice president one more time and caught him looking soberly ahead as he sat in the back of his limousine. It was the last picture I took until he came out of hiding to attend Nixon's funeral twenty years later. My assignment was now to cover his replacement, whoever he might be.

Vice President Spiro Agnew the day after resigning his office, 1973.

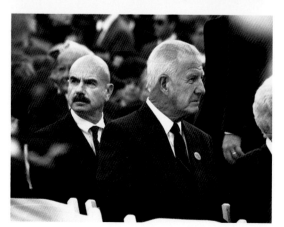

Former Watergate conspirator G. Gordon Liddy and former Vice President Spiro Agnew at Richard Nixon's funeral, Agnew's first public appearance since his resignation, Whittier, California, 1994.

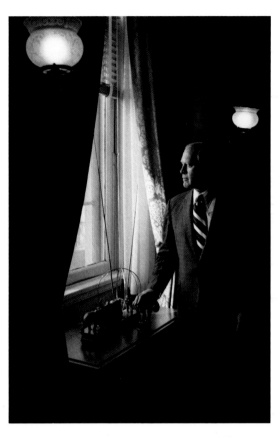

Congressman Gerald R. Ford in his House office the day he was named to replace Agnew, October 12, 1973.

I had never met House minority leader Gerald R. Ford, one of the leading contenders to replace Agnew, but two days after Agnew's resignation I was in Ford's Capitol office doing his portrait for the magazine. Nixon hadn't announced Agnew's replacement yet, and Ford joked that I was wasting my time. That night, however, in a ceremony broadcast live from the East Room of the White House, President Nixon introduced Ford as his choice to replace Agnew. Ford became the first vice president nominated under terms of the Twenty-fifth Amendment. The picture I had taken of him earlier also became the first *Time* cover for both of us, which in the photo world of that day was considered a big deal. It certainly was for me.

For the next few months I was the only photographer who covered Vice President Ford regularly, and I became friends with him and the rest of his family. Mrs. Ford and I became especially close, and I also hit it off with their four children, Mike, Jack, Steve, and Susan. I accompanied them on their yearly Christmas vacation in Vail, where I felt I needed to learn how to ski to cover the family properly. I wasn't that great, and Ford was overheard saying that "Kennerly skis with 10 percent talent and 90 percent intestinal fortitude." (Some people have said that about my photographic ability, too.) One night I took the family to dinner. At the end of the meal fortune cookies were handed out, and I noticed that the vice president tried to hide his after he had read it. I pried it away, and after looking at the little piece of paper I understood why he didn't want anyone to know his fortune. It said, "You will undergo a change of residence in the near future."

When I wasn't on the road with the vice president, I was given other assignments. One was a secret honeymoon, and I figured that, compared to other jobs I'd been handed, it would be a piece of cake. It wasn't. My mission was simple: Secretary of State Henry Kissinger had secretly married and jetted off to Mexico. I was to track the two down and photograph them. I learned from a source in Washington that this honeymoon was going to happen, so I had a big jump on the opposition. If I could just get there ahead of them, I might be able to scoop the rest of the pack and be on my way back to the States by the time the majority of howling snappers showed up. But alas, I was foiled. When I finally caught up with Kissinger and his bride, Nancy, they were securely ensconced behind the big pink walls of a fabulous villa in Acapulco—out of sight behind a huge wooden gate protected by a swarm of Federales and U.S. Secret Service agents. The clock was ticking. If I didn't somehow get into that villa, photograph the blissful couple, and get the film back to New York by Friday afternoon to make *Time*'s deadline, I would be toast.

It was Sunday. I had not only plenty of time but also another advantage: a radio that could intercept the transmissions of Kissinger's bodyguards. With any luck it would give me a jump on the hordes of other photogs who had by then arrived on the scene. It worked. Every time the happy couple left their residence I knew about it, and I could even determine where they were going. My local driver would speed to that location, and we'd get there just in time to see their motorcade disappear behind a huge set of doors similar to the ones at their place. No pix. My big break came when I heard that they were going sailing. I managed to hire a boat and put out to sea after them. What I hadn't figured on was the abundance of Mexican Federales in vessels discouraging fellows like me from getting close enough to take pictures. Once again I was blanked, and worse yet, it was Tuesday morning. That deadline lurked like a monster just over the horizon. I looked into the possibility of hiring a hang glider and soaring over the villa for a few shots, but I realized that I would probably be the one to get shot. On Tuesday afternoon the Kissingers decided to make themselves available for pictures to one and all. My hopes of an exclusive went out the window. I shot and shipped, but if the other 99 percent were happy with what they got, I was the 1 percent who wasn't.

The next afternoon, Wednesday, my office in New York called. They said that the pictures of Nancy were unflattering because she had been wearing huge sunglasses. Was there any way to get something better? Sure, I thought, no sweat, I'll just call Henry and tell him his new wife looks like hell and that they should let me, a person noted more for pictures of dead bodies than of live ones, come over and take a few snaps that will make her look like a million bucks. What the heck; it might actually work. I called a Kissinger aide and said that *Time* was going to run a crummy picture of Nancy. I told him that I realized I was imposing and asked him whether there was any remote chance, no matter how slim, that they might let me come over? He said he'd call back. I hadn't even entered my preanxiety mode when the phone rang. It was the aide. Be at the villa tomorrow afternoon at four sharp, he said. Good news, bad news, I thought. The bad news was that I might not be able to get the film back to the States in time. "Any possibility we could do it earlier?" I asked. The only response was the sound of a phone hanging up. "I'll be there," I said to the dial tone.

At four sharp I was admitted behind the big doors and talked to Nancy for the first time. She said her husband, ever the shy and retiring diplomat, didn't want his picture taken. I ate up fifteen precious minutes convincing him to pose; when he finally relented, I took some good photos of them together and of her alone. It went well, but I could hear the meter running. If I didn't make the airport soon, I might as well toss the film into Acapulco Bay.

The last flight for New York was heading down the runway as I screeched up in front of the terminal. It was not only the last one to the States but the last one to anywhere that day. I was dead. As I walked disconsolately through the terminal, I noticed a Boeing 707 on the field. I asked a ticket agent about it and found out that it was an aircraft chartered by IBM. Damn, I thought, and me without my pin-striped suit and razor. I raced down to the boarding area and talked to one of the people in charge of the group. He said that he couldn't authorize me to go. He didn't say I *couldn't* go, so I boarded the aircraft. I went straight into the rest room and emerged when the plane was airborne. I found an empty seat and, after what I hoped was a polite conversation with a nice couple who wondered why they hadn't met me before during the trip, fell asleep.

We landed in Kansas City at 12:30 A.M. Friday morning. I was considerably short of the mark and had only twelve hours to get to New York. The next flight didn't leave until 6 A.M.—to Chicago. I used to have nightmares that were more pleasant than this. By the time I made it to the Time & Life Building, got the film in and out of the lab, and showed the photos to the editors the clock was just about to strike noon. But I had beat the deadline. The editors liked the pictures and used them well. I was glad but tired. Getting the pictures back in time was much more difficult than taking them, but if you're a news shooter, one is as important as the other.

The funeral of former Chief Justice Earl Warren was a less hectic occasion that provided a rare opportunity to see all the members of the Court past and present gathered together. I photographed the current chief justice, Warren Berger, and the one who would replace him, William Rehnquist. Walking alongside the chief justice with them was William O. Douglas, who served thirty-six years on the court, the longest of anyone. Missing from that picture taken in 1974 was a woman justice. The first ever, Sandra Day O'Conner, wouldn't be appointed for another seven years.

Dirck Halstead was the principal White House photographer for *Time*, but I backed him up at the executive mansion when he was out of town. When I returned from Vietnam I covered Nixon at an event where he was animated and seemed to be having a good time. He was so carried away on one occasion that I shot two rolls of film of him as he seemed to perform a ballet at the podium in the East Room. Several months passed before I saw Nixon again. I was shocked by the president's appearance in January 1974. He looked tired and haggard. The strain of Watergate was taking its toll. I shot several frames of Nixon with a short telephoto lens and called picture editor John Durniak to tell him what I had. *Time* ran one of the close-ups of the embattled chief executive looking like hell. After the picture was published the White House press office reacted noisily, claiming the photo was "unfair." Even a top executive at my old employer, UPI, jumped on the bandwagon, suggesting that my picture was somehow "out of context." I was stung by the criticism but insisted that the only thing out of context was the people who thought everything was status quo with Richard Nixon. (Eight months later General Alexander Haig, who was Nixon's chief of staff at the time and someone who knew exactly what was happening, told me that my picture of Nixon was the only one ever taken that truly captured what was happening to the man. He added that the reason the president looked so bad was that he hadn't slept well for three days—he had been reviewing the tapes that contained that mysterious eighteen-minute gap, the gap that Haig himself at the time said had been caused by some "sinister force.")

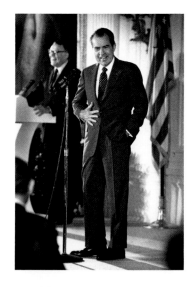
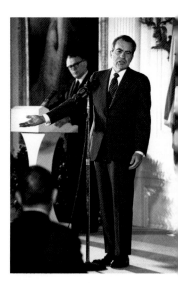

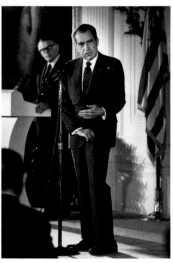
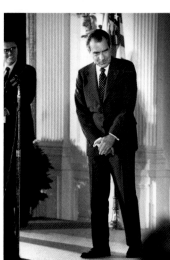

An animated President Nixon at an East Room ceremony, 1974.

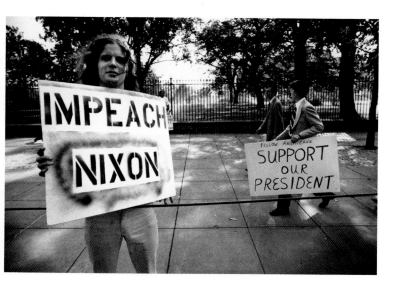

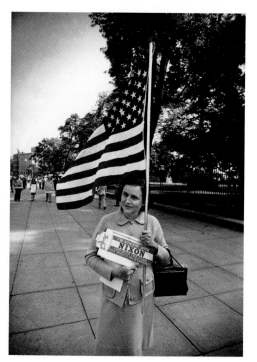

Conflicting
viewpoints,
in front of the
White House,
1973.

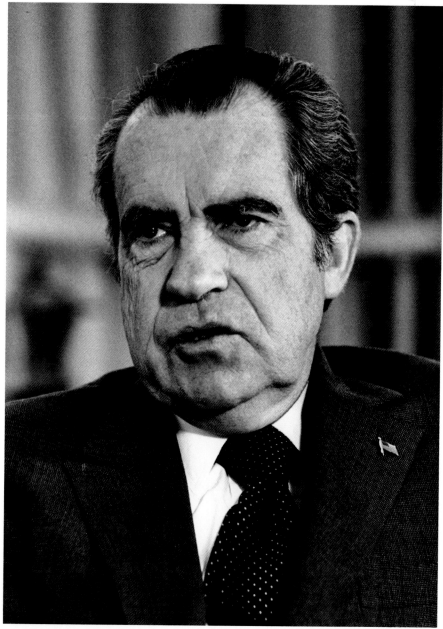

President Nixon shows the strain of Watergate, 1974.

On May 9 the House Judiciary Committee, chaired by Peter Rodino, began impeachment hearings. The Watergate scandal was entering its final phase, and Nixon was being cornered. Vice President Ford was still publicly supporting the president and in fact was one of his last defenders, saying that he didn't believe the president was guilty of an impeachable offense. On July 27 the House Judiciary Committee voted to adopt three articles of impeachment charging Nixon with obstruction of justice, failure to uphold laws, and refusal to produce material that the committee had subpoenaed. Time was running out for the chief of state.

On August 1 Alexander Haig presented to Ford evidence belying his claim that Nixon could not be convicted. Ford was told that a Watergate-related tape made June 23, 1972 (a week after the break-in at the Democratic headquarters), revealed Nixon suggesting that his staff throw the FBI investigation off the track by saying that it would interfere with a CIA operation. That was the "smoking gun" linking Nixon directly to the cover-up. Haig felt that the tape would be devastating once it was made public. He asked Ford whether he was able and ready to assume the presidency. Ford responded that he was but that he was angry that he had been deliberately misled by the president.

Ford continued with his normal schedule after the meeting, but he put out a statement that he would have no further comment on the situation until "facts are more fully available." He didn't have to wait long. On August 8, 1974, Richard Nixon, president of the United States, announced that he would resign the next day. Gerald R. Ford was about to become the nation's thirty-eighth president.

Judiciary counsel John Doar (left) confers with Chairman Peter Rodino and Nixon lawyer James St. Clair (right), 1974.

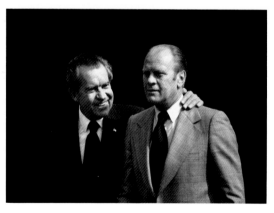

President Nixon and Vice President Ford on the south lawn of the White House, 1974.

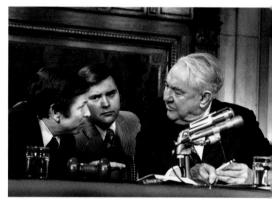

Below: Senator Howard Baker (left) and Senator Sam Ervin (right) of the Senate Watergate committee talk as a committee lawyer looks on, 1973.

E. Howard Hunt, a Watergate conspirator, prepares to testify before the Senate committee, 1974.

I was up early on August 9. I had been a firsthand witness to the events that led up to this extraordinary day, and I didn't want to miss the finale. I was positioned on a stand with scores of other photographers as President and Mrs. Nixon took their last walk from beneath the South Portico of the White House and down a red carpet to the awaiting presidential helicopter. Accompanying them were David and Julie Eisenhower and Vice President and Mrs. Ford. I furiously took pictures as Nixon mounted the steps of his chopper and then turned with lips pursed to give a painful final wave to the assembled crowd. With a last glance at the White House, his residence for almost six years, he turned and his shoulders slumped as he ducked inside the chopper.

Several hours later, somewhere over the heartland of America, the clock struck twelve, and Richard Nixon was no longer president.

At that same moment, in the East Room of the White House, Gerald Ford raised his right hand and repeated the oath of office. He declared, "Our long national nightmare is over." He was the first man in American history to become president without winning a national election. An orderly transition of power had taken place, not a shot had been fired, and the kid from Roseburg was there to record that unique moment for posterity.

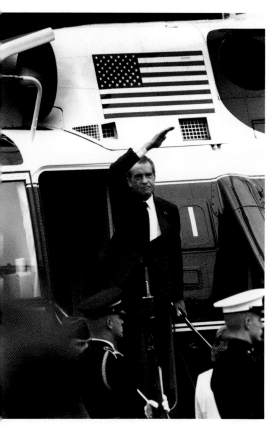

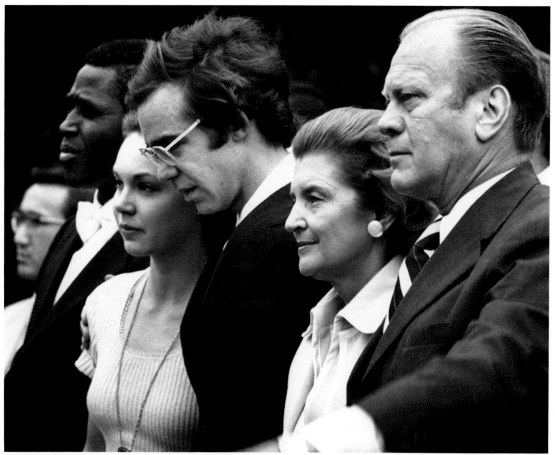

President Nixon leaves the White House for the last time, as David and Julie Eisenhower and Vice President and Mrs. Ford watch, August 9, 1974.

That night the Fords invited me to their modest house in Alexandria, Virginia, for a buffet dinner with some of their other friends. I took pictures as they were toasted by the group. Later, after everyone else had left, the new president and I talked. Until that conversation he had never mentioned anything about a job. He had felt that it was inappropriate to discuss a possible position with anyone before Nixon left. Now that wasn't a problem.

He asked me how I would approach the post of White House photographer. I told him that I could boil it down to two words: total access. I felt strongly that to become his photographer I would need to be able to shoot everything that happened, with no interference from him or the staff. That would be the only way I could provide a true and honest photographic documentary of his presidency. Otherwise, I said, what's the point of doing it at all? "Is that it?" he said. "Are you sure you don't want Air Force One on weekends, too?" We laughed, and he said he thought the idea had merit. I also liked the idea about Air Force One.

It was almost eleven o'clock and time for the news. Gerald R. Ford had been so busy becoming president that he had not had time to watch it happen. He suggested that we look at the television in the den. He turned it on, but it didn't work. I thought that he probably wouldn't see any broken televisions once he moved into the White House. The only other TV was in their bedroom, so he, Mrs. Ford, Susan, and I watched a replay of his swearing-in ceremony there. A part of me suspected I was dreaming. Here I was in the middle of one of the biggest events in this country's history, and I was watching a replay with the main participant. This was more than even Captain Nemo could have hoped for.

The next day I was at my office at *Time* when the phone rang. It was the magazine's switchboard operator, and she sounded a bit flummoxed. "It's the president for you, Dave," she stammered. "He's . . . he's actually on the line!"

"Tell him I'm busy," I said. She gasped. "I'm kidding, I'm kidding," I assured her. This was one of the many reasons I admired the president. He had made his own call to me. He probably still didn't realize that there were five hundred people over there ready to place a call, do back flips, or start a war if he so desired. He asked me whether I wanted the job. "When do you want me to start?" I asked.

"Now," he said, scolding me for wasting half a day of the taxpayers' money.

So my temporary career as a government employee was launched just like that. It was quite a switch: from outside to inside in the bat of an eye. Inside was a place news photographers rarely reach, but it's where they always want to be. All the frustration I had experienced trying to get an exclusive during the Nixon days was washed away with that one phone call. Every day was going to be an exclusive from now on, and the way I worked that meant sixteen hours a day, seven days a week.

The job of White House photographer, or Personal Photographer to the President, had been held by only two other civilians. Previously the picture-taking duties had been handled principally by military personnel. Yoichi Okamoto, who was President Johnson's photog, was the first. Okie, as he was known, told *Popular Photography* magazine, "There wasn't the close personal relationship between us [Johnson and Okie] that there is between Ford and Kennerly. I was always LBJ's subordinate. Everybody was a flunky—including McNamara and Rusk." Okie certainly wasn't a flunky when it came to his photography. Because of the access granted him by President Johnson, his pictures are among the most powerful ever taken in the White House. It was Okie who set the standard for the job and gave me a course to follow.

The next civilian to hold the office was Ollie Atkins, who had been a photographer for the *Saturday Evening Post*. He told *Popular Photography*, "I never had any real understanding with Nixon about the importance of photography . . . picture sessions were usually formal and stiff. Press Secretary Ron Ziegler, who understood nothing about photography, controlled the whole photo office and stood in the way of getting through to Nixon. I never got to discuss anything with the president, not even the weather." After having been frozen out from anything but the most mundane situations, Ollie's revenge was to get some remarkable photos the night before Nixon left the White House. It was small payment for all of the years and hard work he put into his job.

I was as different from Ollie Atkins as Ford was to Nixon. Unlike Ollie, who always dressed in pin-striped suits, I preferred blue jeans and sport jackets. I also wore the full beard that I had grown in Vietnam. Author Perry Deane Young wrote that until I came along, "the only beards inside the White House were on portraits of long-dead presidents."

President Carter didn't have a photographer (his press secretary, Jody Powell, was quoted during the transition as saying, "the last thing we want is another David Kennerly"), although some of my staff stayed to do the duty, so the fourth in the short line was Michael Evans, President Reagan's photog, who said, "if Kennerly was like a son to Ford, then I'm like the favorite nephew." The fifth was President Bush's photographer, David Valdez; the sixth, Bob McNeely, President Clinton's official shooter.

Below: The family celebrates Gerald Ford's first night as president from their home in Alexandria, Virginia. *Left:* Ford commutes from home to the White House for several weeks following Nixon's departure, 1974.

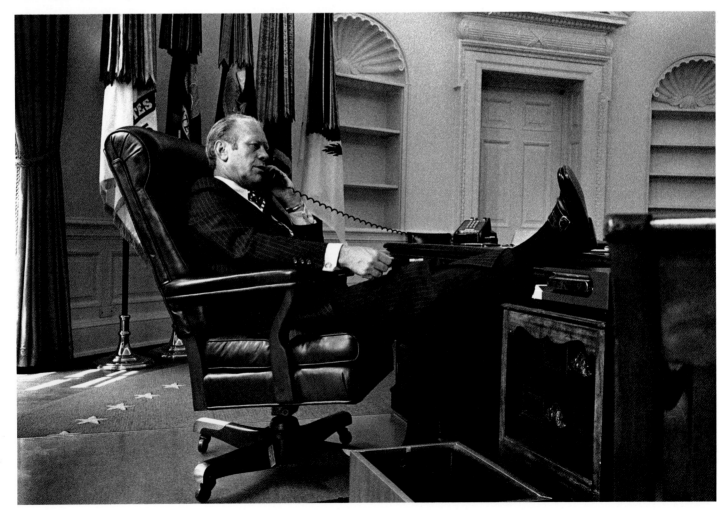

The Oval Office shelves are empty as President Ford slips into his own routine, August 1974.

I ran the photo office in much the same way as I would run a small newspaper. There were four other photographers on my staff, plus the brilliant photo editor Sandra Eisert, whom I had hired away from the *Louisville Courier-Journal*, and my chief of staff, Billie Shaddix, a retired Navy man who covered my rear during the occasional bureaucratic dustup. He also oversaw the photo lab, which employed military men and women from all the branches. Unlike a newspaper, however, some of the material they got from us was classified, so like me they all had top-secret clearances.

I shot black and white (Tri-X, usually rated at 800 ASA) with a Leica M-4 or my trusty Nikons. I found the Leica to be especially good in those quiet moments where a noisier camera might have been disturbing. I chose black and white film over color because it holds up better over time, is forgiving in poor light situations, and more accurately reflects the drama of many situations. I rarely used a flash because it would have called attention to me and my camera and would have taken away from the natural look of the situation.

I was in that most coveted of photographic situations, that of a "fly on the wall." I went unnoticed, or at least I was ignored. After the first few days on the job I became part of the woodwork. The only time I was noticed was when I wasn't there, which was seldom. My presence initially was quite a jolt for some of the Nixon holdovers, who would have preferred to treat this fly with Raid. Fortunately for me, the guy behind the desk had the biggest swatter.

The signal event in Ford's presidency happened a month after he was sworn in. He pardoned Richard Nixon. It happened September 8 on a Sunday morning in the Oval Office. I couldn't help thinking that President Ford did it then in the hopes that nobody would notice. They did. After he signed the document in front of a single television camera, he walked down the hall to an assistant's office. All hell had broken loose. I took pictures as he paced in front of a photo of the former president whom he had just let off the hook. An aide with a clipboard read congressional reaction to him. Some of his former colleagues privately supported the pardon but publicly were going to condemn it. Ford told me later, "I expected some criticism, but the volume and vigor of it shook me." He added, "Some people never forgave me. They had such a hatred of Nixon, and they carried that hatred to me because I granted him a pardon . . . despite that I was convinced it was the right thing to do for the country in the long run, and I had no qualms about it." Ford's popularity dropped thirty points overnight. The Watergate scandal had touched someone else.

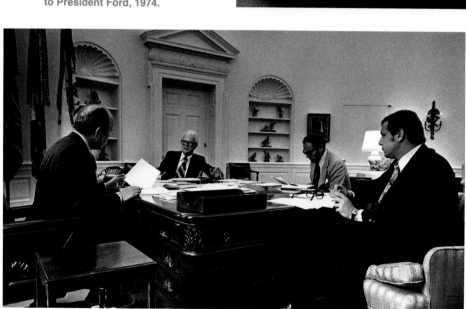

Chief of Staff Alexander Haig talks to President Ford, 1974.

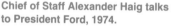

President Ford discusses the pardon of Richard Nixon with (*left to right*) his lawyer Phil Buchen, Alexander Haig, and lawyer Benton Becker, 1974.

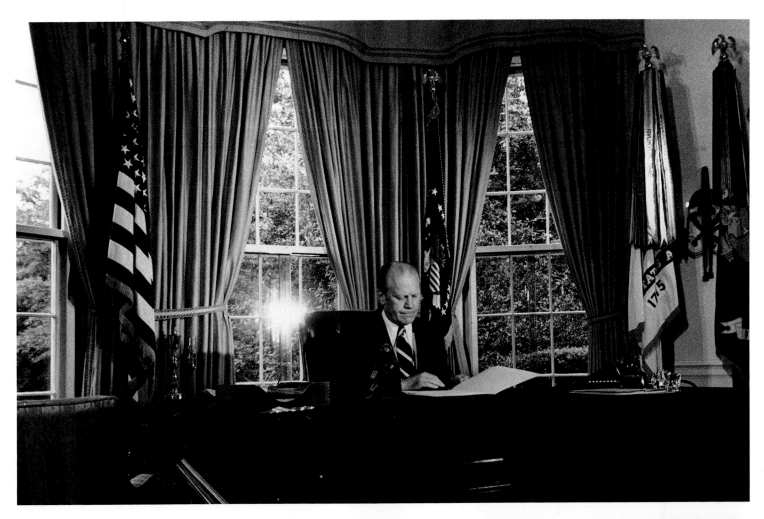

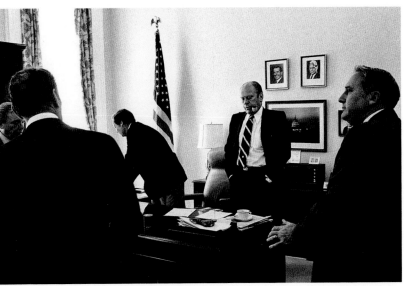

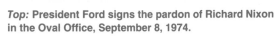

Left: In an aide's office, beneath the former president's picture, the new president confronts the reaction to the pardon.

Top: President Ford signs the pardon of Richard Nixon in the Oval Office, September 8, 1974.

President Ford at the end of the day after his press conference explaining the pardon.

Two weeks later the First Family got some more bad news. Mrs. Ford was diagnosed as having breast cancer and had to have major surgery right away. I accompanied the president and her to Bethesda Naval Hospital and photographed them hugging each other before she was taken away for the procedure. I waited outside the operating room with the president while the operation was successfully completed. They treated me like one of the family, and I tried to be as supportive of the president during that difficult period as if I were. My relationship with them certainly went beyond that of just being an employee. Their warmth and honesty made me feel closer to them than to friends I had known all my life. I was one of the very few who could go to the second-floor residence in the White House without calling ahead, and I was usually the only staffer other than the doctor and military aide who accompanied them to Camp David on weekends.

The president visits Mrs. Ford at Bethesda Naval Hospital after breast surgery, 1974.

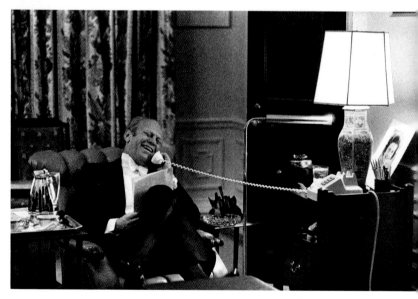

Susan Ford fills in for her mother at a white-tie dinner-dance in the East Room of the White House. Later, President Ford calls Mrs. Ford at the hospital.

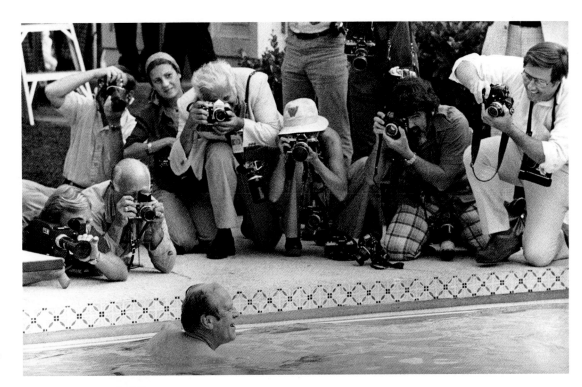

Right: President Ford experiences a "quiet" moment as he tries out the new pool at the White House. *Below:* His presidential style emerges as he gives an open-air press conference in front of the White House.

One especially exciting element of my job was traveling with the president. That meant riding on Air Force One with him, and as a senior staffer I no longer rode in "the back of the bus" with the press but instead sat with the chief of staff and the rest of the biggies in our own cabin. I did, however, invite my fellow photogs up to the VIP lounge whenever I could, and because I could now take matchbooks and napkins with impunity, I gave them out as souvenirs to my buddies.

President Ford put more than a quarter of a million miles on Air Force One during his two and a half years in office, and I flew with him to every stop. We visited forty-six states and seventeen countries—the Soviet Union, the People's Republic of China, Korea, Japan, Indonesia, the Philippines, Spain, Italy, Austria, West Germany, France, Romania, Yugoslavia, Poland, Finland, Belgium, and Mexico.

Today Air Force One is a huge Boeing 747, but in those days it was a shiny blue and silver 707 with a big presidential seal on the side. Inside it was both plush and functional. The president had his own cabin, which could be used either as an office or a bedroom. The president travels with a complete retinue, including chief of staff, Secret Service agents, press aides, communications experts, military aide, advance staff, speech writers, secretaries, physician, press pool, and of course, personal photographer. The presidential aircraft has the best communications setup on earth, and I would occasionally misuse it to impress my friends. The calls would go something like this: "This is the White House signal operator. I have a call for you from Mr. Kennerly aboard Air Force One. Please remember that these calls may be monitored, so don't discuss classified information. Mr. Kennerly's code name is 'Hot Shot,' so please use that designation when talking to him . . . Go ahead."

"Where are you, Hot Shot?" the person called would ask.

"Just about to land in your city. What are you doing for dinner?" I would reply. I used to get a lot of dates that way.

Left: Henry Kissinger has a few laughs at the expense of UPI correspondent Richard Growald as Susan Ford and Mrs. Ford join in, 1976. *Middle:* The president meets Generalissimo Franco in Madrid, while Mrs. Ford talks to Mrs. Franco, 1975. *Below:* The presidential party listens to a chamber orchestra with Franco and King Juan Carlos, 1975.

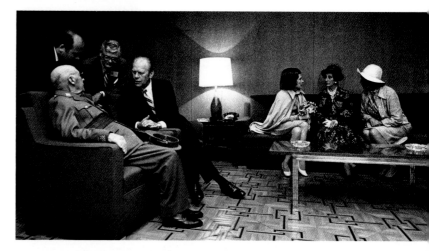

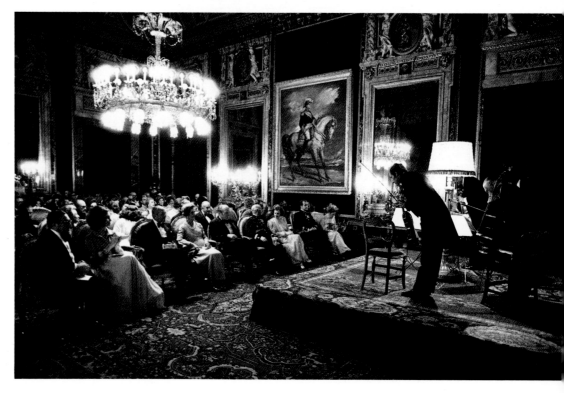

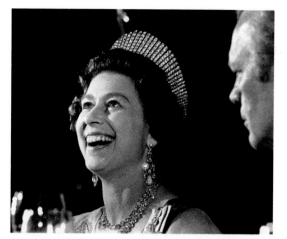

During those travels I was able to get close-ups of some of the most reclusive and important figures in modern history. Members of the press rarely saw, much less got within a hundred yards of, Leonid Brezhnev, Deng Xiaoping, Josip Tito, Emperor Hirohito, Generalissimo Franco, Nicolae Ceauşescu, Ferdinand Marcos, President Suharto, or the Queen of England. Being with the president as part of the official delegation meant that I was right there when he met with the other world leaders, providing me a front-row seat at history.

Queen Elizabeth at the White House for the bicentennial celebration, 1976. *Below:* President Ford and Polish leader Edward Gierek in a Warsaw motorcade, 1975.

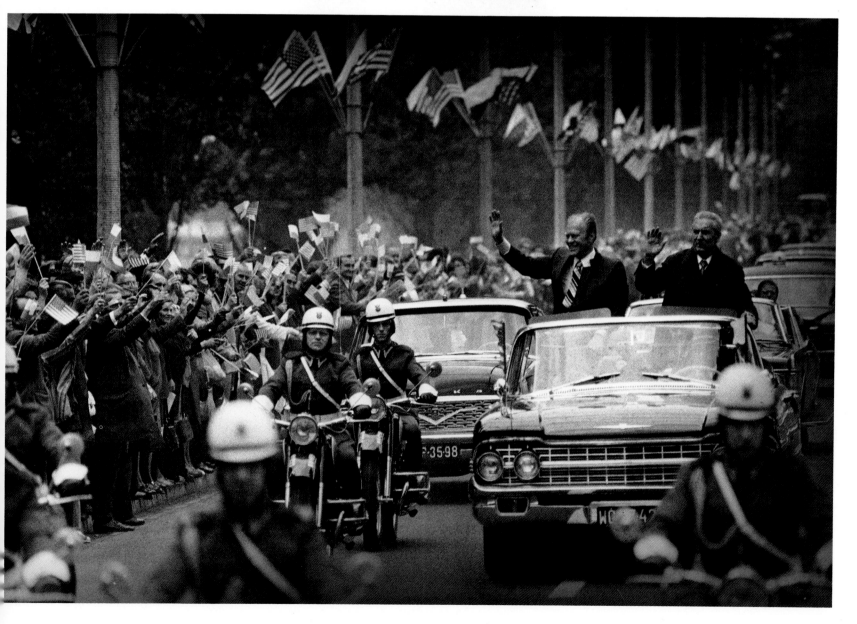

I did have my problems, however. When we visited the Siberian port city of Vladivostok in 1974, a place that had been off-limits to foreigners for decades, I was grabbed by burly Soviet Security agents the moment I descended the stairs from Air Force One. These agents were trained to fall on anyone carrying cameras and were probably awarded points for each one of us they harassed. As a member of the press I was used to that kind of treatment, but I figured that they would not interfere with a bona fide member of the American delegation. Their first and only clue that they may have erred was when Brezhnev, who was standing at the bottom of the ramp alongside Foreign Minister Gromyko and Ambassador Dobrynin, yelled something at the two who were leading me away by the collar. I was dropped like a hot rock. Détente was alive and well.

President Ford had made the trip to the Soviet Union to try to finalize the SALT II agreement, which extended SALT I's limitations on the deployment of nuclear weapons. The talks took place outside Vladivostok at the Okeanskaya Sanatorium, a health spa for Soviet military personnel. Although the resort had been tricked out for our visit, President Ford thought it looked like "an abandoned YMCA camp in the Catskills."

Security measures were taken to guard against KGB surveillance while we were at the summit site, including the use of a "babbler," which is a tape of hundreds of conversations mixed together and played through several speakers that surrounded the secret staff discussions. The main problem with the babbler is that coherent communication is practically impossible when it's on—although the KGB certainly couldn't hear very well if no one else could. The president finally chose to confer with his team outside the conference building in minus-twenty-degree weather. They could certainly understand one another out there, but they nearly froze to death in the process.

Eventually an agreement between the two sides was reached, and the world inched a little farther away from nuclear conflict. (It occurred to me, by the way, that I was finally seeing at close range the people who inspired all those bomb shelters in my hometown. They weren't as scary as I had imagined back then, and in fact I rather liked them.)

Below: President Ford and General Secretary Brezhnev on a train from Vladivostok to the summit site, 1974. During SALT negotiations President Ford and his advisors talk in the subzero weather outside the Soviet meeting hall to avoid being overheard by KGB bugging devices.

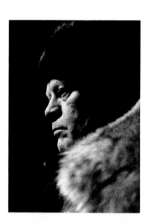

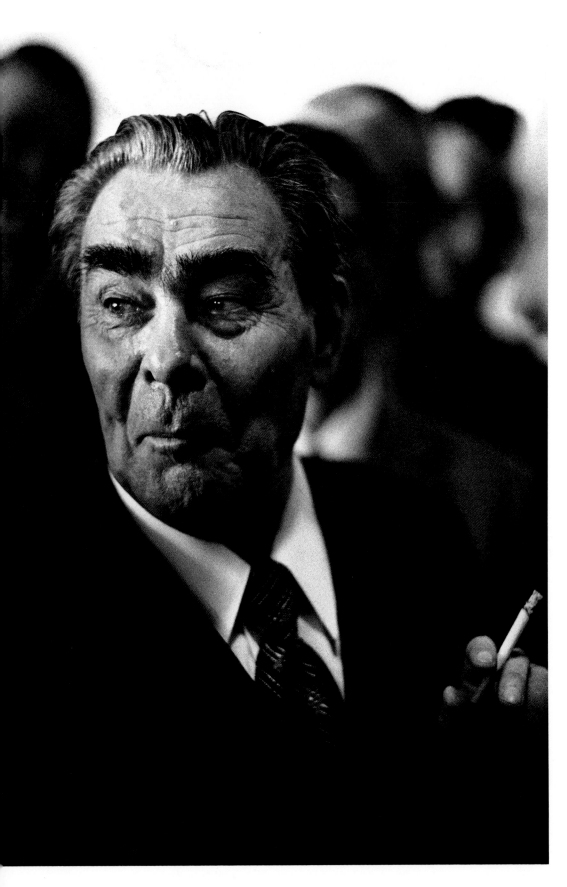

My only other experience with Brezhnev came in Finland, where he and thirty other heads of state were attending the Helsinki Conference. I took a picture of him that Brent Scowcroft, a Brezhnev expert, said absolutely captured his personality. It showed Brezhnev with a cigarette in hand glancing slyly to one side. After we returned to the States I wanted to get that photo signed, so I sent a copy along with Peter Rodman, who was an aide to Secretary Kissinger, on his next trip to Moscow. During a break Rodman presented the picture to Brezhnev, who looked at it for a moment and then picked it up and left the room. He returned later and handed Rodman a photo. "I think you'll like this one better," was all he said. The picture, which he had signed, was a very formal and airbrushed image of himself taken twenty years earlier. The substitute looked as if it had been hastily removed from a frame in the adjoining room. But even if he didn't like my picture of him, I got a signed Leonid Brezhnev nonetheless, and it hangs proudly at the top of my rather large collection of other Communist kitsch.

Leonid Brezhnev in Helsinki, 1975.

There is always a historic element when a U.S. head of state goes overseas, and the journey to Japan was no different. Ford was the first American president to visit Japan, thus making history the moment his foot touched their soil, but he had a small problem after he arrived. It happened just before he was about to meet the emperor. Tradition dictated that he and the other members of his party (myself included) had to wear a morning coat and striped pants when being received by Hirohito. I dropped in to Ford's room at Akasaka Palace, which is the state guest house modeled after the palace at Versailles, to see how he was doing. He was all dressed up and ready to go.

"How do I look?" he asked.

"Great," I said, looking him up and down, "but your pants are too short." He looked into a mirror.

"Oh, my God," he said and disappeared into his bedroom. When he reemerged he said, "I've discovered the problem, and it isn't the pants."

"That's terrific," I said. "What is it?"

"The suspenders are too short," he said, "but if I don't wear them, something of a more embarrassing nature is going to happen." So he greeted the emperor, whose pants were too long, and the press made fun of his, which were too short. It's not easy being the president.

Terry O'Donnell photographs the president and I as we wait to meet the emperor, Akasaka Palace, Tokyo, 1974.

A pajama-clad president deals with his staff at Akasaka Palace in Tokyo during a state visit to Japan in 1974.

The first visit ever of a Japanese emperor to the United States took place two years later when Emperor Hirohito visited the White House, 1976.

In Kyoto, Japan's ancient capital, the president made more history with another first. The Japanese have a game that is similar to ours of holding an apple against your neck with your chin and passing it to someone else. Their version involves holding a straw by pressing it between your upper lip and your nose and passing it along to the next person, who in this case was a geisha. President Ford looked askance at this process but, ever the sport, gave it a shot. To the delight of the crowd and his traditionally costumed partner, he succeeded on his first try. Every staffer was next to a geisha and each took a turn, from Chief of Staff Don Rumsfeld to Secretary of State Kissinger. It was Kissinger who made the biggest hit, taking off his glasses, a sight we rarely saw, and valiantly contorting his face into a froglike grimace to pin the straw between his lip and his nose. He managed to pass the straw to his partner on the second try. Everyone laughed and applauded his diplomatic effort coupled with his undiplomatic demeanor.

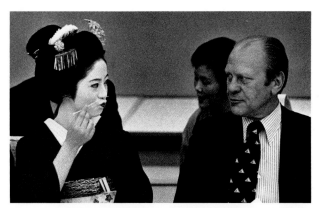

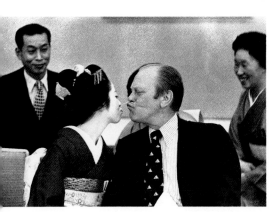

Geishas entertain the president and his staff, Kyoto, 1974.

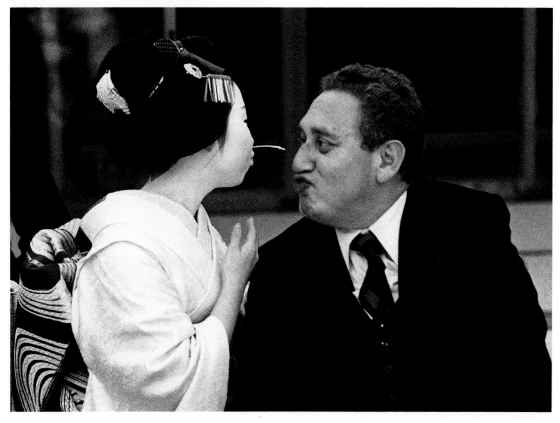

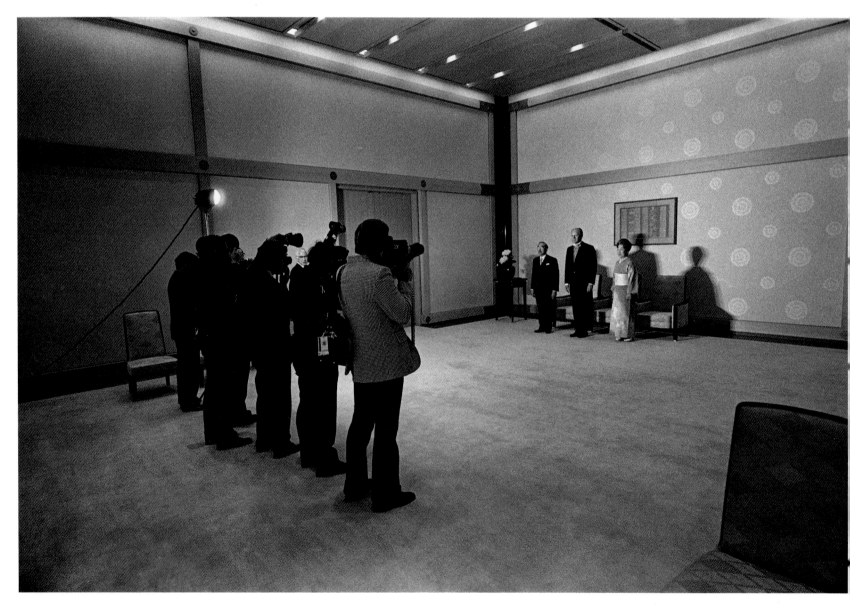

A "photo op" at the Emperor's Palace with Emperor
and Mrs. Hirohito and the president, 1974.

Some of the other stops along the way included a return trip to the People's Republic of China. I hadn't been there for two and a half years, and with Zhou Enlai seriously ill, the diminutive Deng Xiaoping was the man out in front. My dream on that visit was to photograph the legendary Chairman Mao, and I figured that being with the official party, and not a bottom-feeding newsie, I might have a chance. I was wrong. No foreign photogs allowed, even those who wore a staff pin and had Henry Kissinger batting for them. No way, no how, no ifs, ands, or buts. Dick Kaiser, the head of President Ford's Secret Service detail, told me that he and his agents were also barred. No guns, no cameras. The heavily retouched official picture released by the Chinese showed Mao looking healthy, but it didn't help. He died the following year, and President Ford was one of the last Westerners to lay eyes on him.

Deng Xiaoping, the leader of the People's Republic of China, in the Great Hall of the People, Beijing, 1975.

In 1975 the PRC was still in the throes of the Cultural Revolution, and the revolutionary ballet called *Song of the Yimeng Mountains*, was performed in the Great Hall of the People for the presidential party. The ballet, which was about the People's Liberation Army, gave me a chance to photograph some small portion, if only a symbol thereof, of the upheaval that China was experiencing. Mao's campaign to purge his enemies and renew revolutionary zeal led to widespread chaos, and the Red Guard, who got out of control, were the vicious tools of the experiment. China was at the end of the failed campaign when we visited and would take years to recover from its violent excesses.

Top: Deng Xiaoping has a private meeting with President Ford in Beijing, 1975. *Left:* Deng Xiaoping. *Above:* Dancers depicting members of the People's Revolutionary Army perform for the president.

In early 1975 Vietnam was starting to come apart at the seams. The North Vietnamese had mounted a major offensive, and they were gaining ground quickly. Things were deteriorating just as rapidly in Cambodia. The Khmer Rouge had practically encircled the capital of Phnom Penh, and only an occasional flight was getting into the besieged airport.

I heard that old voice calling as I watched the classified reports pour into the situation room, and the war-horse in me started to rear its wild-eyed head. I needed to go back to Southeast Asia, and one way or another I was going to get there. It didn't take long for the Kennerly luck to kick in. The next day I was in the Oval Office photographing a meeting concerning the crisis. President Ford was dispatching Army Chief of Staff Fred Weyand to Vietnam to assess the situation. Ambassador Graham Martin, who was in the States at the time, was going back with him. I wanted to be on board that plane with them. After the general and group left the office I told the president about my wish to return to Vietnam. He knew I had a personal and emotional stake in going, so he agreed. He also said that he wanted my personal report when I returned. He said he knew that I would give him the unvarnished truth about the situation. I thought he was going to get more than he bargained for.

When we arrived in Saigon I was given a top-secret briefing. Things were falling apart more quickly than anyone had imagined. Even the newsies were getting upset. Arthur Lord of NBC, an old friend from my earlier days in Saigon, asked me to help get him an appointment with Ambassador Martin. Art, like many of the American press in Vietnam, wanted to get his Vietnamese employees out of the country, but Martin wouldn't discuss the issue with anybody. I managed to get Art in, and he made his pitch. The ambassador told him that he had his own problems, and the first sign of an evacuation would create chaos. He also reminded Art that press reports were saying that nothing would happen to the civilian population even if the North Vietnamese won the war. Martin truly believed that the press was totally hypocritical. Lord did, however, manage to get his people out.

While General Weyand and his staff were getting their information through briefings in Saigon, I headed north to see things firsthand. I photographed a cargo ship that was crammed with retreating South Vietnamese soldiers, some of whom fired on my helicopter. I can only presume that they were frustrated and angry and that the sight of the American flag on the side of the chopper made them shoot. I spent the night in Nha Trang, which was abandoned the next day to the advancing North Vietnamese. Things weren't looking too good for the government, and people were heading south in a panic.

General Fred Weyand and Ambassador Graham Martin meet with South Vietnam's President Nguyen Van Thieu at the presidential palace in Saigon. This was Thieu's last photographed appearance before he fled the country three weeks later, 1975.

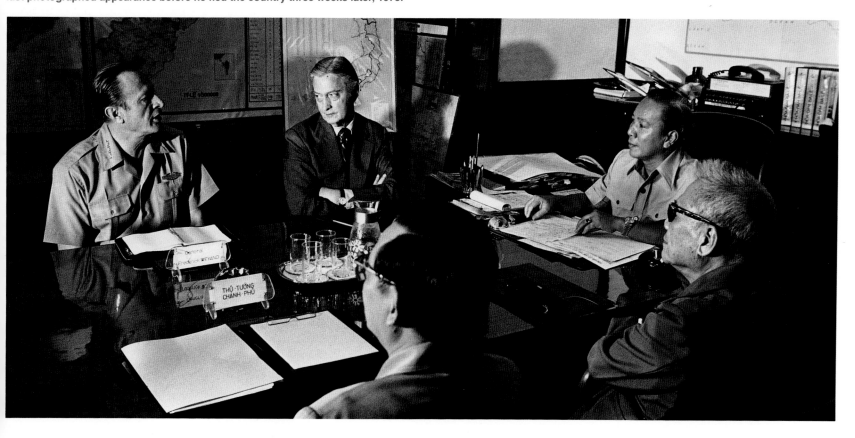

The next day I flew to Cambodia on Air America, the CIA-owned airline. The pilot, who had volunteered to fly me despite the danger, corkscrewed into the capital's airport, which was receiving constant artillery fire from the Khmer Rouge. I jumped out of the plane as he taxied past the terminal, and then the pilot jammed the throttle forward and took off. Anybody left at the airport was hiding behind sandbags. It was a bit hairy in old Phnom Penh.

I spent the day being driven around by my old buddy Matt Franjola, who was AP's representative there. We saw the human devastation wreaked by the fighting, with hundreds of wounded people jamming makeshift hospitals. I took pictures of a woman being comforted by her husband moments before she died. Her little boy looked on in anguish. Matt took me to a refugee center, which was nothing more than a half-finished hotel occupied by countless civilians left homeless by the war. I photographed a little girl as she looked up at me, a dog tag around her neck and a tear streaking her cheek. Her eyes were vacant; they had seen too much for such a little thing. It was a catastrophic situation, and it was going to get worse. Millions of people ending up dying in Cambodia at the hands of the Khmer Rouge after they took control of the country. I can't help wondering whether that little girl was among them.

By the time I arrived back in the States I was haunted by the faces of the people I had left and the scenes I had witnessed. It was time to make my presentation to the president, and I chose to say it with photos. He sadly looked through the grim images of refugees and suffering children. It may have been the first time that an American president was shown such graphic documents of war by the person who produced them. It was one thing to read about statistics and events and quite another to have them right before your eyes in stark black and white. I told him that, in my opinion, Vietnam had no more than a month left, and anyone who said different was living in a dreamworld. He was devastated, both by the pictures and by my brutal assessment.

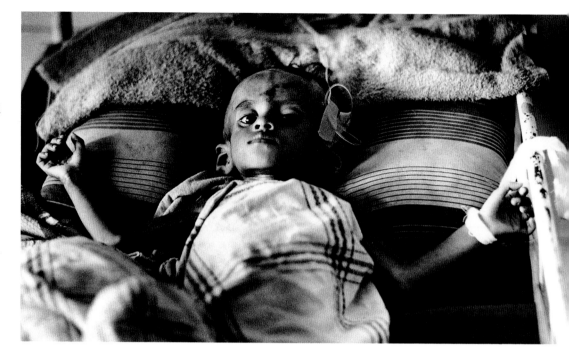

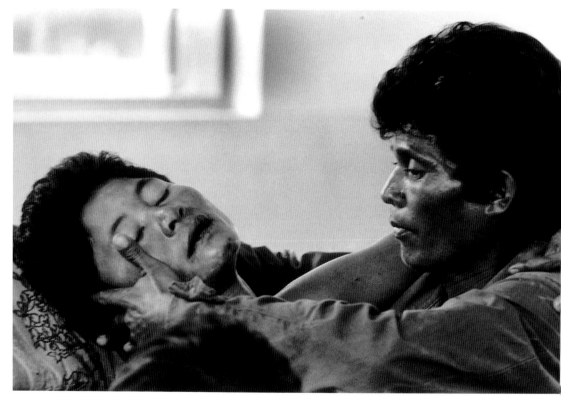

Above: A child dies of starvation in Phnom Penh, 1975.
Below: A dying woman in a makeshift hospital is comforted by her husband, Phnom Penh, 1975.

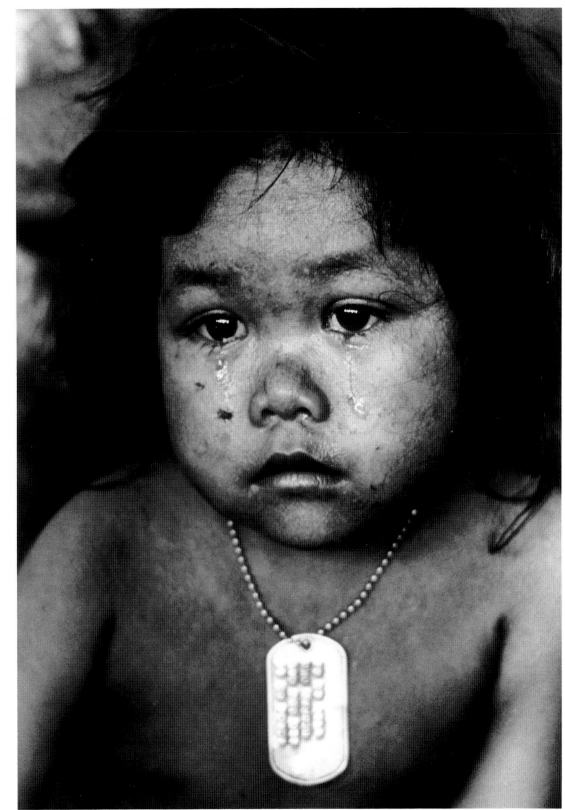

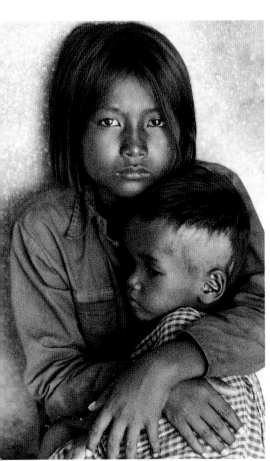

Vietnamese refugee kids, Cam Ranh Bay, 1975.

A little Cambodian refugee girl wears a dog tag
as a trinket in Phnom Penh, 1975.

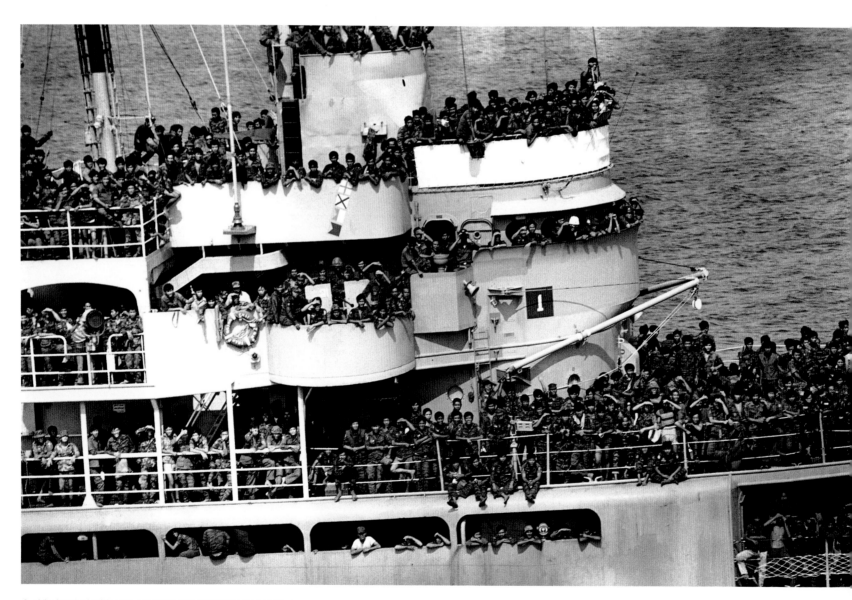

A ship loaded with retreating South Vietnamese soldiers
pulls into Cam Ranh Bay after escaping Da Nang, 1975.

Left: President Ford reads General Weyand's report that says the chances of South Vietnam's surviving are practically nil, 1975.

Henry Kissinger in the Cabinet Room as the withdrawal from Vietnam is contemplated, 1975.

President Ford weighs pulling the plug on America's involvement in Vietnam.

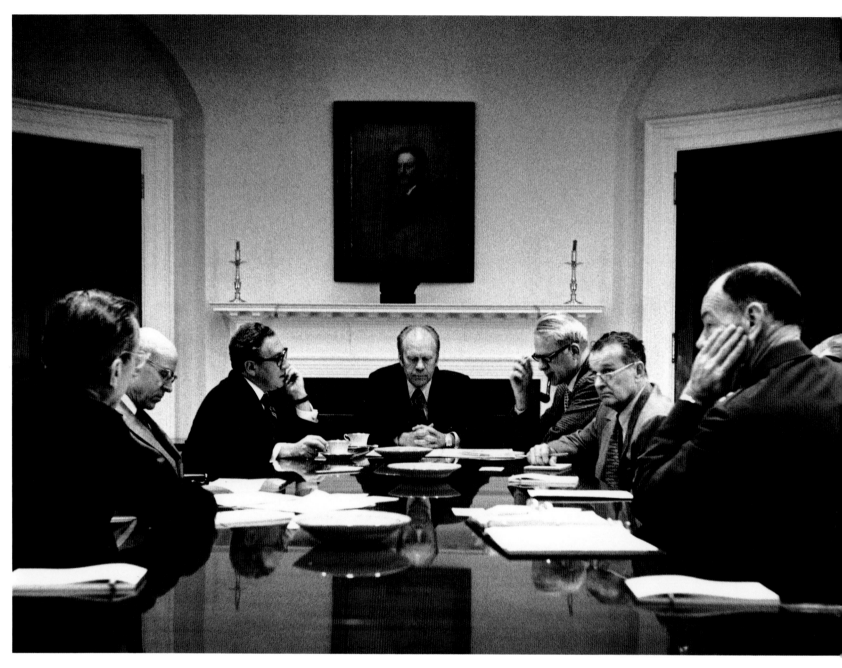

Under a portrait of Theodore Roosevelt, President Ford
meets with the National Security Council to discuss
the final withdrawal of Americans from Vietnam.

Vietnam fell to the communist forces three and a half weeks later. Even though I envied my friends like Dirck Halstead and others who were in Vietnam for the final days, I had the unique opportunity to see it from the "other side," which this time meant behind the closed doors of the National Security Council, where the decisions to pull out of Cambodia and Vietnam were made. The last time anyone photographed a chief executive in such secret and crucial meetings was Okamoto documenting LBJ as he ordered the bombing halted in North Vietnam. It was fitting, then, that Vietnam was once again the main topic and another president was on the hot seat.

The evacuation of Saigon was filled with high drama, not only there but also in the White House. The president monitored the evacuation closely and relayed messages to Ambassador Martin through Kissinger. It was the president who ultimately ordered the plug pulled on Vietnam, thus closing the last chapter on one of the most difficult periods of our nation's history.

After making the decision to withdraw, the president is overcome with emotion, 1975.

While Mrs. Ford watches, the president calls from the White House residence and orders operation "Frequent Wind," which will begin the process of evacuating Americans and thousands of Vietnamese from Vietnam, 1975.

Vietnam radically affected my generation. I don't know of one person in my age group that it didn't touch, usually in a negative way. Three members of my graduating class at West Linn High were killed in Vietnam. Perhaps it was fitting that one who had survived that terrible war was there to record its official end. It was one job, as the photographer of the Class of '65, that I was happy to do.

Less than two weeks after the U.S. withdrawal from Vietnam, Cambodian communists seized the U.S.S. *Mayaguez* in international waters off the coast of Cambodia near the port of Kompong Som. The vessel's thirty-nine crew members were taken prisoner by the Khmer Rouge, and their whereabouts were unknown.

The president called an emergency meeting of the National Security Council, which convened in the Cabinet Room. I was there taking pictures. They debated various options on how to get the crew released. The military presented contingency plans ranging from massive B-52 strikes on Phnom Penh to smaller military operations. Diplomatic initiatives through the Chinese had failed, and there was some doubt that anyone, including the Chinese, knew who was running Cambodia. It appeared that the remaining options involved the exercise of military force. The only question was how much.

The Defense Department's charts showed proposed timetables for B-52s accompanied by fighter jets to darken the skies over Cambodia, dropping bombs that the leaders no doubt thought would bring the Khmer Rouge to their knees. They were still acting on the assumption that someone in Phnom Penh was in control and could make a call that would free the captives. As I listened to the debate, I envisioned the beautiful old French colonial Khmer capital in smoking ruins and American sailors who would remain prisoners. I also saw a president who would be vilified for unnecessarily destroying ancient landmarks to show U.S. military power.

President Ford, in his book *A Time to Heal*, described what happened next.

There was a lull in the discussion. Then, from the back of the room, a new voice spoke up. It was Kennerly, who had been taking pictures of us for the past hour or so. Never before during a meeting of this kind had he entered the conversation; I knew he wouldn't have done so now unless what he had to say was important. "Has anyone considered," he asked, "that this might be the act of a local Cambodian commander who has just taken it into his own hands to halt any ship that comes by? Has anyone stopped to think that he might not have gotten his orders from Phnom Penh? If that's what happened, you know, you can blow the whole place away and it's not going to make any difference [in getting the crew released]. Everyone here has been talking about Cambodia as if it were a traditional government. Like France. We have trouble in France, we just pick up the telephone and call. We know who to talk to. But I was in Cambodia just a few weeks ago, and it's not that kind of government at all. We don't even know who the leadership is. Has anyone considered that?" For several seconds there was silence in the Cabinet room. Everyone seemed stunned that this brash photographer who was not yet thirty years old would have the guts to offer an unsolicited opinion to the President, the Vice President, the Secretaries of State and Defense, the Director of the CIA and the Chairman of the Joint Chiefs of Staff. Yet I wasn't surprised, and I was glad to hear his point of view.

Ford went on to write, "The decision was up to me. Subjectively, I felt what Kennerly had said made a lot of sense. Massive airstrikes would constitute overkill. It would be far better to have Navy jets from *Coral Sea* make surgical strikes against targets in the vicinity of Kompong Som."

And that's what he ordered. Captain Miller of the *Mayaguez* later said that President Ford's actions were what saved him and his crew. I photographed the president in the Oval Office that night jubilantly announcing to his staff that the crew had been released. You could almost see the weight of the crisis lift from his shoulders.

The president later told me that although he was glad I spoke up, I shouldn't make a habit of it. I didn't.

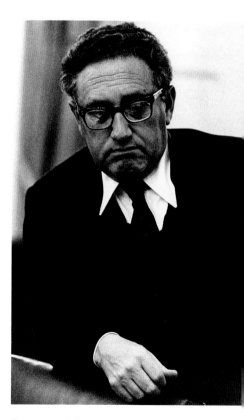

Secretary of State Henry Kissinger during *Mayaguez* crisis, 1975.

CIA Director William Colby with charts showing proposed bombing of Cambodia during the *Mayaguez* situation, 1975.

Right: President Ford orders Secretary of Defense James Schlesinger to commence action against Khmer Rouge soldiers in order to free the captured ship U.S.S *Mayaguez*, 1975. *Below:* Later, with Brent Scowcroft, Robert McFarlane, and Don Rumsfeld, they celebrate news of the release of the *Mayaguez* crew by the Cambodians.

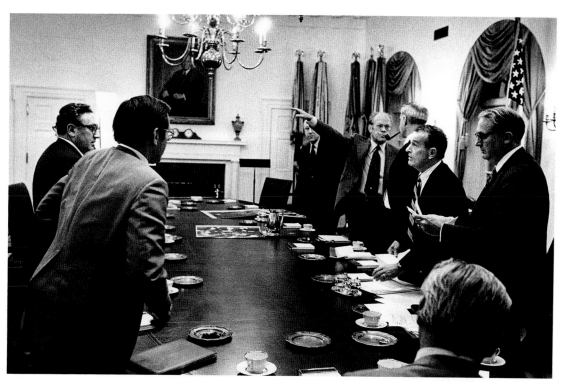

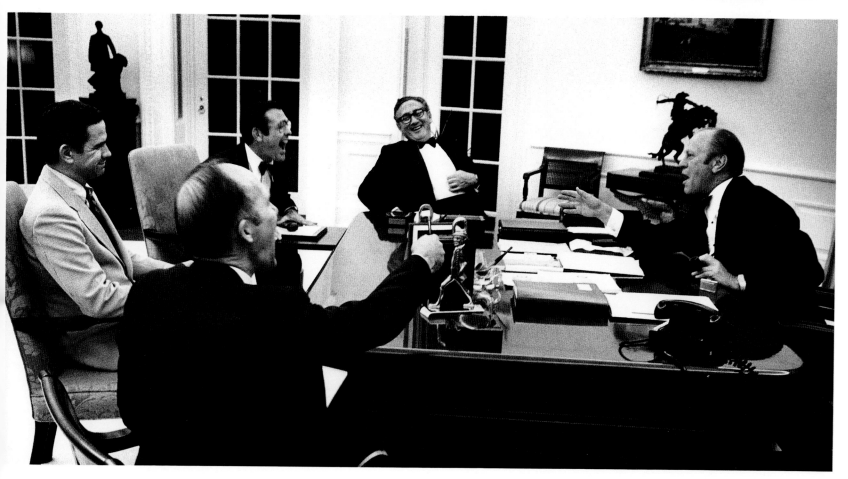

Secretary of State Kissinger invited me along when he left Washington in August 1975 for what turned out to be his last shuttle mission to the Middle East. Kissinger had always fascinated me. He was brilliant and had a quick wit, but he was a fearsome boss. He once said that his way of complimenting his staff was not to criticize them, and there weren't many compliments handed out by Henry the K.

There was a time early in the new administration when Kissinger got into the habit of calling President Ford and threatening to resign because someone on Ford's staff had been leaking uncomplimentary things about him. The president would listen patiently and then talk him out of leaving, and everything would be fine until the next leak. I was sitting with President Ford one evening after such a call, and he openly expressed his frustration. "Why don't you just accept his resignation," I suggested, "then I bet he'll never do it again." The president laughed, and I don't know whether he ever acted on my suggestion, but Kissinger quit quitting soon thereafter.

Kissinger's change of heart was a good thing for me, and probably for the Israelis and Egyptians as well. Traveling with Kissinger on a peace mission was a brutal affair. On a typical day he would arrive in Tel Aviv, board a helicopter for Jerusalem, and meet with Prime Minister Rabin. Afterward, he would take a chopper back to Ben-Gurion Airport, board his jet, and make the short flight to a secret Egyptian air base near Alexandria. From there he would get on another chopper and make a forty-five-minute trip to President Sadat's summer home. After that meeting he would get on the chopper again, fly to the base, get on his jet, and wing his way back to Israel. That's how it went, day in and day out.

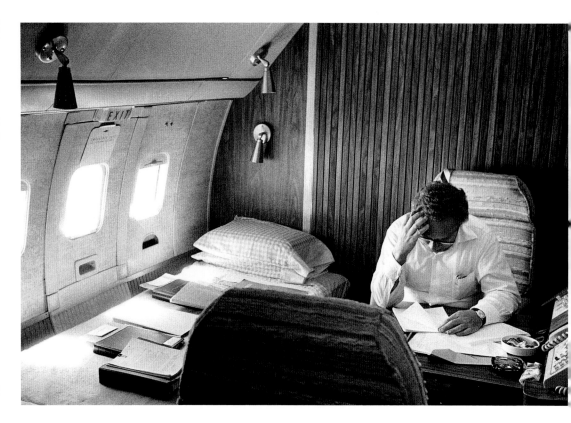

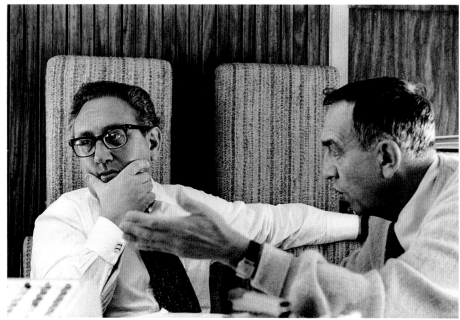

Secretary of State Henry Kissinger in the cabin of his aircraft during his last Mideast shuttle, and with Assistant Secretary of State Joe Sisco, 1975.

Kissinger stands on a huge map of the Sinai desert in the prime minister's office in Jerusalem, 1975.

That routine would be broken only by side trips to Syria, Jordan, and Saudi Arabia to keep their leaders abreast of the talks. This marathon had adverse effects on Kissinger's staff, Secret Service agents, and the press, who occasionally were felled by health problems. Kissinger himself was unaffected by the diseases that plague mere mortals and plowed ahead at full speed.

The sensitive talks didn't match my expectations. Kissinger met with Egyptian Foreign Minister Ismael Fahmy in the seaside city of Alexandria, and the participants were generally pretty casual, wearing shorts and flowered shirts. Fahmy and his top aides would carry on the sensitive negotiations in a small beach house. It wasn't much differ-

ent in Jerusalem. I photographed some of Rabin's and Kissinger's aides as they crawled around the floor on a big map, which was held down on one end by an ashtray, showing the border between Israel and Egypt.

Despite the informality, a formal deal was reached. The second Sinai Disengagement Agreement, which provided for partial Israeli withdrawal in the Sinai, was concluded in Alexandria and Jerusalem. The land that the Israelis had taken in the 1973 Yom Kippur War was finally being given back. I took a shot of Anwar Sadat in profile as he quietly puffed on his pipe and watched the ceremony. That picture became his favorite.

Kissinger meets with Egyptian Foreign Minister Ismael Fahmy and his staff in Alexandria, Egypt, 1975.

Open-air meeting between Henry Kissinger and Anwar Sadat, Alexandria, Egypt, 1975.

Kissinger gets a pat on the head from his wife, Nancy, after successfully concluding his last shuttle mission.

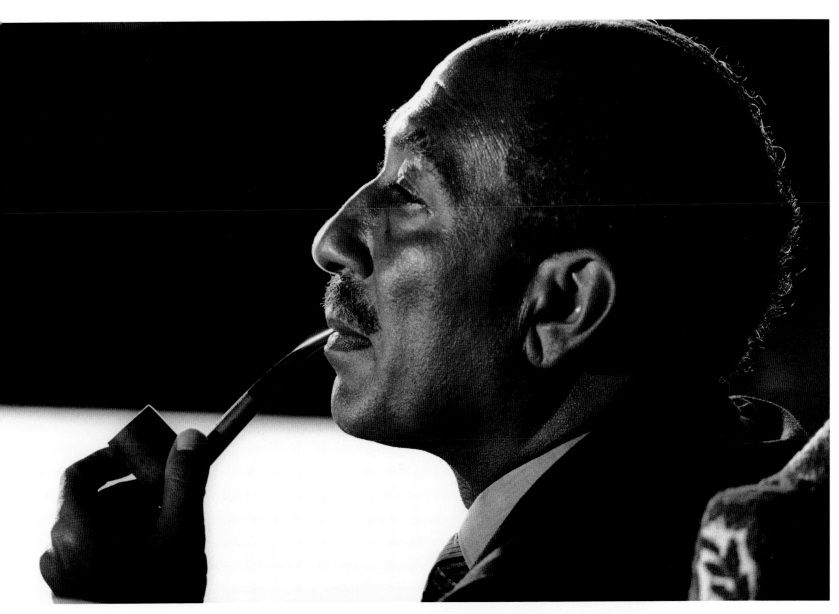

Egyptian President Anwar Sadat at the successful
conclusion of the Sinai II negotiations, which
resulted in land being returned to Egypt, 1975.

After traveling with Kissinger around the world, everything at home seemed pretty tame. It was, however, time to go back to my real job. In the course of a normal day I would arrive at the White House around 6:30 A.M., look through the president's schedule, check off the appointments or events I wanted to shoot, and assign the rest to the other photographers. I'd usually find time to drop in on Mrs. Ford in the residence each afternoon. One time I walked in to find her in her bathrobe on the couch, gazing at the west wing from the big window in the living room. I took a photo without her knowing. I thought she looked like a bird in a big glass cage, which was pretty much the way she felt about the place. She commented later after seeing the picture, "This shows a lonely fishbowl. Me up here and my husband down there in the Oval Office. Two worlds as different as one continent from another." After their first night in the White House, she told her husband, "This is all a nightmare. When we wake up let's be back at our home on Crownview Drive." She asked me what people would think if she just packed up and moved out. I'm not so sure she was kidding. (She did add in a later conversation that there *was* a good side—she was able to spend more time with her husband.)

Mrs. Ford in her "fishbowl," the second floor or family residence of the White House.

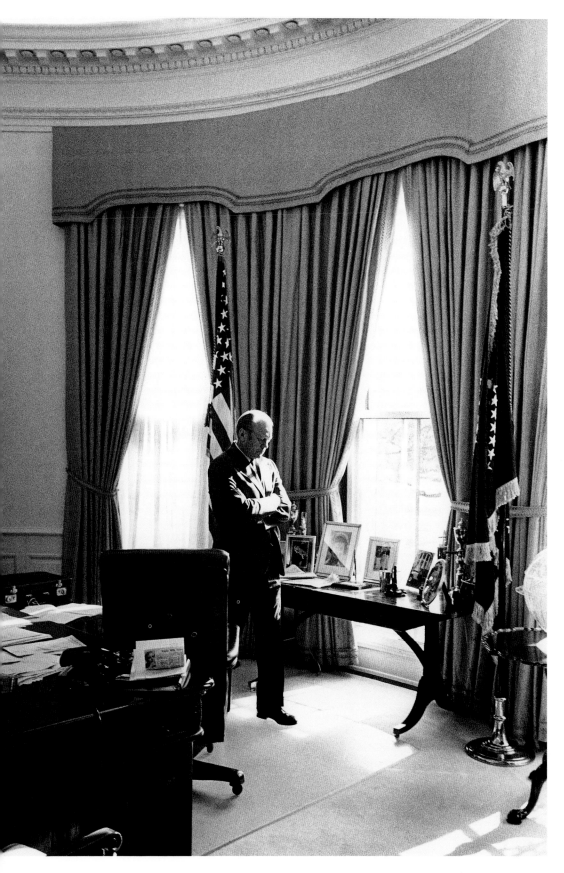

At the beginning of 1975 William Colby, director of the CIA, presented President Ford with a set of highly sensitive papers, which came to be known as "the family jewels." They outlined details of assassination attempts, drug experiments, domestic wiretaps, infiltration of U.S. radical groups, and other illegal activities. I photographed Jack Marsh, one of President Ford's counselors and the man in charge of looking into the problem, as he gave Ford what he called a "cold turkey, bark off" assessment of where things stood with the agency. Later, former CIA chief Richard Helms waited nervously outside the Oval Office for a meeting with the president. What had been billed as a courtesy call ended up being a frank discussion of certain events that transpired while Helms ran "the Company." They talked about the congressional intelligence committees' recent investigations into CIA abuses. Helms defended many of the CIA actions and told the president that Congress hadn't been more involved in overseeing the agency because "members of Congress really don't want to know what goes on in every back alley of Paris." He made a strong defense for people who had been involved in certain activities that before Watergate might have been seen as proper but now were being judged by a new set of standards.

The president was faced with a difficult situation. He had to walk the line between the various congressional committees that wanted to eviscerate the CIA and the people within his own administration who wanted to preserve the status quo. A typical problem occurred when one of the president's lawyers left behind a highly sensitive top-secret document in the office of the congressman chairing the House committee that was investigating the CIA. He did it accidentally, after telling the chairman in no uncertain terms why he wouldn't give him the document. The chairman sent it to the president with a note lambasting the lawyer and criticizing his handling of top-secret material. He also casually mentioned that he had kept a copy of the document. Shortly thereafter the lawyer was reassigned.

The president ponders what to do about the CIA, 1976.

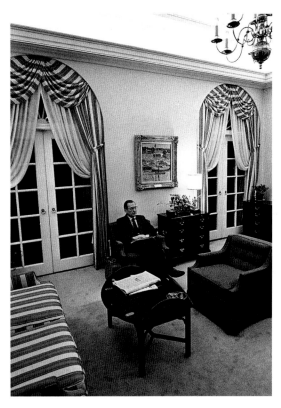

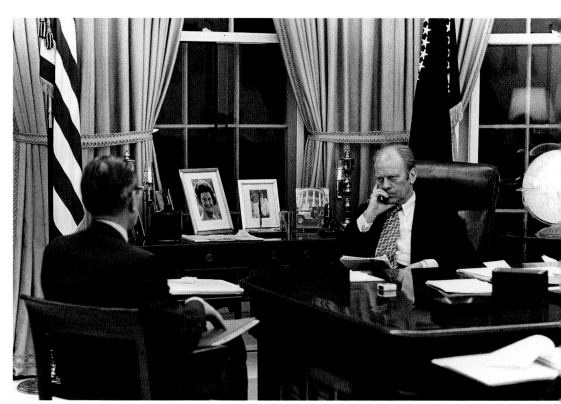

CIA director William Colby waits outside the Oval Office to see the president in order to present the "family jewels," 1975. *Right:* President Ford listens as Colby explains the past abuses of his agency.

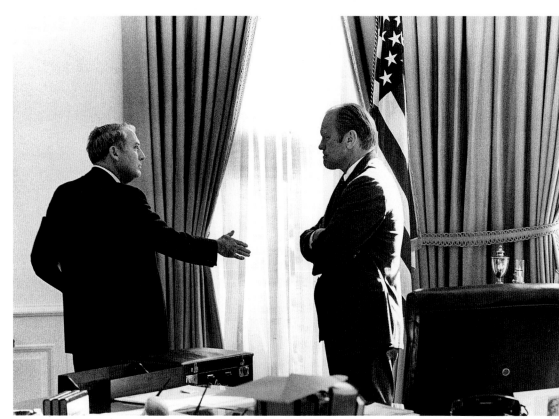

Presidential counselor Jack Marsh and the president discuss the abuses of the CIA, 1975.

A reorganization of the intelligence community was completed in early 1976, despite heavy opposition from Secretary Kissinger and others. In a last-ditch appeal, Kissinger, who also served as National Security Advisor, made an emotional pitch against the change. After he had finished, the president turned to him, thanked him for his views, and told him that the decision was made and that he better deal with that fact.

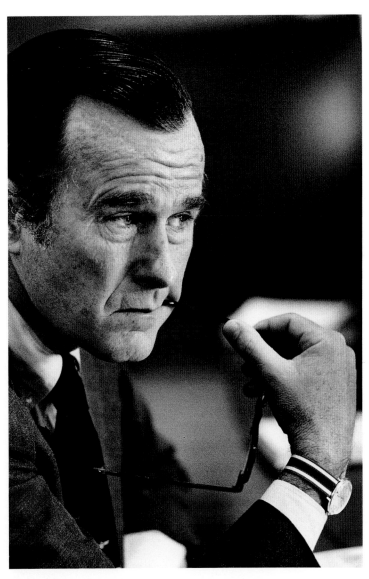

George Bush, appointed to head the CIA, in a Cabinet Room meeting, 1976.

Before the review was complete, President Ford reshuffled his cabinet in what became known as the "Halloween Massacre." He replaced CIA director Colby with George Bush, who gave up his position as ambassador to China, and fired Secretary of Defense James Schlesinger, whom he didn't like anyway, replacing him with Chief of Staff Don Rumsfeld, whom he did. Rumsfeld's deputy, Dick Cheney, replaced Rumsfeld. Kissinger's NSC adviser's hat was given to his deputy, Brent Scowcroft, and Elliot Richardson took over for Rogers Morton at the Commerce Department.

The story of George Bush provides a sidebar to that of the "massacre." The Senate committee that would confirm the new CIA chief had stated that Bush should remove himself from consideration as Ford's running mate in 1976. This was ostensibly to "depoliticize" the embattled agency. During a meeting in the Oval Office, which I photographed, Bush told the president that he really wanted the CIA post, even if it meant possibly not being on the ticket— this despite the blatantly political caveat from the Democrat-run committee. But there were those who saw in this the Machiavellian hand of Rumsfeld pushing Bush into the CIA corner in order that Rumsfeld himself might become Ford's running mate. (A few days earlier Vice President Rockefeller had withdrawn from the ticket, leaving things wide open.)

Bush jumped, but he was not pushed. Ford, in his autobiography, said that Rumsfeld first heard of the new lineup when he told him about the changes and that he had not consulted with his chief of staff about them. Rumsfeld himself told me that he tried to discourage Bush from taking the post under the unfair conditions imposed by the Democrats and that he felt that Ford needed to keep his options open at the convention. Bush chose to run the spy agency. Ford ended up picking Senator Bob Dole, not Rumsfeld, as his running mate later the next year, but he might have been able to win if Bush had been his vice presidential choice.

In the middle of the politicking another crisis erupted in June 1976. The U.S. ambassador to Lebanon was murdered, prompting Ford to order the evacuation of 263 Americans who were living there. I was in the Cabinet Room taking pictures as Ford, CIA chief Bush, and other members of the NSC monitored the evacuation. From that time on Lebanon was torn apart by a civil war that resulted in thousands of people killed and dozens of Americans taken hostage.

The campaign for the nomination of the Republican party would have been a cinch had it not been for Ronald Reagan's entry into the fray. Ford finally came out on top, but it was a close race, and he thought Reagan's actions had been divisive and had hurt his chances. Working behind the scenes at Reagan's hotel the night that Ford won the nomination in Kansas City, I took a picture of a grim-faced Ford walking down the steps as he headed for a press conference with Reagan, who followed close behind him. The deal was that the winner would go to the loser's hotel and make peace. Then they would go out together and smile for the cameras. I've always been fascinated by the difference between what really happened and what you thought went on. This case made the point.

Even though Ford was selected by his party to head their ticket, he fell short with the American people when it came time to choose between him and Jimmy Carter. Despite Nixon's pardon and other negative factors, he came close to winning the presidency in his own right, losing the election by fewer than 700,000 votes out of 80 million cast.

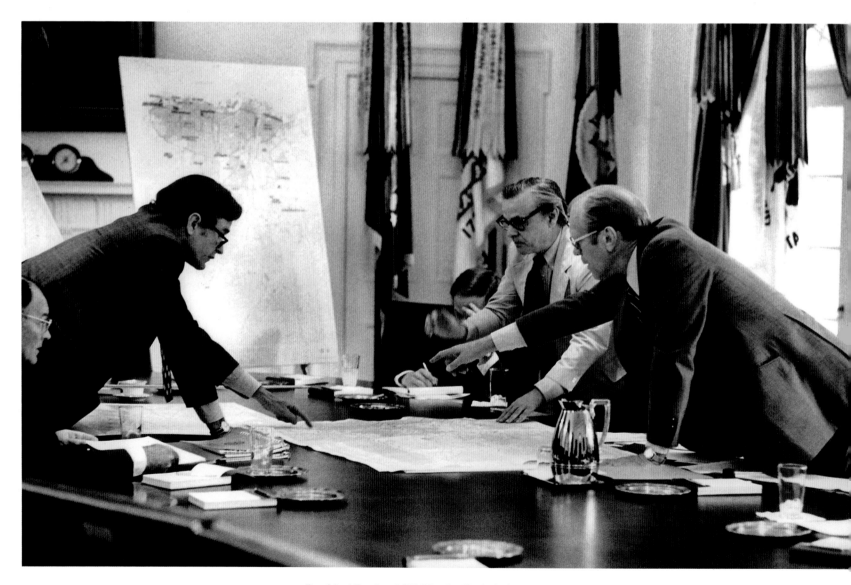

President Ford and CIA Director Bush during a National Security Council meeting discussing the evacuation of American citizens from Beirut, 1976.

President Ford and Ronald Reagan on the way to a press conference after the president beat Reagan for the Republican nomination in Kansas City, 1976.

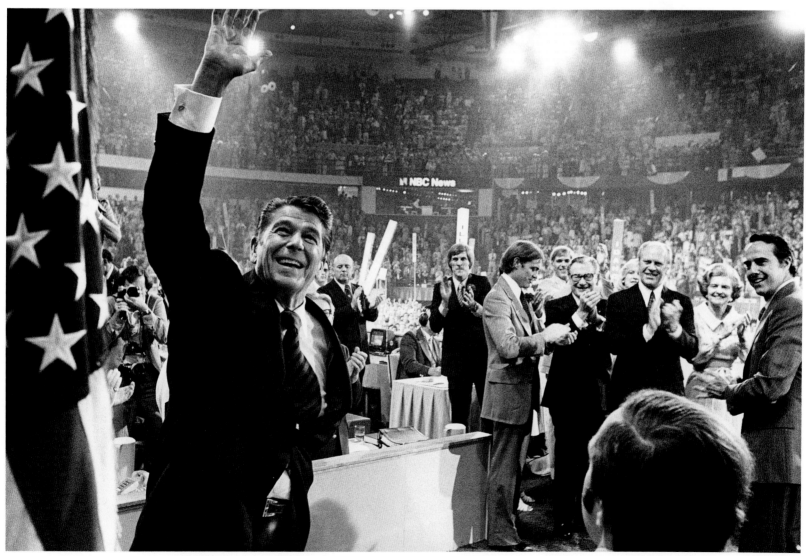

A smiling Reagan is introduced to the convention, 1976.

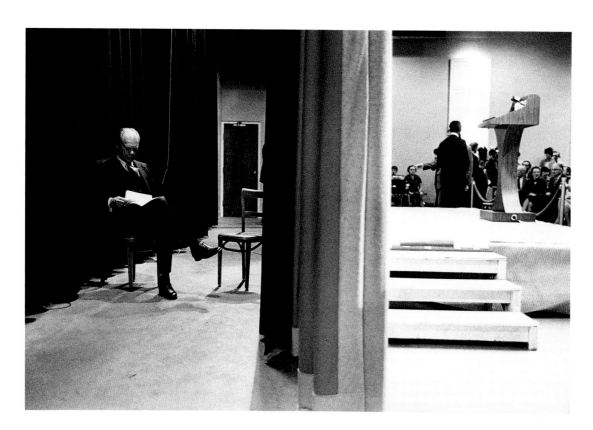

The presidential campaign, 1976.

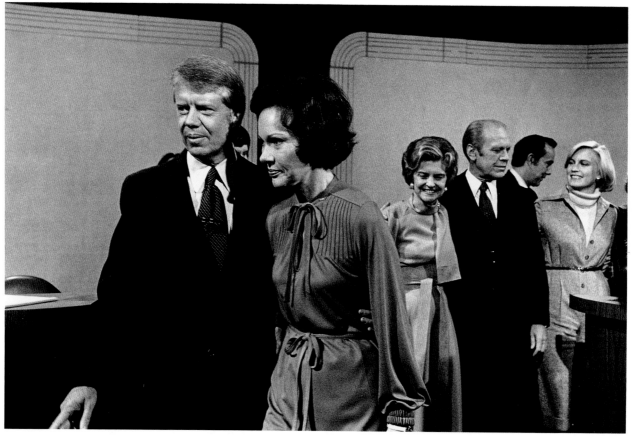

It's hard to be with a friend who suffers such a big loss, but as the photographer and as a historian, I kept on taking pictures. My photos tracked the night's events and then showed the anguish that his family went through the next morning in the Oval Office before Ford publicly conceded the election.

After making the announcement, the president, Terry O'Donnell, and I walked back into the oval room. Terry had been Ford's close personal assistant from the day he had entered office. As Terry and I turned to leave, the president put his arm around Terry's shoulder and thanked him for his service over the previous two years. He then said, "If there's anything I can do for you once we leave here, just let me know." I suppose most men my age were brought up not to show their feelings, but at that moment my early training flew out the window. Tears sprang from my eyes, and I kept my camera in front of my face to hide them. Terry cried, too. We turned into a couple of simple Middle American kids overcome by emotion. Of all the staff, the two of us had probably spent more time with President Ford than anyone else. The fact that he was more concerned about Terry's well-being than about his own was why we loved working for the guy.

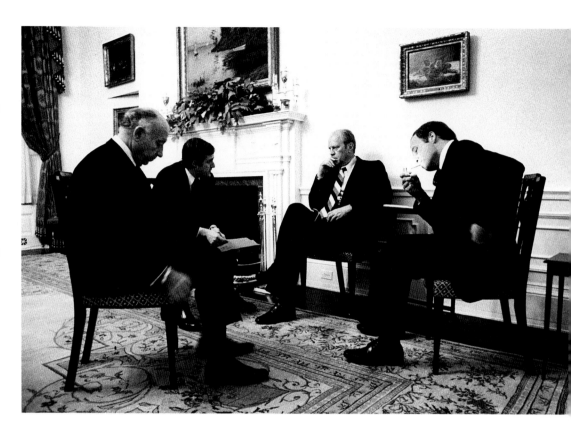

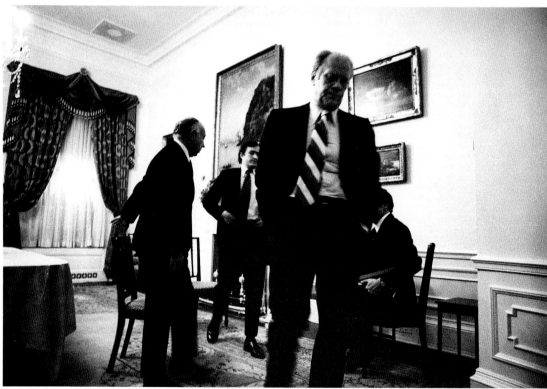

This page: President Ford with his aides late on election night as he hears New York state going to Jimmy Carter. The president leaves to go to bed, his chances of beating Carter all but over.

Opposite page: President Ford with his family in the Oval Office, and consoling his aide Terry O'Donnell, after losing the election.

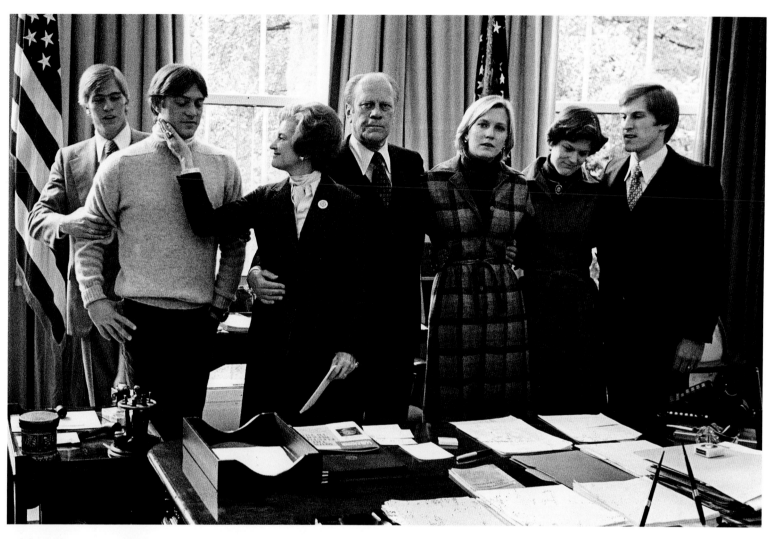

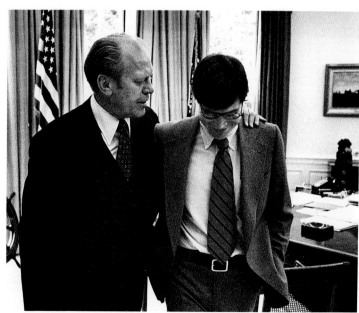

When Jimmy Carter visited the White House a few weeks after winning the election, he was graciously received by President Ford, who showed him around the Oval Office. The two of them sat in the chairs next to the fireplace, and Jerry Ford stuck out his hand and congratulated the president-elect on winning. I shot that moment across the wide expanse of the desk in the foreground. There were the two figures behind it—the president who was and the one who would be—dwarfed by the immensity of the office.

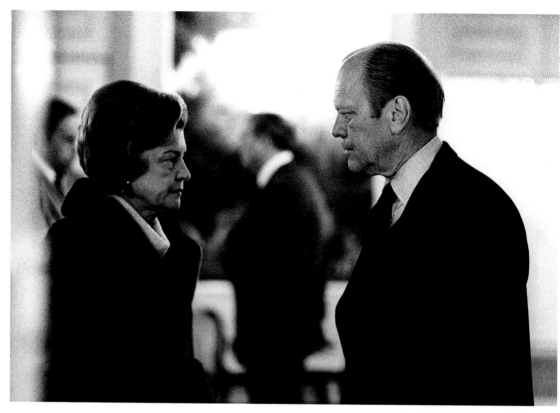

The Fords wait in the White House Diplomatic Reception Room for the first visit of President-elect and Mrs. Carter.

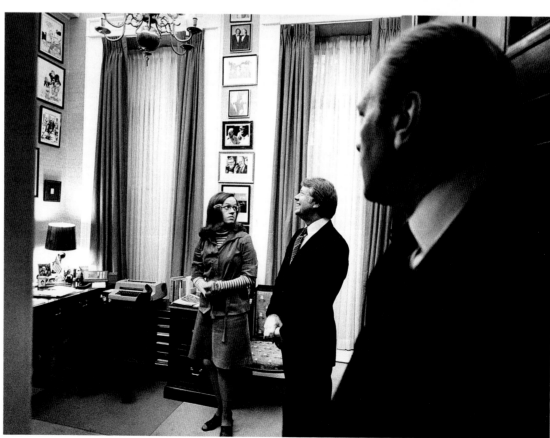

The president's private secretary, Dorothy Downton, sizes up the man who beat her boss as the president looks on.

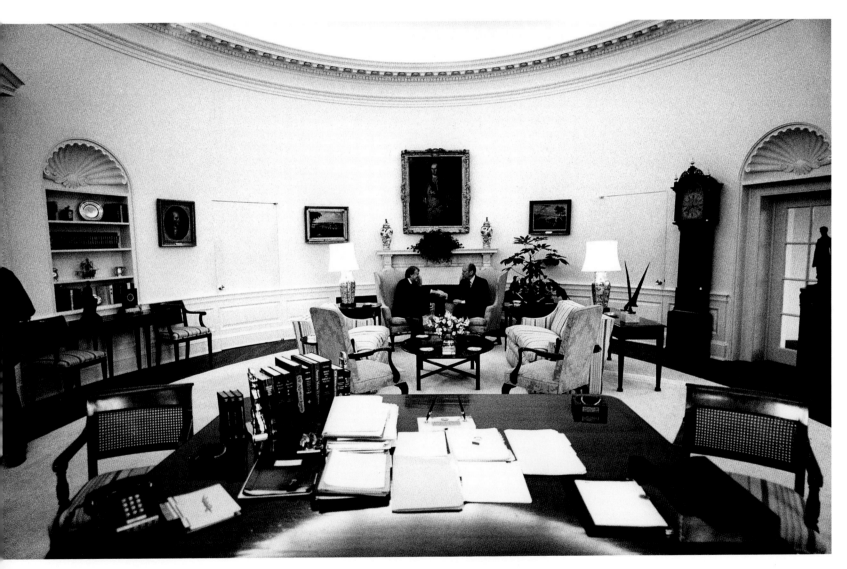

President Ford congratulates Jimmy Carter, 1976.

So I was going to be out of a job. It had been a great ride though, and I couldn't have asked for more. The president had lived up to his agreement. During my tenure as the White House shooter there were only two times when the president asked me not to take a picture, and they were both occasions that would have proved embarrassing to the participants. Otherwise, he had given me total access to everything that happened behind closed doors, and I had given him my best in making sure I got it all on film.

My final correspondence with the president was dated Jan. 14, 1977. It read:

Dear Mr. President,

Effective January 20, 1977, at twelve noon, I hearby resign my position at the White House.
It's been real!

Sincerely, David Hume Kennerly

And it was.

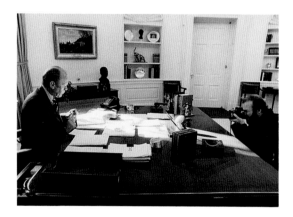

David Burnett took this picture of me photographing President Ford, 1975.

On January 19, the day before we exited the White House, Mrs. Ford and I took a stroll through the corridors of power. She poked her head into one office after another to say farewell. As we walked, we talked about the various things we had accomplished and all the things that we hadn't. On the way back to the residence, we stopped by the empty Cabinet Room. Betty Ford stood there for a moment looking around that historic chamber where so many important decisions had been made over the years. She turned to me and said, "You know, I've always wanted to dance on the Cabinet Room table."

"Why don't you?" I said glancing back over my shoulder like a thief in the night. "Nobody's looking." With a mischievous twinkle in her eye, she removed her shoes, stepped on the president's chair, and leaped up on the huge surfboard-shaped table. With the portrait of Harry Truman looking on, she posed for a moment under one of the chandeliers and then did a delicate little pirouette, her days as a dancer showing. She then stepped down, made a cleansing motion with her hands, and said, "I think that about wraps it up." Truman was the one president who would have appreciated that.

Betty Ford dances on the Cabinet Room table, 1977.

Leaving the White House is like walking away from a heroin habit. It ain't that easy. Even though I knew it was coming, nothing really prepared me for the cold reality of just being David Kennerly again. One of the many perks of being a key member of the president's team was having a phone in my house that would be answered by a military operator when I picked it up. At 12:01 P.M. on January 20 it went dead. I also don't recall ever having a call not returned during my brief reign (unless, of course, it was to one of my fellow shooters, who were less impressed than most with my lofty position). I missed Air Force One, never having to check my baggage, the motorcades that didn't stop at red lights, Camp David, free matches with presidential seals, and simply being there with the people who made history. But most of all I missed the pictures. For a couple of months I experienced a culture shock that rivaled my first trip home from Vietnam. The difference was that I couldn't go back to the White House. It was 1977, and I was twenty-nine years old. I felt like I'd just been ejected from Mr. Toad's wild ride and was still sailing through the air.

Press Secretary Jody Powell pokes his head into President Carter's office, 1977.

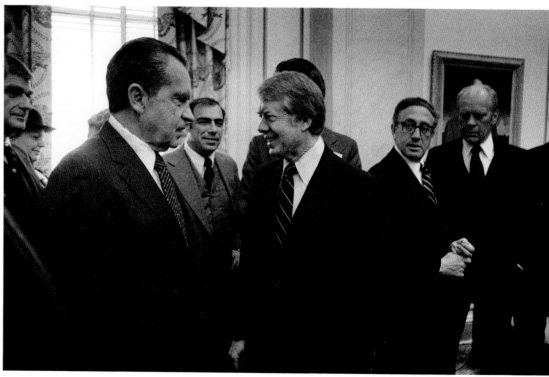

Former President Ford and Henry Kissinger watch President Carter and former President Nixon before a memorial service for Hubert Humphrey at the U.S. Capitol, 1977. This was Richard Nixon's first public appearance since resigning.

President Carter in his private office at the
White House, 1977.

That same year I turned thirty, and according to my own generation, I could no longer be trusted. It was also the year that Elvis, Charlie Chaplin, Groucho Marx, and Bing Crosby died. The movies *Saturday Night Fever*, *Star Wars*, and *Annie Hall* came out; *Roots* aired on ABC; and New York police arrested David Berkowitz, the "Son of Sam" murderer, who claimed that his neighbor's dog ordered him to kill.

John Durniak, *Time*'s picture editor and my old boss, got me back into the photographic mainstream. While I was moping around trying to decide what to do with my life he called me up, told me to get myself in gear, and sent me to Havana. The spell was broken, but it took the combination of Durniak and Fidel Castro to do it. There was an ironic twist to my first major assignment on leaving the White House. I was heading into the lair of a leading communist, one whom my old boss President Ford had labeled "an international outlaw." Castro may have been considered an outlaw by some, but he was an excellent, animated subject for my camera. If I could have bottled the essence of his personality I could have sold it to politicians back in the States and made a fortune. It was great to be back in the game.

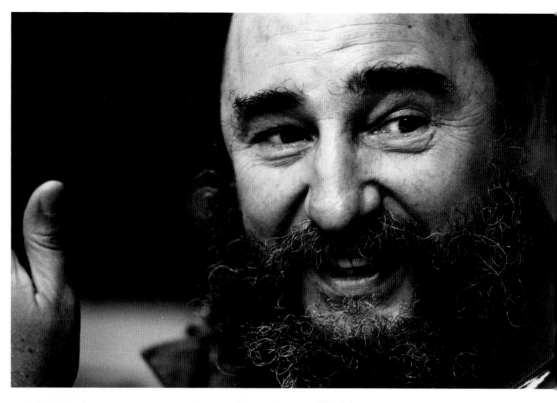

Fidel Castro, Havana, 1977.

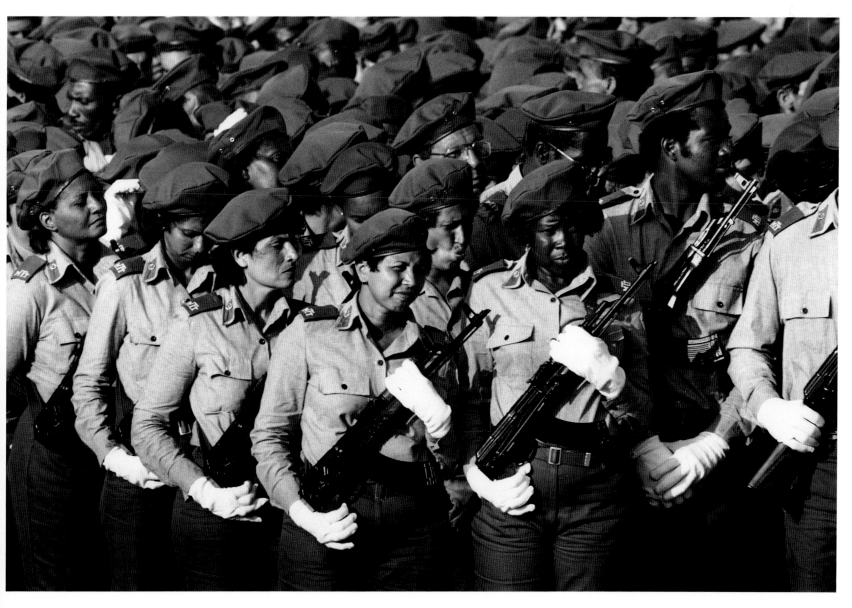

I returned to Cuba several times over the next few
years. Women in the Cuban militia, Havana, 1980.

After my successful venture in Cuba, Durniak sent me to the Middle East to do detailed photographic profiles of the leaders of Jordan, Egypt, Saudi Arabia, Syria, Lebanon, Oman, and Israel. I spent months in the area, revisiting many of the places I had gone to with Kissinger. My contacts from those days paid off: I was granted incredible access by most of the top people and even made my way into a rare picture opportunity with King Khalid of Saudi Arabia as he received his subjects petitioning him for various favors.

It was in the Middle East that I discovered the meaning of the Arabic word *bukhara*, which literally translated means "tomorrow." One evening at an embassy reception an Arab and a South American diplomat were arguing about which language is superior for politely putting off an appointment, Arabic or Spanish. The Spanish-speaking envoy said, "In my language we have a word called *mañana*, which may mean tomorrow, or it may mean never."

The Middle Eastern statesman just smiled, shook his head, and replied, "In Arabic we also have such a word, and it's *bukhara*, but it doesn't convey the same sense of urgency . . ."

I discovered the meaning of patience in that land of *bukhara*. A photographer can't work effectively without patience, particularly in that part of the world. I am not by nature a patient person, and I spent many frustrating weeks biding my time in various Middle Easten capitals, waiting for the summons that would take me to their leader. Sometimes the call came, sometimes it didn't. After a while I learned to live with the wait, and I actually became more effective after I calmed down.

One place where I couldn't calm down was Iraq. I was sent there to do a story in 1979, long before the United States ever had a problem with it. Even then I was thwarted by their bureaucrats from doing most of what my editors wanted. The bureaucrats had assigned "minders" to help me out, but they were much more interested in preventing me from taking pictures than in helping me to get what I needed. It was practically impossible to get away from the minders, who accompanied me everywhere I went. On one of my forays into the countryside I had noticed a huge nuclear facility under construction. Rather than let on that I had even seen it, much less try to photograph it, I noted its location, which was about twelve miles outside Baghdad. The next day I told my diligent followers that I wanted to

quit early and stay in the hotel. They left, and so did I—out a back door. I hired a taxi driver who spoke a little English, told him I wanted to go outside of town to shoot pictures of people working in the fields, then guided him back toward the reactor site. I shot a few clandestine snaps and then hightailed it back to Baghdad, where I sneaked into the hotel unnoticed. One of those pictures, although not that great, turned out to be one of the most published images I've ever made, including being run on the cover of *Time*. Two years later the Israelis, in a preemptive air strike to prevent the Iraqis from producing plutonium, destroyed the Osirak nuclear reactor before it went into operation. I had the only "before" picture, and there wasn't an "after."

Iraqi nuclear facility outside of Baghdad, which was later destroyed by Israeli jets, 1979.

The Sultan of Oman in his office, Muscat, 1979.
Above right: Syrian President Hafez Assad at a mosque in Damascus, 1978.

Prime Minister Menachem Begin walks from the Knesset in Jerusalem, 1977.

King Khalid
of Saudi Arabia
greets petitioners,
Riyadh, 1978.

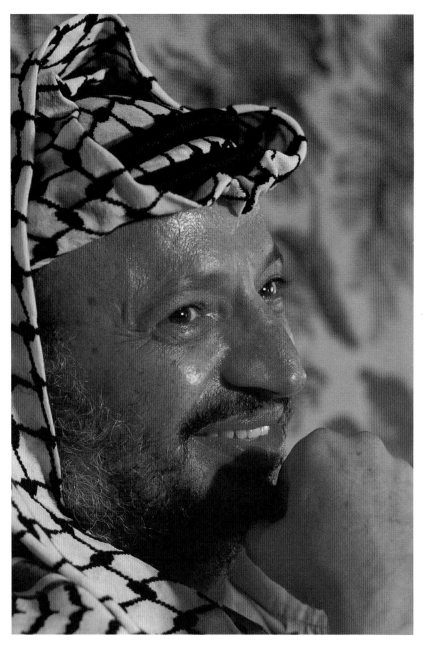

PLO leader Yasser Arafat, Alexandria, Egypt, 1977.

Syrian President
Hafez Assad in a
rare look inside the
Syrian Parliament,
Damascus, 1977.

King Hussein is greeted by his daughter Iman after he landed his helicopter in Amman, 1984.

King Hussein and Queen Noor, Amman, 1979.

One of the biggest stories I ever covered was Sadat's trip to Israel. I had spent weeks with him earlier on the *Time* assignment and got to know him fairly well. He even let me sit outside the door during some crucial discussions with Yasir Arafat, who was mediating a border dispute between Sadat and Moammar Khadafi. I'm sure it would have been interesting if I had understood Arabic, because I heard the conversation easily, especially when Sadat raised his voice in anger, which he did frequently. But I was there to take pictures, not to report what people were saying to one another. In fact, even if I had known what they were discussing, I wouldn't have repeated it to anyone. News photographers depend on access for stories; we stay in business by not betraying that trust.

Anwar Sadat was the first Arab head of state to visit Israel, and I managed to snag a ride with his press delegation at the last minute and fly to Tel Aviv on their plane. Unfortunately for me I had no Israeli accreditation, and Sadat's historic mission was taking place, in the words of an Israeli official, "under the biggest security tent ever put over a state visit." Not a good sign for me, and even if I showed up with the Egyptians, it didn't mean I was going to be able to shoot the main event—or even any of the minor ones, for that matter—without the appropriate press pass. I was sitting in one of my old haunts in Jerusalem, a place called the Goliath Bar, which is right across the street from the King David Hotel, where Sadat and his party were staying (the Goliath bills itself as being "just a stone's throw from the King David"). As I watched the motorcades go back and forth, I hit on a scheme that I thought might get me through the hotel's door. The paper coasters used at the Goliath Bar were the same color as the Israeli press passes. I took one of my passport pictures, pasted it on the corner of the coaster, and stuck it in my pocket. I had managed with less in other situations. Two Israeli photographer friends, Moshe Milner and Alon Reininger, provided the other part of the equation. They got me on the bus that passed through the outer security perimeter, but after that I was on my own. If my ruse didn't work, not only was I going

David Burnett photographed me taking Anwar Sadat's picture in front of the pyramids, Giza, 1978.

to miss the last event of Sadat's trip, but I was probably going to get thrown in jail. I watched nervously as the guards at the door checked each member of the press, and after about half of them went through I lowered my head, flashed my fake pass, and walked by the guards. I was expecting to be stopped at any moment, but nobody said a word. I was in.

The occasion was a farewell dinner that concluded Sadat's two-day journey to Israel. There were Sadat and Moshe Dayan, who had fought against each other as younger men, sitting side by side at a dinner in Jerusalem. There was Menachem Begin, the prime minister of Israel and a former fighter for his country, toasting his former archenemy, the president of Egypt. And there I was, shooting this historic event close up. I wouldn't have sold my seat for a million bucks.

The following day, his short "sacred mission" over, Sadat flew back to Cairo, and I went along at his invitation. I took a picture of him as he looked out his window. Outside, just a hundred feet from his plane's wing tip, were two Israeli fighters escorting him to Egyptian airspace. Sadat told me that if that had ever happened before, he would have been in deep trouble.

Time named Sadat its Man of the Year for his accomplishment and asked me to do a special photo of him for the issue. I envisioned a bigger-than-life location for this magnificent man and suggested to him that he pose in front of the pyramids at Giza. He

was reluctant but became convinced when I told him that the picture would show him as a modern pharaoh against the backdrop of his country's heritage. He thought about that a moment, his eyes twinkling, and agreed. I didn't specify a time, but he took care of that minor detail in short order. "Tomorrow I will go," he boomed.

His willingness to do the photos began a great adventure for me. One difficulty was that the first official meeting of the Egyptians and Israelis was also taking place the next day. That wouldn't have been a problem except that they were gathering at the historic Mena House, which is just downhill from where I wanted to take the picture—they and a few hundred members of the press. Sadat had been unavailable to the media prior to the conference, and everyone wanted his picture and comments. He was going to arrive by helicopter and land practically in their backyard. What I didn't need was a bunch of rival photogs trying to poach my picture, so I devised a ruse that would keep them in the hotel. I told several newsies individually, and in strict confidence, about a rumor that Sadat was going to attend the opening of the joint talks, and anyone not inside would miss him altogether. "In strict confidence" among that group meant that you tell only five of your closest friends, and in no time at all word got around to everyone—unofficially, off the record, and effectively.

The next day went like clockwork. Sadat arrived as planned and walked out on the desert sands just in front of the guest house that had been built for him and other visiting dignitaries. Sadat had posed at that exact spot in 1974 with President Nixon.

The view was breathtaking under a royal blue sky, a real Kodak moment. I used a 20 mm lens and a polarizing filter to make the shot. I had the Egyptian president face the sun in profile as I clicked away. He looked elegant and in command, very much like the pharaoh I had envisioned. My exclusive picture ran across two pages in *Time* as the lead illustration of the Man of the Year story. It was a good snap.

Anwar Sadat on the outskirts of Cairo, 1977.

Anwar Sadat and Menachem Begin at the
King David Hotel in Jerusalem, November 1977.

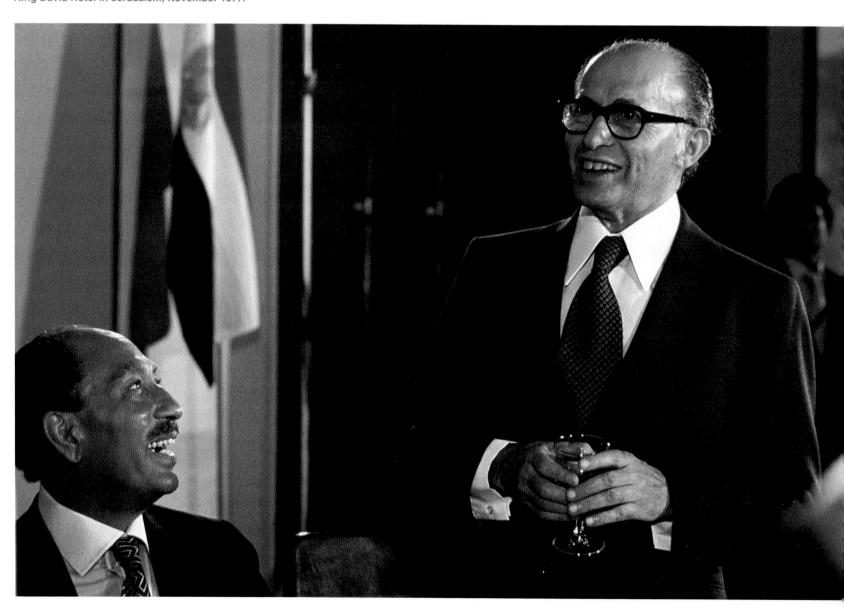

A year later I was at Camp David as a member of the press corps covering the meetings with President Carter, Prime Minister Begin, and President Sadat. This summit led to an unprecedented peace agreement between the two countries. The last time I'd been to Camp David I'd been very much on the inside, and in fact I used to stay in the cabin that Sadat now occupied. This time, however, I was outside with the rest of the press. Ironically, the public pictures turned out to be more emotional and dramatic than those behind the scenes. The best example of that was in the East Room

of the White House when Begin and Sadat grabbed each other's hands, watched by a smiling Jimmy Carter. Sadat ultimately paid for this peace treaty with his life: he was gunned down Oct. 6, 1981, by Islamic extremists while watching a parade of troops in Egypt's capital. I covered Sadat for the last time as the casket bearing the fallen leader was carried from a mosque in Cairo. His bold and brave step onto Israeli soil led to many positive developments, including the meeting between Chairman Yasir Arafat of the PLO and Israeli Prime Minister Yitzak Rabin in Washington, D.C., in 1993.

Below: President Sadat, President Carter, and Prime Minister Begin in the East Room of the White House after the historic Camp David meeting, September 18, 1978.

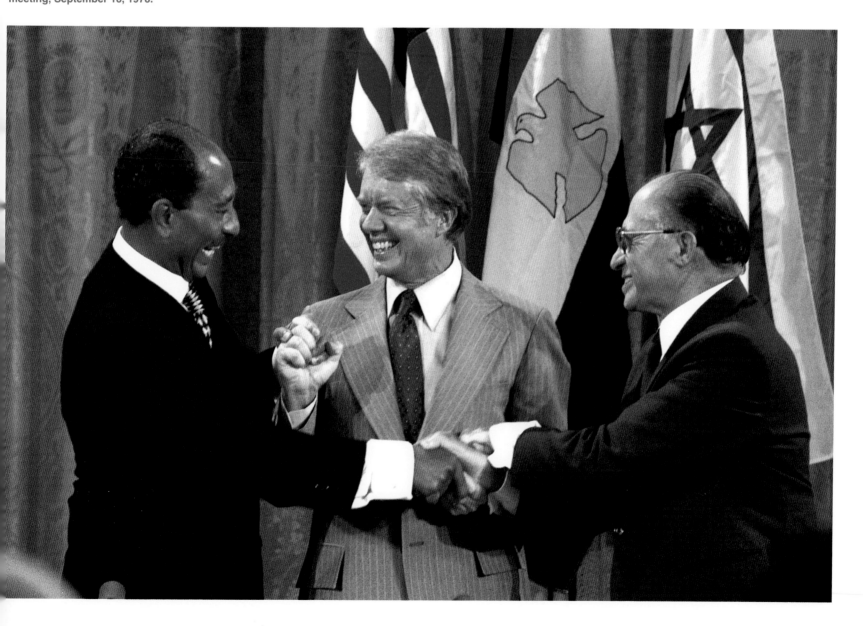

Arnold Drapkin, *Time*'s new photo editor, liked to keep me on the road as much as his predecessor Durniak did. He called me up one day and said he thought I needed a respite from all the difficult assignments I'd been handed. "That's great!" I said, visions of the South Pacific dancing in my head. "Where do you want me to go, Bali? Bangkok?"

"You're close," he said. "Where I want you to go starts with a 'B' . . . Belfast." The guy was a real card.

Funny or not, Drapkin got his way, and I went. I hadn't been in Northern Ireland more than three hours when I ended up at the site of a killing. The dead man was Hugh McConnell, an officer with the Royal Ulster Constabulary. He and his partner had been shot in an IRA ambush. The men who shot them had hidden in a thicket waiting for them to drive by. They must have waited a while, because there were some sandwich wrappers along with the thirty or so shell casings from the automatic weapon they had used. By the time I arrived, however, all that was left at the scene was a chalk outline where the body had fallen. McConnell's partner was never found, but the IRA announced that they had kidnapped him and killed him as well.

I went to the funeral and took a picture of his casket, draped with the Union Jack, as it was taken from his modest home. His wife, the mother of his two young children, sobbed in the background. A police band playing a dirge walked in front of the hearse that carried the slain man as several thousand people followed.

Elizabeth McConnell, wife of policeman Hugh McConnell, who was killed by IRA gunmen at his funeral procession, Besbrook, Northern Ireland, 1978.

There was a war going on in Northern Ireland, no less a war than any of the others I had covered. To prove the point I went over to the other side, to that of the IRA. They were having their own funeral. Theirs was for three IRA men who had been killed by British troops as they tried to blow up a post office. Their coffins were draped not with the Union Jack but with the flag of the Irish Republic. A lone bagpiper played as the three coffins were carried through the streets accompanied by young men and women wearing black jackets, berets, and dark glasses. Just before the procession reached the graveyard a volley of shots was fired by pistols raised in the air by the mourners. I had just witnessed a military funeral of the Irish Republican Army. I asked someone whether I could photograph the salute, but he warned me against it. "Something bad might happen to your cameras—or worse," he said. I believed him.

Irish Republican Army funeral in Belfast, 1978.

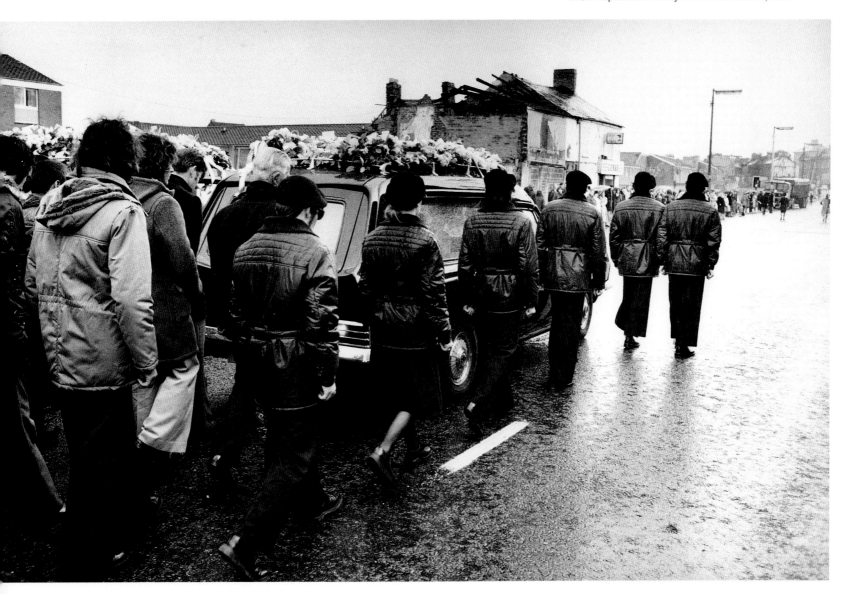

I would have traded ten bad experiences with the IRA, however, for the one day I spent in Jonestown. Nothing could have prepared any rational mind for the evil that took place in that remote jungle in Guyana. Before going there, we were briefed by officials in Georgetown, the capital of Guyana. They knew only that U.S. Congressman Leo Ryan and some newsmen had been killed by Jim Jones's followers, and it was rumored that dozens in his cult had committed suicide afterward. That was about all we knew.

I flew to the site with *Time* correspondent Don Neff and NBC reporter Fred Francis. When I first saw that insignificant clearing in the lush vegetation, I thought that the rumors of mass suicide had been exaggerated. "Look," I said to my companions, "there are dozens of people gathered around that building down there." Sure enough, it looked like a crowd of folks wearing brightly colored garments had congregated around a tin-roofed pavilion in the center of a small village. As our plane dipped closer to the ground, however, and I saw the reality, I got a cold feeling in the pit of my stomach. Those people gathered round that structure were all dead, and there were hundreds of them.

I wish that were all I had seen, because after the plane landed I had to walk through the death tableau to do my duty as a photographer. I stepped over the bodies of men, women, and children who either were murdered or had committed suicide—917, all told. The most deeply disturbing statistic was that 280 of them were children, and I'm sure that they didn't take their own lives.

I was on autopilot; it was the only way I could keep taking pictures as I made my way through the field of bodies. They were everywhere, in the buildings, under chairs, and on the walkways. Most of them were concentrated in and around the pavilion where Jones had sat on his throne and ordered them to die. I tied a handkerchief over my nose and mouth to try to ward off the stench.

And then I spotted Jones himself, a bullet through his head and his chest crudely sewn shut after having been autopsied by the Guyanese authorities. His body had started to bloat. Not too far away, maybe twenty feet, was a big vat filled with a deadly purple brew. It had been laced with cyanide and apparently was what many of Jones's followers drank to follow him to the grave. My photo of that liquid-filled tub in the foreground and the bodies in the background ran on the cover of *Time*.

Through most of my life I've been able to make sense of the things I have seen and photographed. Not this time. I don't think that being in Jonestown gave me any insight at all into what happened on that dark day in that little corner of hell.

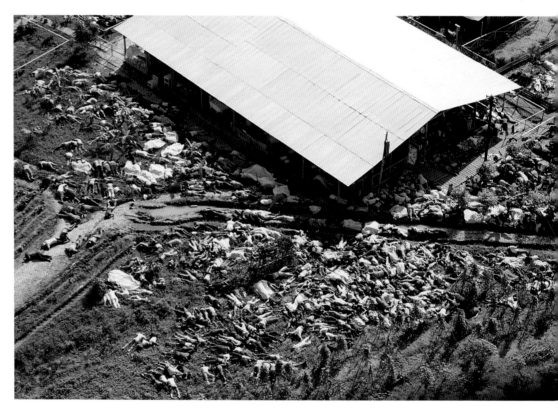

Aerial view of some of the 913 bodies at Jonestown, Guyana, 1978.

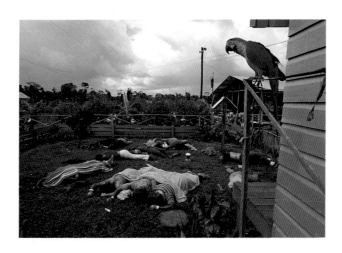

A survivor of Jonestown, 1978.

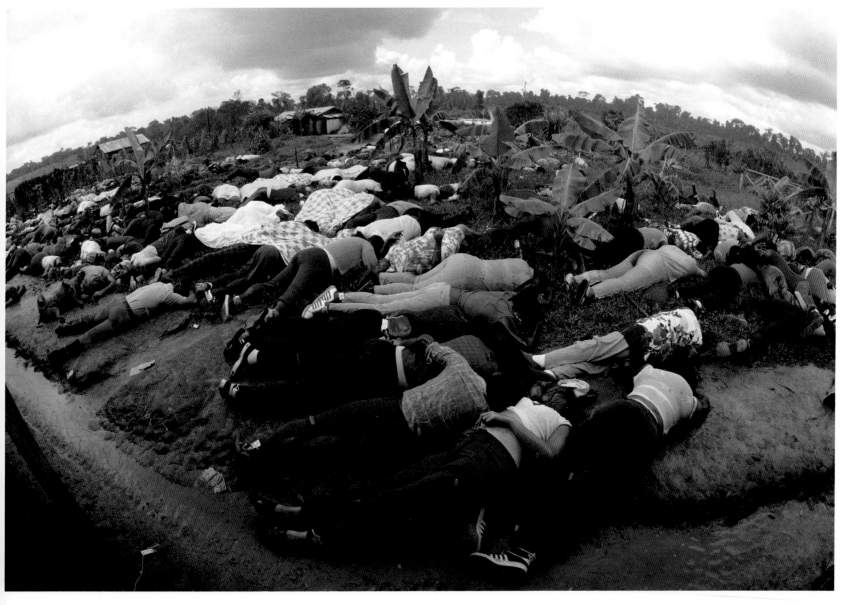

In 1979 I saw another person who was responsible for mass deaths. He was Khieu Samphan, who shared the leadership of the Khmer Rouge with Pol Pot and was responsible for millions of Cambodians being killed and tortured during his brief and violent reign.

I photographed him as he walked out of a Cambodian jungle to meet me and *Time* correspondent Marsh Clark. The Khmer Rouge leader was accompanied by several dozen heavily armed soldiers. Marsh and I had worked together in Vietnam, and he was a tough reporter. The first question he asked of Khieu Samphan was about our colleagues in the press who had been captured by his forces during the war. Marsh focused on two men in particular, Sean Flynn, Errol's son, who had been on an assignment for *Time*, and his partner Dana Stone. They had been taken prisoner by the KR as they rode into the enemy lines on motorbikes. It had been a one-way trip. Khieu Samphan, even when pressed, said he knew nothing about them. It was hard for me to sit across from this man and not conjure up the kind of images that were later portrayed in the movie *The Killing Fields*. Blood was on his hands, but there was no way for me to show that.

From the frying pan of Cambodia I jumped into the fire of El Salvador. Drapkin told me that if I wanted to stay in a warm climate, then I should try Central America. It turned out to be another detour to disaster. I went with the army on a door-to-door raid in one of the poorest parts of San Salvador and discovered that war fought in Spanish is just as dangerous as one fought in any other language. Underscoring that point was Olivier Rebott, a fine young photographer who was shot and killed while covering the action. I couldn't escape the feeling that the same thing could happen to me if I hung around there for too long, and I was happy to get out after completing my assignment.

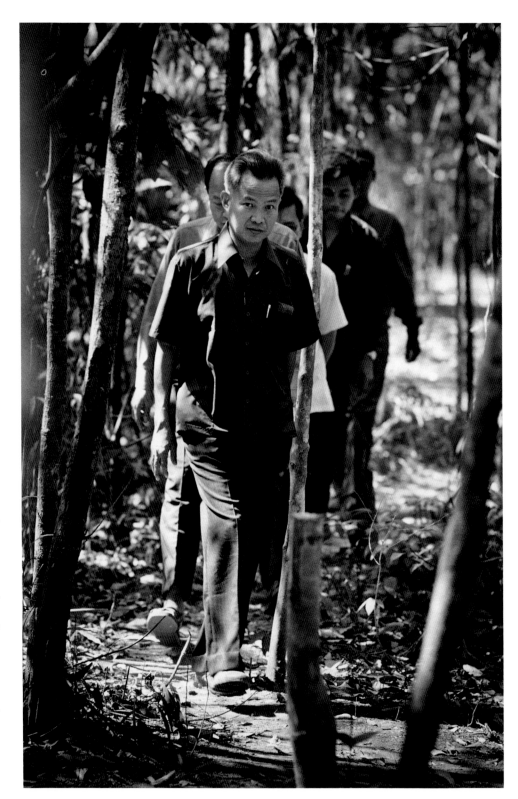

Khmer Rouge leader Khieu Samphan emerges from the jungle in Cambodia, 1980.

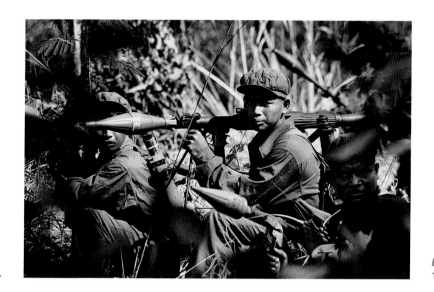

Khmer Rouge soldiers, 1980.

Below: Government troops training in San Salvador, 1980.

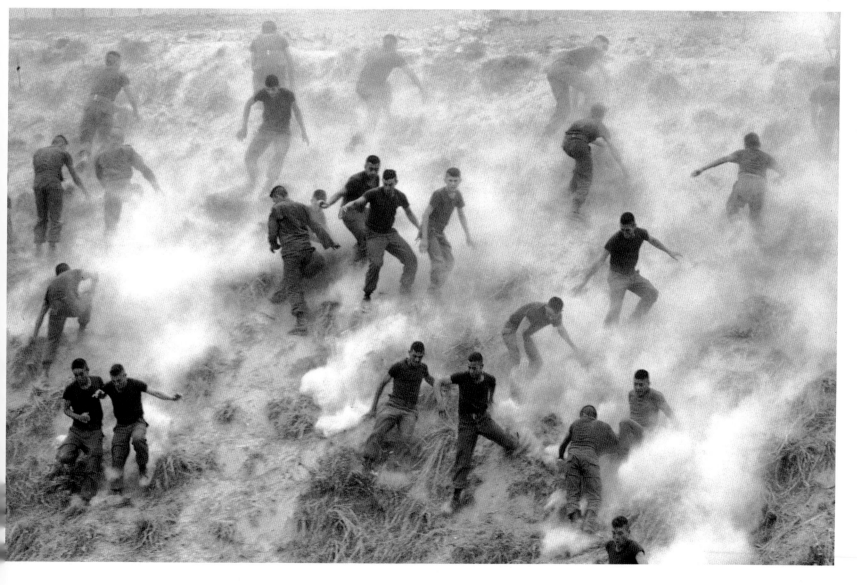

So the picture editor was finally going to give me a break. He handed me a job in one of the really colorful places on earth: Morocco. A place that was generally safe and where there was hardly any war being fought—*hardly* being the operative word, because there was a war, although it hardly mattered to anyone unless you were in the middle of it. My mission: find it, shoot it, and get the film back. "C'mon Arnold," I thought. "I'm getting sick of this!"

The conflict started in 1975 when an International Court of Justice ruled that the people of the Western Sahara, then called Spanish Sahara after the country that had colonized it, had a right to independence and self-determination. Two bordering countries promptly moved in on huge parts of the fledgling nation, Morocco in the north and Mauritania in the south. Another neighbor, Algeria, protested, and Spain pulled out, leaving the self-determining natives in a huge bind. It had all the ingredients for trouble.

The locals took umbrage at the encroachment and, backed by the Algerians, named themselves the Polisario and started fighting the Moroccans. My friend Joseph Reed, who was the U.S. Ambassador to Morocco and lived in Rabat, filled me in on the situation and arranged for me to visit the front. The front was actually a dirt wall several hundred miles long that the Moroccans were building as a political boundary to mark their new territory. The day I arrived we promptly came under artillery attack by the Polisario rebels. As we scrunched down behind the wall, my guide proudly pointed out that I was the first newsman ever to see combat in their war. I told him I was honored and wondered when we were going to leave. His comment led me to believe either that there hadn't been that much action or that this particular conflict was too esoteric even for the press. I suspected the latter.

I figured that as long as I was in the area, I might as well try to get over to the other side to see what the Polisario were fighting for. That meant a trip to Algiers, where I was invited to stay with the American ambassador, Michael Newlin, and his wife. They lived in one of the most beautiful villas I have ever seen. It was so nice

The remains of a Moroccan soldier, Western Sahara, 1982.

that I didn't want to leave, although the idea of traveling to Tindouf at the opposite end of Algeria might have had something to do with that. Tindouf was further away from Algiers than Paris was. It was also the Polisario's jumping-off point to the Western Sahara.

After getting to Tindouf, which was experiencing a driving sandstorm, I linked up with seven Polisario guerrillas. We headed into the desert on a pair of open Land Rovers. My hosts spoke no language known to me, but with a combination of Spanish, French, English, and Arabic we worked out adequate communication. Our journey took us through a thousand miles of the Sahara, and after a few days I started to like it. It was peaceful and quiet, and there was no way I could ever be reached. My guides didn't even have a radio. I think it was the first time since I discovered money that I didn't spend a penny for more than ten days. I was concerned that it might be a bad precedent to set for the accountants in New York.

I saw evidence of the fighting and took pictures of dead Moroccan soldiers half-buried in the sand. There had been a big battle in a small town, and the Polisario had driven out the invaders. I suspected that Morocco was going to cede this middle and inaccessible part of the land to the rebels and hang on to the more valuable north. I admired the determination of the fighters, but I had a hard time believing that they could ever win. My pictures seemed as if they had been taken in another era. I also understood how Lawrence of Arabia could have loved the desert and the people who lived there.

In a big departure from desert conditions, I found myself on a first-class flight to Hong Kong in late 1979, seated next to a distinguished Canadian businessman who was a friend of his country's prime minister. As the flight wore on we talked at length about our interests in politics, world affairs, and so on. I told him about my days in the White House, and we discussed the American hostage situation in Iran. I felt that President Carter was in a no-win bind over the issue and that it could cost him the election. At that moment my acquaintance dropped a bombshell. He told me that there were American embassy personnel hiding out in the Canadian embassy in Tehran, but that only a very few Canadian and American officials knew about them. The Iranians certainly didn't, or they would have taken over the Canadian embassy as well. I could have let the editors at *Time* know about this on an off-the-record basis, but I chose to keep it to myself. I didn't want to be responsible for any kind of leak that would have endangered not only the Americans who were hiding out but also the Canadians. Almost three months later, when Canada closed its mission in Tehran, the hidden Americans got out of Iran using Canadian-issued passports and posing as diplomats. U.S.-Canadian relations became better than they had ever been.

Left: A grisly reminder of the fighting.

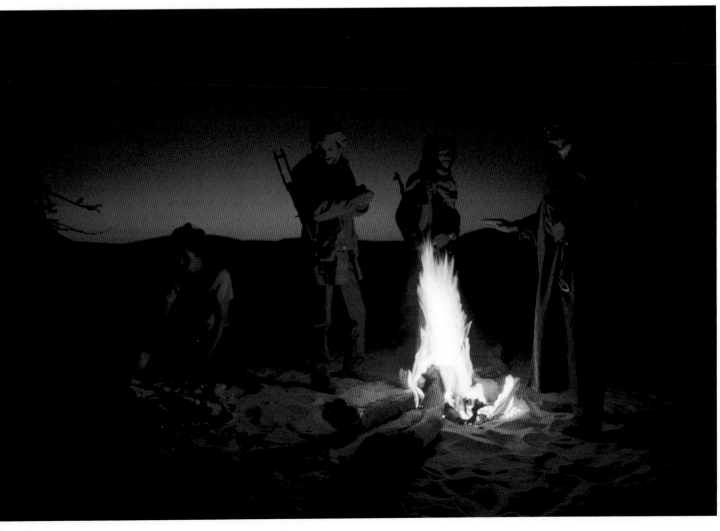

Polisario rebels in the Western Sahara, 1982.

In January 1980 America got a new president, and fifty-three American hostages held by the Iranians in Tehran were released. I was there as the buses carrying the former prisoners made their way down Pennsylvania Avenue. It was a fresh start for them and the first week on the job for Ronald Reagan.

I split the White House duty with Halstead, who had convinced me that it was a good thing to do. ("Hey, it's a job where you don't get shot at," he said. He ate those words after John Hinckley wounded the president. Dirck was just a few feet away when it happened and captured some dramatic pictures.)

It's hard not to like Ronald Reagan. I think the word *affable* was coined for him, and although he had a tough time remembering the name of anyone he met after 1950, he wasn't a bad guy. My old boss used to get up at the crack of dawn and work until midnight. Not President Reagan. He believed firmly in the principle of a short workday and stuck to it. He delegated responsibility, probably to a fault, but left office after eight years looking better than when he had arrived. There's a lesson in there somewhere.

I did the first "day in the life" story of Reagan for *Time*. I followed him around from morning to evening a few weeks after he took office. I found him incredibly detached from the whole process. Granted, my only real experience was with President Ford, a man who stayed on top of everything. Reagan seemed happy to let the oth-

ers look after the details and sometimes seemed to be in another dimension. (A White House press wag compared Ronald Reagan to the Wizard of Oz, saying you were better off not knowing what was behind the curtain. I disagreed, saying he came off better in the open.)

Despite his laid-back working habits, Reagan definitely created good "photo ops." He had grace and style, and if he was a bit bored with the routine away from the cameras, he responded with renewed energy when in front of them. I watched him one day at an event as he sat waiting to speak. Reagan's batteries looked low. When the emcee began the introduction, however, Reagan started to transform. It was as if someone were pumping air into a flat tire.

When the moment came and those magical words, "Ladies and gentlemen, the president of the United States," were uttered, he was on his feet, full of vim and vigor, ready to deliver one of his patented great speeches. I can only presume that his years of acting taught him pacing and that he saved the best for when he had to go onstage.

To my way of thinking, Reagan's biggest accomplishment was engineering the fall of the Soviet Union, or at least speeding it up. His first meeting with Mikhail Gorbachev, the new general secretary of the Soviet Communist party, took place in Geneva on November 21, 1985. I engineered my own accomplishment of sorts, which was an exclusive inside photo session of that historic summit for *Time* magazine.

American hostages who had been held in Iran return to Washington, D.C., 1981.

CIA Director William Casey confers with Secretary
of State Alexander Haig outside the Oval Office, 1981.

President Ronald Reagan waits for his chief of staff,
Jim Baker, and congressional liaison, Max Friedersdorf,
in the Oval Office, 1981.

President Reagan waves farewell after campaigning
for a congressman in Billings, Montana, 1982.

Sandra Day O'Conner testifies before the Senate Judiciary committee that confirmed her as the first woman to take a seat on the U.S. Supreme Court, 1981.

Recovering Press Secretary James Brady, who was shot in the assassination attempt on President Reagan, Washington, D.C., 1983.

I left Washington and moved to Los Angeles in the summer of 1984 to attend the American Film Institute's directing school.

I'd taken myself out of the photo loop, but when I heard about Reagan and Gorbachev's upcoming meeting several weeks away, my old newshound juices started flowing. I immediately called Mark Weinberg, the press office assistant at the White House who handled photo affairs, and told him that I'd fly to Geneva if he could guarantee me access to the meeting. Weinberg responded affirmatively a few days later, but he warned me that if any of my competitors asked for similar entrée prior to the event it would probably kill the deal.

Hundreds of photographers and writers attended the Geneva summit. I tried to keep my presence there concealed because, given Weinberg's warning, I didn't want anyone to suspect what I was doing. I had one close call when I ran into *Newsweek*'s Peter Turnley in the lobby of my hotel. We knew each other from covering various assignments in Europe. (In fact, Turnley was so good that I'd once tried to get *Time* to hire him away from the competition.) When Peter asked what I was doing in Geneva, I answered, "Oh, a little of this and a little of that." No flags were raised, and my mission was still a go.

Once inside the villa where the first round of talks was going to be held, I was shown around by the White House advance team. They took me into a small room that would be the site of the initial private meeting between the two principals. I noticed that the chairs they would be sitting in were so far apart that I wouldn't be able to get them in the same frame using my largest wide-angle lens. I also figured that it would be a pretty poor start on the road to peace if the main participants had to shout at each other. Besides, Reagan was hard of hearing. So I moved the chairs closer—so close that Reagan and Gorbachev would practically be touching knees when they sat down. "There," I said to one of the aides, "this is a little cozier."

"Uh, I don't think this is a good idea," he said. "This positioning was all worked out ahead of time by the two sides."

"Oh, come on," I joshed. "This is our chance to change history by a few inches." He shrugged and gave me a "what-the-hell" look, and we walked out. The chairs stayed together.

Another thing that the summit's meticulous planners had worked out was the number of participants from each side. There would be equal numbers of negotiators, security, staff, and . . . official photographers. I was not included on the official party list, yet there I was. I was hoping that nobody from the Soviet side would notice.

Before Gorbachev arrived I took pictures of President Reagan as he prepared to greet the communist leader for the first time. Reagan walked over to a window and gave a thumbs-up to the crowd of press shivering outside on a riser. They would have heated up quickly had they known that one of their competitors was inside shooting out. After joking around with his staff for a few moments, Reagan stood quietly and appeared anxious as he waited for the arrival of the man who governed what he had once dubbed "the evil empire."

It was in the little room with the rearranged chairs that the Soviet staff first noticed that there was one too many photogs from the other side. I guess you can count to three in Russian just as quickly as you can in English. They were pointing at me and grumbling, but the red flag hadn't gone up yet, so I just kept shooting. The White House staff all had special pins officially identifying them. I had nothing but a suit, a smile, and three Nikons. When one of them finally questioned my presence, the person to whom he talked, my friend the advance man, said that he'd look into it. As he was saying that, he winked at me. Safe—for the moment.

I still had not been thrown out of the villa when the second round of talks commenced in the afternoon. The two leaders were supposed to walk to a boathouse a few hundred yards from the main chateau to continue their discussions, but nobody knew when they'd do it. I had repaired to a bathroom, something I had to do frequently since picking up a bug on a recent trip to Vietnam, when I heard a big commotion outside. Chairs were being pushed back,

feet were moving fast, and Secret Service agents were excitedly talking on their radios. Someone knocked on the door and said simply, "They're walking." I scrambled, trying to button my pants with one hand while grabbing my cameras with the other. This was an important shot, and I didn't want to miss it, bug or no bug.

I managed to catch Reagan and Gorbachev before they arrived at the beautiful little house by Lake Geneva. A large fire roared inside, and the two men sat in a couple of big chairs with only their interpreters present. I was taking pictures alongside Bill Fitz-Patrick, the White House photog who had worked for me when I was with Ford. The Soviet shooter was nowhere in sight, and I figured when he showed up he was going to be short of breath. A couple of minutes later he came panting in, and the three of us shot while the superpowers talked.

My exclusive coverage of the "Fireside Summit" was the biggest scoop of my life, but at the end of the day it was also one of my biggest disappointments. I was stunned by the reaction of my friends and colleagues who were also my rivals. They shrieked in protest to anyone who would listen, claiming that I had somehow taken unfair advantage of my former position as White House photographer in securing the exclusive pictures. I always thought that anyone who won a battle fair and square would be appreciated for the way he or she fought the war. I was wrong. I had to endure a withering attack from friends and foes alike, including an attempt to get my film released as "pool" coverage. That night I sat in my hotel room in Geneva totally depressed.

Opposite page: **President Reagan waits anxiously for his first meeting with General Secretary Gorbachev. Their first meeting, which included their historic "fireside chat," ended on a positive note, Geneva, 1985.**

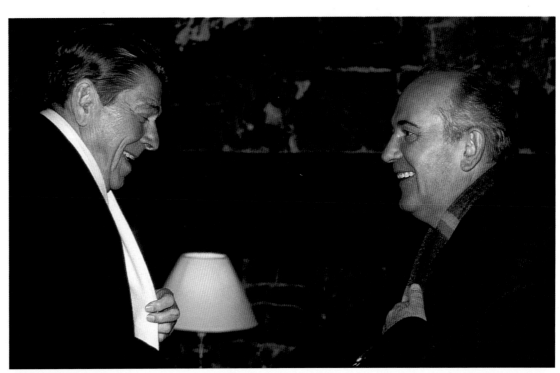

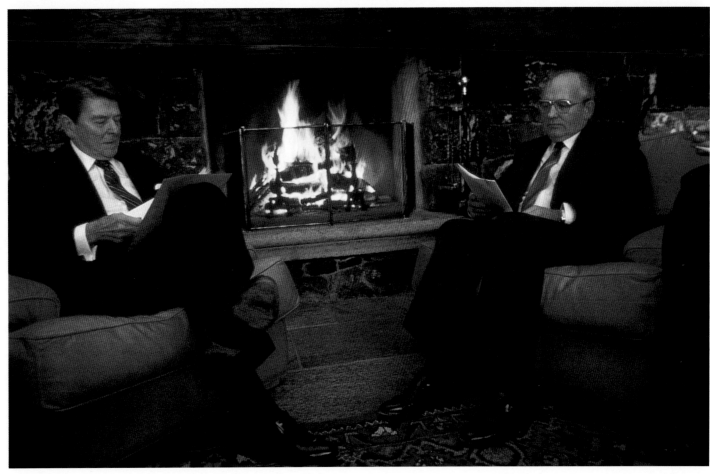

The correspondents at *Time,* who I thought would be grateful that we had hit one out of the park for the home team, instead complained that I had somehow cut them out of their portion of this world-beating exclusive. They couldn't believe that I had done this without informing them. The White House photo staff, some of whom had worked for me before, tried to torpedo my initiative in order to preserve the story for themselves. But the most vitriolic were my rivals, many of whom I had helped to get their own exclusives with the president while I was the official photographer. They bitterly complained to the press office about my "special treatment." Kennerly didn't get special treatment, Press Secretary Larry Speakes told them. They demanded to know how I'd managed to get inside. "He asked Mark Weinberg, just the way you could have if you'd thought of it," was Speakes's answer.

A couple of them even led a campaign later to have my pictures excluded from the White House Press Photographers contest because I no longer lived in Washington. I don't ever recall being more unhappy or pained on a day when I should have been tap-dancing with joy.

Time ran six pages of my pictures to lead off their issue the following week. Halstead's photo of Reagan and Gorbachev greeting each other outside the chateau ran on the cover. It was the definition of teamwork.

A few months later I ran into Peter Turnley at a ceremony in New York. The two of us were receiving awards from the Overseas Press Club, mine for Geneva and his for coverage of South Africa. Peter was one of the few shooters who understood what I'd pulled off and hadn't taken it personally. He warmly congratulated me for it. "So what have you done lately?" I asked. "Oh, a little of this and a little of that," he said laughing.

When you work alone and miss a picture, nobody knows it but you. That's not true when you're going head to head out in the open, but that's also part of what I love about the business. Still, outfoxing the competition is only part of the game, and although satisfying, it is not the most important. Getting behind the scenes of history has always been a personal challenge, one that springs from the overriding curiosity I was born with. Sometimes that means finagling access to events from which other shooters have been barred, but it's the event that's important, not the fact that I got the exclusive. I don't believe that I was brought into this world just to show up others.

The next Reagan-Gorbachev meeting provided me with an excellent opportunity not only to shoot elbow to elbow with arch-rival *Newsweek* but also to have a little fun. Dirck Halstead, my friend and mentor, was running *Time*'s summit coverage in Iceland, where the conference was convening. Richard Nixon once referred to Iceland on a visit there as "this Godforsaken place." It's actually far from that. In fact, it's quite beautiful, although the weather there is highly erratic.

Before I flew into Reykjavík, Dirck, picture chief Drapkin, and I had set the wheels of a plot in motion. After arriving I stayed out of sight, "accidentally" appearing only for a moment, which lent credibility to our plan. Dirck then started a rumor that I was going to do an encore performance behind the scenes at the summit. Word reached the opposition in no time, and being totally paranoid about me anyway, they swallowed the bait. My outraged adversaries vehemently protested my exclusive to White House officials, who looked at them as if they were nuts. We hadn't even asked for one.

After successfully pulling off our prank, I still had work to do. This time doing my job meant freezing my rear for hours on the photo stand with the rest of the photographers as we waited for Gorbachev and Reagan to emerge from their talks. I think the other photographers really believed that I wasn't inside scooping them only when they saw me alongside them.

When the big moment arrived and the leaders came out, it was dark and the scene was lit poorly with TV lights. I was holding a 300 mm lens and shooting wide open at 1/15th of a second. Technically speaking, it was atrocious.

Reagan looked particularly grim and determined as he walked Gorbachev to his bulletproof limo. They stopped directly across from where I was shooting, and although I couldn't hear a word they said, it didn't look like a pleasant conversation. It did, however, make a great shot, and I prayed that the decisive moment wasn't shaky. There's only one thing worse than missing a good picture, and that's getting an unusable one of a big moment.

Because this particular summit was supposed to go off without a hitch, *Newsweek* hadn't scheduled the story as a cover; instead, they were planning on running a Beirut hostage story. Halstead, ever the worrier and planner, had made arrangements to have a state-of-the-art color transmitter flown in to Iceland's capital and had secured the best color lab in town. *Newsweek* had made no such arrangements, figuring that the last day of the summit was Sunday night and too late to meet a deadline anyway. Unfortunately for them, the story veered sharply into the news fast lane, which never seems to respect magazine deadlines.

Every minute counted, so I got on my two-way radio to advise *Time*'s correspondents that something was up and that they should be prepared for breaking news. None of them had been with me on the photo stand to see the look on Reagan's face, which clearly had signaled trouble. My "heads-up" saved them at least one valuable hour as they pursued the story.

My instincts were right: there had indeed been big trouble behind those closed doors. The summit fell apart when Reagan rejected demands that the United States restrict development of its "Star Wars" program. Reagan was playing hardball, which was an unexpected development and huge news. Because of Dirck's foresight we were able to transmit my picture of Reagan and Gorbachev facing off (which I had nailed). Even though it was late Sunday night, Time went to great expense and used it on the cover, which hit the stands the next day with the headline "NO DEAL."

The *New York Times* ran Jose Lopez's picture, which was almost the identical moment to mine, on the front page. *Newsweek*'s film of the event rode back to Washington, D.C., undeveloped on the press plane. They did end up changing their cover to try to avoid a total debacle, but they had to use an earlier shot of the two leaders smiling and looking chummy. It was a bit off the point. In an article a few days later about press coverage of the summit, the *New York Times* said that *Time* had clearly and decisively beaten *Newsweek*, attributing much of its success to the photo department. The only "special treatment" I got in helping with that victory was a cold from standing around in the bad weather. It was worth it.

Mikhail Gorbachev may not have pleased Reagan on that particular occasion, but his policy of perestroika, or reform, opened up the Soviet Union in a way that it had never been open before.

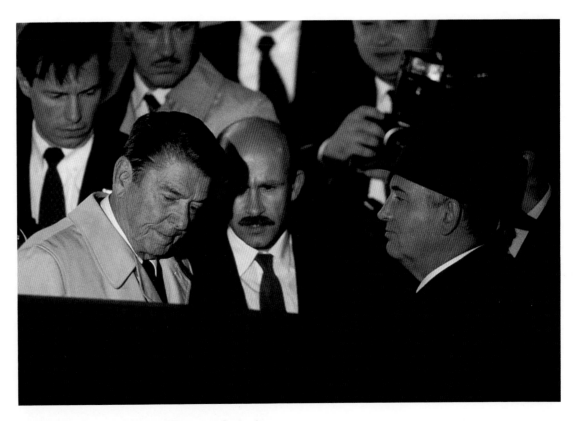

President Reagan and General Secretary Gorbachev at the conclusion of their second summit in Reykjavík, which ended on a sour note, 1986.

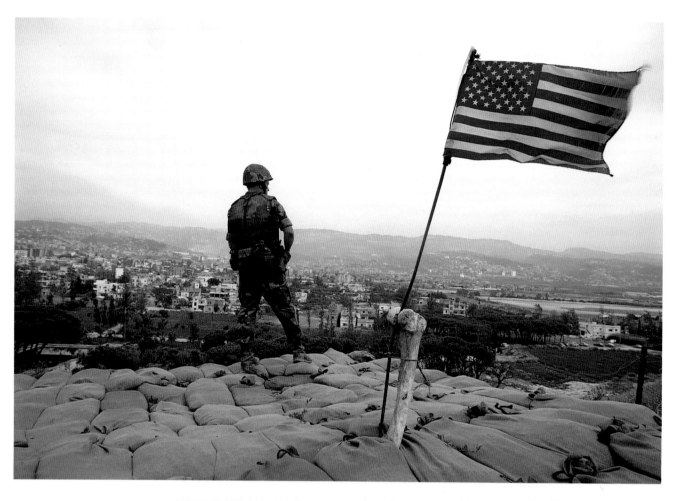

A lone Marine looks out
over Beirut, 1983.

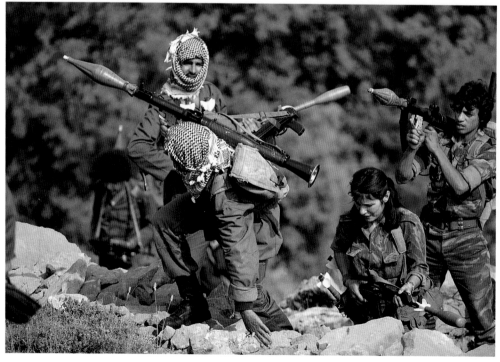

Soldiers of the Popular Front for
the Liberation of Palestine (PFLP)
patrol the hills above Beirut,
1983.

There have been a lot more stops along the way. My camera and I were in Beirut with the U.S. Marines on one day, then on patrol in the mountains above Beirut with guerrillas from the PFLP the next. We went back to Vietnam ten years after the war ended to have a look around and saw the rusting remains of U.S. helicopters and people who were happy finally to be at peace. We visited King Hussein and watched his troops jump through fire for him during training.

The rusting wrecks of U.S. helicopters sit at the old Tan Son Nhut airbase outside Ho Chi Minh City, Vietnam, ten years after the end of the war, 1985.

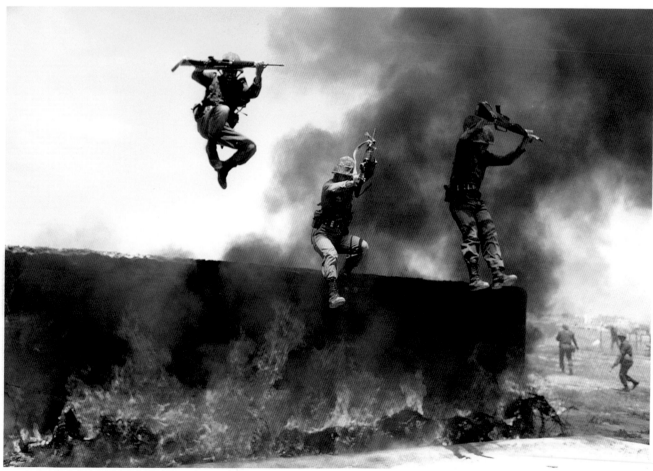

Jordanian troops in Amman, 1983.

I learn things in the most unusual ways, but one of the most bizarre happened when I flew on a private jet between Ankara and Zurich. I was returning from an assignment in Turkey and was relaxing with a cocktail as we soared high above the clouds. There was something strangely familiar about the aircraft, but I couldn't quite put my finger on it. Then it came to me. This looked like the same plane that had brought the American hostage David Jacobsen to freedom after his captors in Beirut had released him. Accompanying him was the Englishman Terry Waite, who himself was taken prisoner a few months later while trying to win the release of more hostages. I took their picture as they exited the small aircraft in Germany after flying in from Cyprus. Jacobsen looked haggard, but he talked to the press long enough to give credit to Terry Waite for his freedom. I told the steward my story. "It is the same aircraft," he told me, "but there were three." I said I had seen only two men get off. He said that the third man had stayed on board and out of sight. "Who was it?" I asked. The flight attendant told me that he wasn't at liberty to say. A mystery. I quickly narrowed down the list of possible suspects to one person, and then, to confirm my suspicion, I called a friend who was highly placed in the government and who would have known about the mysterious passenger. He did: it was Oliver North. I looked back through all my pictures with that plane sitting in the background to see whether I could spot his shadowy figure in a window, but I couldn't. Too bad; it would have made one hell of a snap.

Freed Beirut hostage David Jacobson gives credit to Anglican envoy Terry Waite for his release, Rhein Mein Air Base, Germany, 1986.

When I turned forty on March 9, 1987, I had a most unusual party. Deposed president Ferdinand Marcos and his wife, Imelda, presented me with a cake and sang happy birthday. That's the kind of occasion that's hard to forget. I was photographing them at an estate in Hawaii where they had fled after being kicked out of the Philippines. I took a picture of Mrs. Marcos looking lonely and forlorn as she sat watching a sunset from their house high above Honolulu. I can't imagine what was going through her mind, but what came to mine concerned why she was sitting in the United States and not at home in the Philippines. I remembered standing on an overpass in Manila with Willy Vicoy photographing the funeral procession of Philippine opposition leader Benigno "Ninoy" Aquino as it made its way through thousands of his supporters in August 1983. Aquino had been killed by Marcos supporters, and Marcos himself had been implicated in the slaying. Corazon "Cory" Aquino, the wife of the slain leader, ran against Marcos and beat him. Stripped of popular and American support, Marcos chose to leave his homeland and died exiled in Hawaii in 1989.

Imelda Marcos in exile, Honolulu, 1987.

The casket of slain Philippine opposition leader Benigno "Ninoy" Aquino passes through a huge crowd in Manila, 1983.

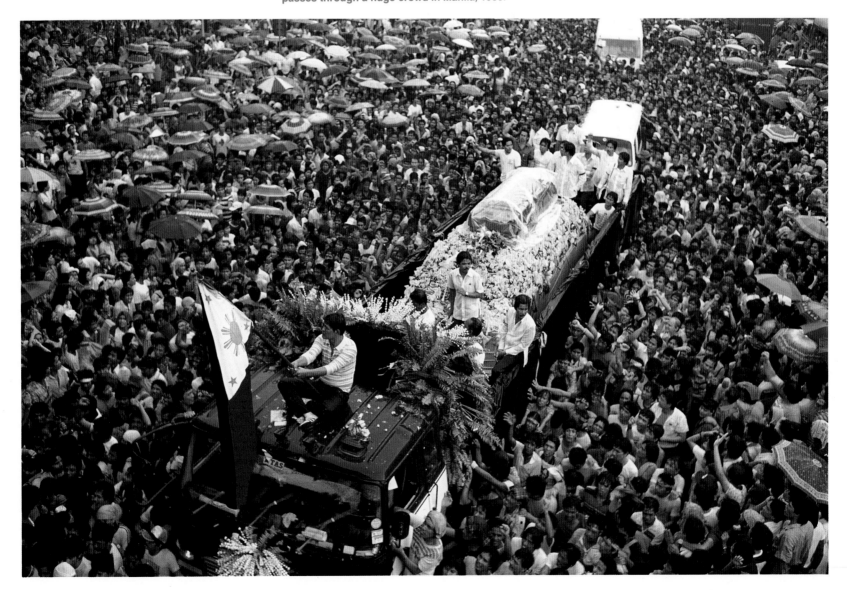

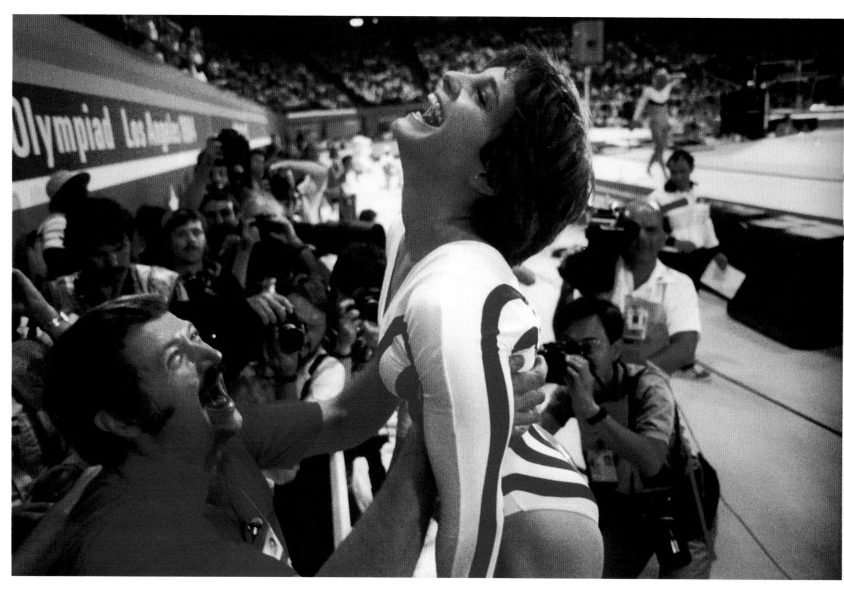

Covering the 1984 Olympics in Los Angeles, I took
a picture of gymnast Mary Lou Retton being hoisted
into the air after winning the gold medal in the
all-around competition.

Jodie Foster, Vancouver, 1987.

Michelle Pfieffer, Los Angeles, 1986.

Arnold Schwarzenegger, Venice, California, 1986.

In May 1987 I went back to Leningrad to work on the book *A Day in the Life of the Soviet Union.* My assignment was to shoot inside the Nakhimov Naval Academy, which was a prep school for aspiring naval officers. I was the first person ever to be allowed to take pictures in there. The day before the shoot I was given a tour by the school's director, a Soviet admiral. He admitted that I was the first American he had ever dealt with, and at the end of the tour he said he found me very nice, very professional, but a bit peculiar. I wasn't sure how to take that, but I figured he meant it in a positive sense, because just before I left he presented me with a Soviet navy hat bearing the school's name for my son, Byron.

They also allowed me to take pictures inside a Soviet army officer's club. I photographed men playing chess and pool and engaging in other activities, but the most moving moment came when a group of elderly World War II veterans gathered around a piano and sang an emotional song about their country's struggle during the war. Behind them was a huge painting that depicted an earlier conflict.

At the Soviet officers' club in Leningrad, World War II veterans sing revolutionary songs and young officers play chess, 1987.

Hats of cadets at the Nakhimov Naval Academy, Leningrad, 1987.

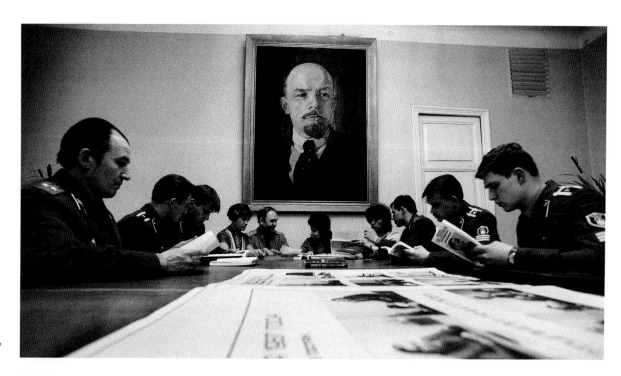

A reading group at the officers' club,
Leningrad, 1987.

Cadets stand for
inspection at the
naval academy, 1987.

Another *Day in the Life* project took me to Tiananmen Square in Beijing in April 1989. I was able to shoot inside Mao's tomb as long as I didn't take pictures of Mao, who is carefully preserved under glass. There is, however, a huge statue of him in the entryway that made a good snap. Outside I photographed the entrance to the Forbidden City as a few of the city's millions of bicycles zoomed by in the foreground. It was on that very day that former Communist party secretary Hu Yaobang died. Hu had been removed from office two years earlier and became associated in the minds of many Chinese as the embodiment of free speech and personal liberty. His death triggered the student democracy movement, which culminated in the deaths of hundreds of protesters in the square a few weeks later. On that day, however, all was normal, but it would never be quite the same there again.

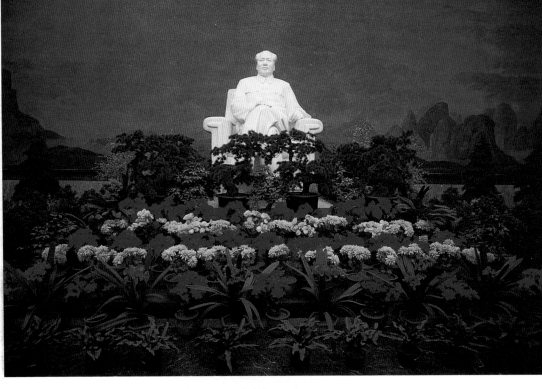

A statue of Mao Zedong sits among flowers in his mausoleum, Beijing, 1989.

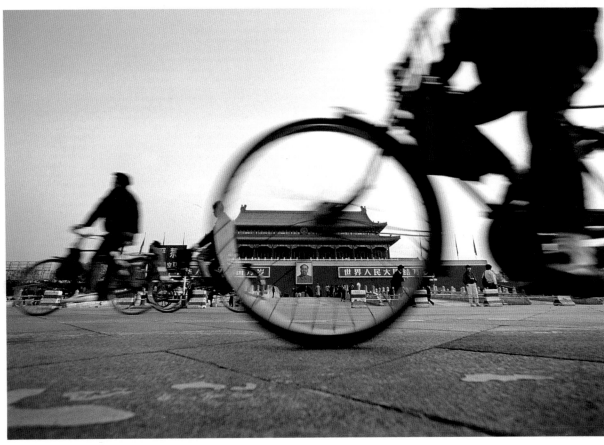

Bicycles pass the entrance to the Forbidden City, Tienanmen Square, Beijing, 1989.

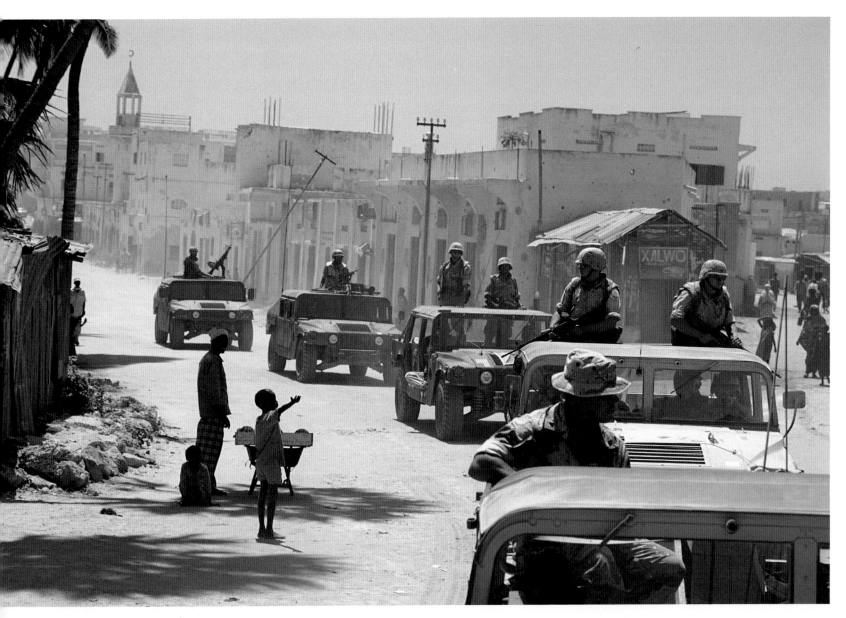

GIs patrol Mogadishu, 1993.

Author Herman Wouk and a miniature of Berlin's Brandenberg Gate, which was used during the filming of "War and Remembrance," Vienna, 1986.

Whoopi Goldberg, Malibu, 1986.

Clockwise from below: **Sammy Davis, Jr., and Bob Hope, Grand Rapids, Michigan, 1986; Eddie Murphy, Los Angeles, 1991; Steven Spielberg, Los Angeles, 1985; Michael Jackson, Los Angeles, 1991.**

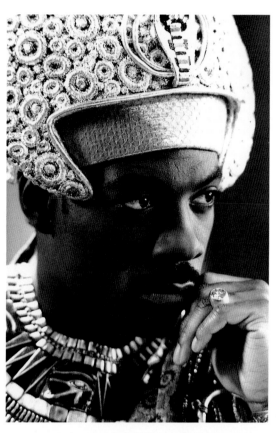

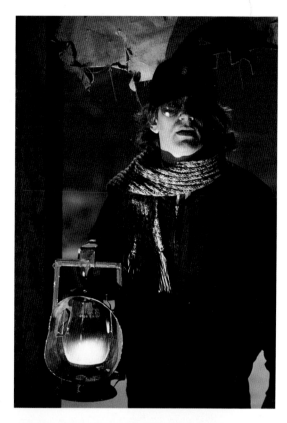

On an exclusive assignment for *Life* magazine, I flew with Secretary of Defense Dick Cheney and General Colin Powell to Saudi Arabia during the war with Iraq.

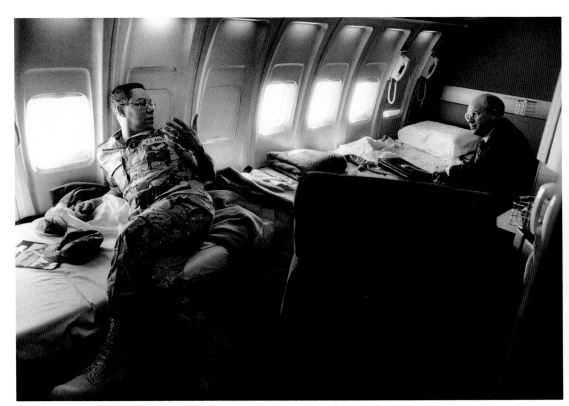

Chairman of the Joint Chiefs of Staff Colin Powell and Secretary of Defense Dick Cheney address U.S. military personnel in a hangar at a secret F-111 base somewhere in Saudi Arabia, 1991.

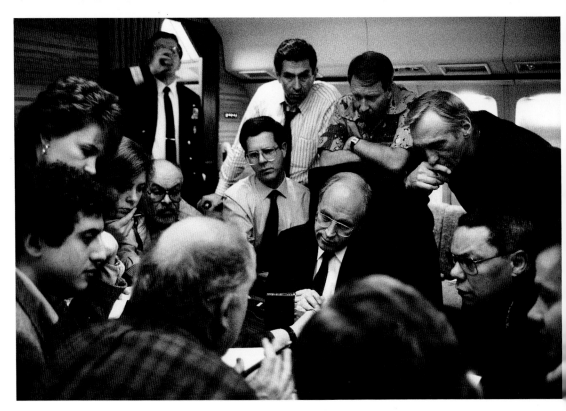

General Powell and Secretary Cheney on their way to Saudi Arabia and briefing the press in the airplane, 1991.

Secretary Cheney reports to President Bush
at the White House after his Mideast mission;
Below: An American "Scud Buster" unit outside
Riyadh, Saudi Arabia, 1991.

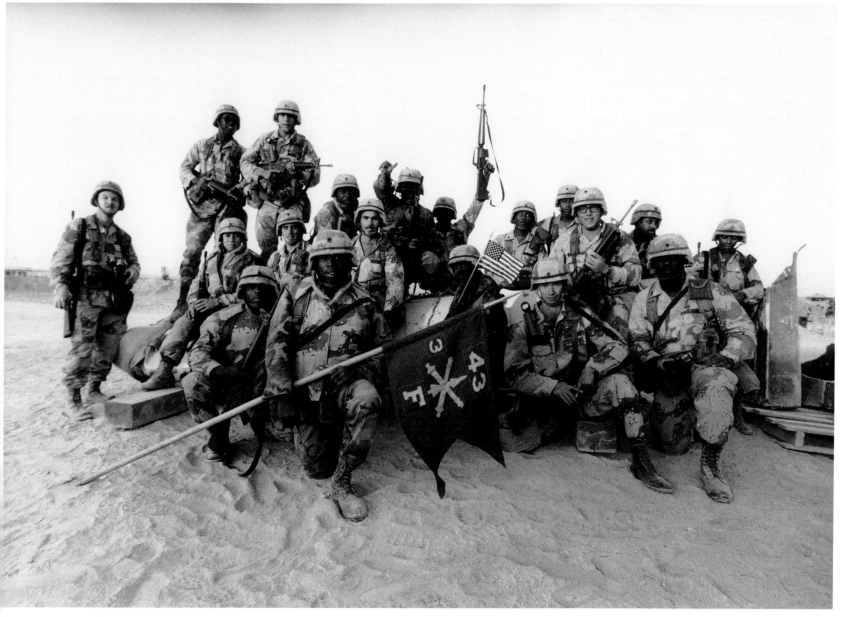

When they came together for the dedication of the Ronald Reagan library in 1991, I pictured five presidents in one frame, and there have been only ten so far in my lifetime. I followed George Bush's last campaign and watched him go down in defeat to the first member of my generation to become president. And I rode with that young president-elect as he took the bus trip up to Washington, D.C., to his new address at 1600 Pennsylvania Avenue. And I was there when Richard Nixon, the man who made a young photog a martini and who shook our country to its core, was laid to rest.

Five presidents, Simi Valley, California, 1991.

Senator Robert Dole is overcome with emotion after delivering remarks at President Nixon's funeral. In the foreground are President Clinton and former presidents with their wives, Whittier, California, August 27, 1994.

President George Bush campaigns for a second term,
Akron, Ohio, 1992.

President-elect Bill Clinton and
Vice President–elect Al Gore en route
to Washington, D.C., 1993.

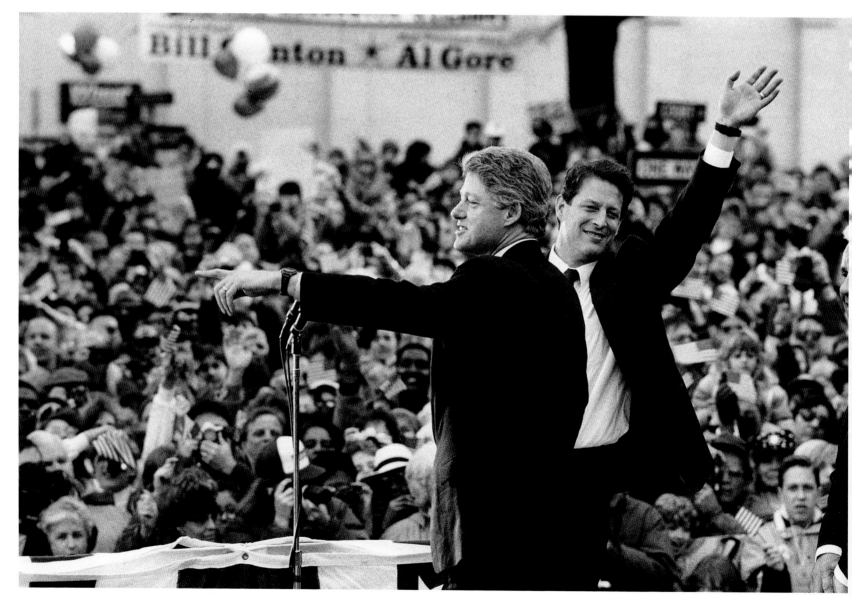

On Jan. 20, 1993, my generation's class president became the president of the United States. I was inside the Oval Office as the desk of the man from my father's era was carried out and replaced by the one to be used by the man from my own. That was a powerful image of the journey taken by members of my generation, and I was there to take the picture.

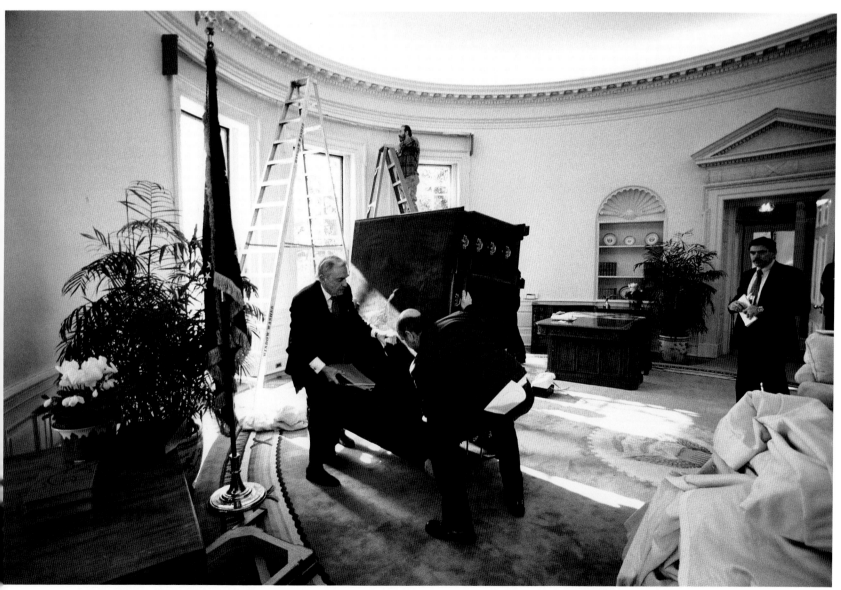

Desks are exchanged in the Oval Office at the stroke of noon, January 20, 1993.

PHOTOGRAPHS SELECTED FOR *Time* MAGAZINE COVERS.

October 22, 1973

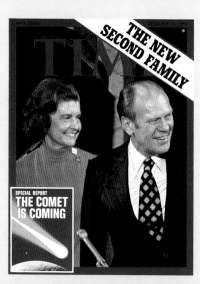

December 17, 1973

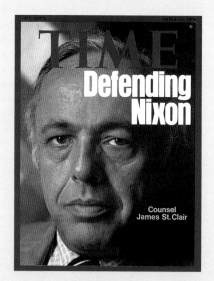

March 25, 1974

June 10, 1974

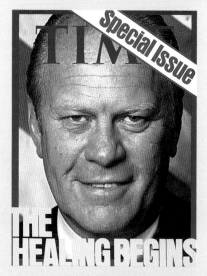

August 19, 1974

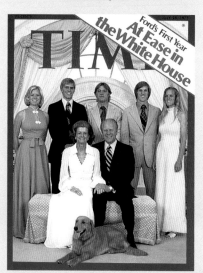

July 28, 1975

November 28, 1977

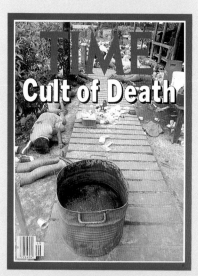

December 4, 1978

September 3, 1979

March 16, 1981

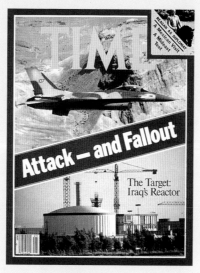

June 22, 1981

August 22, 1983

February 6, 1984

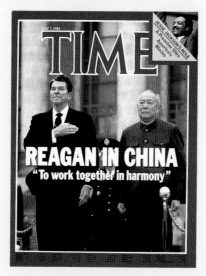

May 7, 1984

July 15, 1985

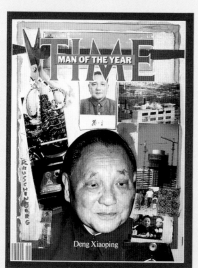

January 6, 1986

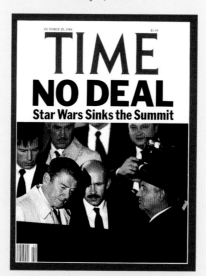

October 20, 1986

December 15, 1986

ACKNOWLEDGMENTS

It's not easy to thank everyone who had anything to do with this book, mainly because this project has been almost thirty years in the making—at least that's how long I've been taking pictures! But here are a few people who made me smile along the way:

To Nick Nicholas and Charles Jennings, a pair of aces. And (in alphabetical order) Virginia Adams, Naz Alam, Bob Albieri, Susan Allwardt, Ernie and Kelly Anastos, John Anderson, Nguyen Ngoc Anh, Teruaki Aoki, Army Archerd, Peter Arnett, Terry Ashe, Fouad Ayoub, Jim Baker, Susan Ford Bales, Frances Barnard, Bob Barrett, Larry Barrett, Skye Bassett, David Beckwith, Ed Begley, Pamela Bellwood, Ron Bennett, Chris Berardo, Tom Berenger, Candice Bergen, Frances Bergen, Grazyna Bergman, Craig Berkman, Michel Bernard, Richard Bernstein, Susan Biddle, Artyum Borovik, Chuck Bowman, Ken Boxer, Dennis Brack, Ed Bradley, Nolan Briden, Skip Brittenham, Norman Brokaw, Tom Brokaw, Skip Brown, Larry Buendorf, David and Iris Burnett, Bobbi Baker Burrows, George and Barbara Bush, Pat Butler, Jim Caccavo, Jim Calio, Jim Cannon, Lou Cannon, Don Carleton, Shaun Cassidy, Ben Cate, Red Cavaney, Ray Cave, Suzy Chaffee, Rosiland Chao, Toren Charnoff, Eddie Cheever, Linda Chen, Dick and Lynne Cheney, Connie Chung, Penny Circle, Marsh and Pippa Clark, Stan Cloud, Jodi Cobb, Jennifer Coley, Manny and Alison Coto, Bob Crestani, Ann Cullen, Bruce Dale, Karen Danaher-Dorr, John Davis, Al Dawson, Tom DeFrank, Dan deMoulin, Uli Derickson, Larry DeSantis, David and Ann DeVoss, Bob Dilenschneider, John Dominis, Adam and Amie Donovan, Bob Dougherty, Tony Dow, Bill and Pam Doyle, Arnold Drapkin, Leonard and Maryanne Duboff, Dick Duncan, John Durniak, Mike Duval, Nguyen Quan Dy, Janet Eilber, Eric Engberg, Bill Eppridge, Michael and Story Evans, Hamed and Dolly Fahmy, Jackie Fain, David Falconer, Shao Guang Fang, Dana Fineman, Leonard Firestone, Bill and Maura Fitz-Patrick, Jack and Julianne Ford, Michael and Gayle Ford, Steve Ford, Matt Franjola, Paul Freeman, John Full, Joe Garagiola, Ginger Garrett, Vic and Dale Gold, Diego Goldberg, Gary David Goldberg, Arthur and Florence Grace, Peter Greenberg, Darrell Greenlee, Gregory Grenon, Sunny Griffin, Paul Gruenberg, Henry Grunwald, Mandy Grunwald, Rick and Joan Hacker, Bob Hagedohm, Al Haig, Fawn Hall, Marion Halphen, Dirck Halstead, Jerry Hanafin, Dawn Hannan, Linda Hannan, Mel Harris, Gregory Harrison, Chick Harrity, David Hartman, David Alan Harvey, Mark and Antoinette Hatfield, Mark and Inger Hatfield, Jr., Jeff and Susan Hayes, Michael Healy, Christie Hefner, Daryl Heikes, Roger Helliwell, John Hensley, Doug Hessler, Yanal Hikmat, Howard Hinsdale, Karen Hinsdale, George Hiotis, James Hollingsworth, Kim Hoon, Queen Noor and King Hussein, Carol Huston, Bill Jacobson, Steven-Charles Jaffe, Val James, William Jamison, Al Jennings, Cristine, Faith, Nayana, and Mat Jennings, Peter Jennings, Linda Johnson, Frank Johnston, Phil Jones, Ilene Kahn, Joe Kamalick, Yousef and Estralita Karsh, Shelly Katz, Stanley Kayne, Larry and Virginia Keene, Dick Keiser, Dennis and Pat Keller, Jake Keller, Donna Kendall, Chris Kennerly, Cliff Kennerly, Gary and Glenda Kennerly, Joe King, Henry and Nancy Kissinger, Steve and Bo Kline, Lisa Koenig, Ted Koppel, Tom Korologos, Jean-Pierre and Eliane Lafont, Sherry Lansing, Owen Laster, Boots, Joanne, and Brookie Lebaron, Van Lim, Sun Dao Lin, John Linehan, Norman Lloyd, Larry and Lilly Logan, Jose Lopez, Mike Lorenzen, Harry Lunn, J. C. Luyat, Jim Lynn, Jeff and Susie MacNelly, Dezso and Mary Magyar, Barry Mann, Paul and Rebecca Manning, Ron Mardigian, Bob Markowitz, Jennifer Matthey, Rudy Maxa, Steve McBeth, Wally and Nikki McNamee, Chris Meigher, Bill Messing, Nicholas Meyer, Reza Mizbani, Art Monterastelli, Penny Morse, Robin Moyer, Carl Mydans, Debbie Naughton, Matthew Naythons, Don Neff, Gary and Judy Nelson, Ron Nessen, Michael and Milena Newlin, Johanna Newman, Nguyen Thanh Ngoc, Cu Ba Nguyen, Lynn Nicholas, Steve Northup, Eileen O'Conner, John and Sandra Day O'Conner, Terry and Margret O'Donnell, Chris Ogden, Terrance O'Hara, Kathy O'Hearn, Jack Ohman, Bert Okuley, Pat Oliphant, Graeme Outerbridge, Bill Palmer, Ike Pappas, Leon and Barbara Parma, Morning Pastorok, Paula Patrick, Don Penny, John and Debbie Perry, Mike and Marian Peters, Bill Pierce, Bill Plante, Robert Pledge, Wally Pond, Maury Povich, Colin Powell, Nick Profitt, Ed Rabel, Deborah Raffin, Peter Ross Range, Dan Rather, Shanna Reed, Alon Reininger, Tom and Beth Rickman, Steve Roberts, David Rockefeller, Al Rockoff, Peter Rodman, Michael Rosenblum, Diana Ross, Roy Rowan, Larry Rubenstein, Alan Ruck, Don and Joyce Rumsfeld, John Saar, Nola Safro, Toshio Sakai, Sebastiao Salgado, Cynthia Schneider, Bob Schnitzlein, John Schulman, Brent Scowcroft, Pete and Joan Secchia, Robert Sedlack, Mitch Semel, Billie and Lucy Shaddix, Hugh Sidey, Lee Simmons, Neil Simon, Guy Smith, Madeline Smith, Robin Smith, Rick Smolan, Bill Smullen, Bill Snead, Jay and Salle Soladay, Jim Soladay, John Stacks, Ken Starr, Rusty Staub, Herbert Stein, Michele Stephenson, Phil Stern, Jane and John Straight, Anne, Marv, and Artie Strutzenberg, Charles and Connie Stuart, Mary Sullivan, Dick and Germaine Swanson, Mark Tager, George Tames, Bill Tanner, Mary Taylor, Wayne and M'Lou Thompson, Larry Tiscornia, Dennis Troute, Sarah Tuor, Peter and David Turnley, Neil Ulevich, Frank Ursamorso, Nick Ut, Giancarlo Uzielli, Michael Viner, Viviane Vives, Paul Vogel, Janja Vujovich, Jeff Wachtel, Cheryl Waixel, Natalie Walden, Diana Walker, Jane Wallace, Mary Walsh, Charles Wang, Tom Waskow, Mark Watson, Kate Webb, Cynthia Weil, Mark Weinberg, Bob Weiner, Robin Weiner, John and Susan Weisman, Sam and Constance Weisman, Nik Wheeler, John Whelpley, Robin Williams, Jeannie Winnick, Bob Woodward, Lydia Woodward, Herman and Sarah Wouk, Joe and Suzanne Wouk, Nell Yates, Patty Young, Perry Deane Young, Frank Zarb, and Susan Zirinsky.

Special Acknowledgments

It's too bad that my dad O. A. "Tunney" Kennerly didn't get a chance to see this book completed. He died November 5, 1994, at the Veterans Administration hospital in Lebanon, Pennsylvania at the age of 69. Dad always seemed a bit perplexed by what I did for a living and wondered when I was going to get a real job, but nobody was prouder than he of my accomplishments. After I won the Pulitzer in 1972, he was seen walking down 42nd Street with an armful of *New York Times* newspapers containing the story. I even heard that he would stop total strangers to tell them about it. One thing I believe for sure—wherever he is now he'll have a bunch of my books under his arm and will be telling anyone who will listen about his son the photographer. He was like that. I miss him.

Having a son who occasionally calls from places where you can hear gunfire in the background cannot have been a pleasant experience for my mother. Joanne Kennerly faced it all with resignation and a sense of humor. Her dedication to my dad, to me, and to my sisters Jane, Chris, and Anne has been an inspiration and a comfort to me. Thanks, Mom!

And thanks also to President and Mrs. Gerald R. Ford for sharing a most dramatic and difficult part of their life with me. The Fords took me under their wing and treated me like one of the family. They are wonderful and special people, and I love them a lot.

Thanks as well to Joanna Hitchcock, Shannon Davies, David Cohen, Nancy Bryan, David Cavazos, Zora Molitor, and the other folks at the University of Texas Press.

George Lenox designed this book. He's a genius. Thanks, George!

To my old buddy Steve Kline a special note: No matter how difficult things get, they can't be worse than the North Slope on any winter night.

To Nancy Richardson, thanks for the title.

To Michael Brown I extend thanks and gratitude. Michael offered to make a CD-ROM of this book, and did it. There aren't many people who follow through on what they say they're going to do. Michael is one of them.

Thanks to Jennifer Coley, Michel Bernard, and everyone at Gamma Liaison Agency in New York for their excellent help.

To Jerry McGee, Neil Leifer, Dick Swanson, and Bruce Oppenheim, old friends who have been there when I needed help. Thanks.

To Mary Fisher, who is fighting a courageous battle, all of my love.

Every photographer needs a good picture editor, and I had one of the best. Sandra Eisert not only helped me select photographs for this book but was also my accomplice and friend while we were at the White House.

Likewise every writer needs an editor, and again I had one of the best. Rebecca Soladay took time out from her own writing project to lend me her expert and good-natured guidance on mine. Knowing Rebecca and working with her on our dueling PowerBooks has been one of the joys of my life. Being married to her is another. I love you, Reb.

And cheers to Pluggers everywhere. Go Byron!

NOTE: Reference material used includes *The People's Chronology,* by James Trager; *A Time to Heal,* by Gerald R. Ford; *The Times of My Life,* by Betty Ford with Chris Chase; *Gerald R. Ford, 1913–,* by George J. Lankevich; *Chronicle of the 20th Century,* ed. Clifton Daniel; *The World Almanac,* ed. Mark S. Hofman; and *Shooter,* by David Hume Kennerly.

A fond farewell for some old friends

Dick Growald
1931–1993

Ansel Adams
1902–1984

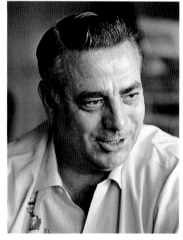

O.A. "Tunney" Kennerly
1925–1994

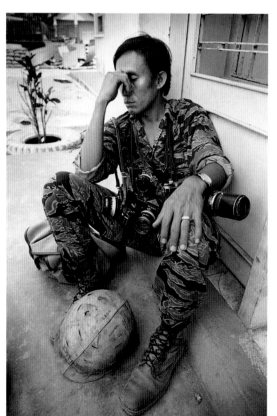

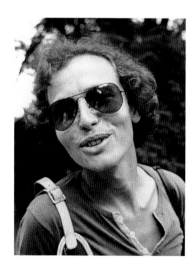

Michel Laurent
1946–1975

Willie Vicoy
1941–1986